D1576716

OFF STAGE

Cambridge Jones would like to extend a big thank you to the following:

Nick Evans Lombe (Getty Images) for encouragement and help where none was expected; Patricia Myers (RADA) who has masterminded the whole project; Nicholas Barter (RADA) whose inspiration and idea it was to link the Centenary to 100 new portraits; Eddie Morgan (BBC Culture Show) for enthusiasm, belief and always coming through; Adrian Murrell (Getty Images) for straight-talking support at all times; Louise Garczewska (Getty Images Gallery) for finding space for the exhibition in a very full year; Sue Smerdon for helping in so many ways; Holly and Andre for everything; Charles Merullo (Getty Images) for selfless help when choosing a publisher; Lucie Greene for working tirelessly behind the scenes to help Miranda and myself get the book together; Dewi Lewis for being the most flexible publisher ever while holding the highest standards in all his work.

Dedicated to my three girls – Ondine, Amber and Sasha
without whom there is no light!

www.cambridgejones.com

OFF STAGE

100 PORTRAITS CELEBRATING THE RADA CENTENARY

Cambridge Jones • Miranda Sawyer • Lord Attenborough

dewi lewis media

Within RADA at any one time, there is always a host of singular personalities and this, I can attest, is by no means limited to the students. Many former graduates, idiosyncratic and major figures in the theatrical world, derive great satisfaction from fostering and encouraging our eager young actors on the nursery slopes of their careers.

Capturing the essence of a singular personality is, for me, the great skill of the portrait photographer and this Cambridge Jones has achieved brilliantly with the fascinating studies contained in this book. Here are one hundred RADA alumni, each trained at the Academy and each going on to make their individual impact on our wonderful and quixotic profession.

Sadly, a number of famous faces and names are missing, having already departed life's stage, and I only wish they could have been included. Among them are Charles Laughton and John Gielgud, John Thaw and Alan Bates.

RADA is unique in its ability to provide a nurturing and testing environment from which the determined player may venture to stride into the limelight. It is this environment which allows our directors to rely on the diversity of acting talent, appearance and interpretation which is the hallmark of compelling drama.

The Academy is profoundly grateful to Cambridge Jones for celebrating that diversity – and RADA's Centenary – with these portraits.

Lord Attenborough Kt CBE
President, Royal Academy of Dramatic Art

The recently refurbished RADA is a busy, buzzy place; arriving at its Malet Street entrance is like rocking up to any London café in the centre of town. Open to the public, offering coffee and cake within photo-covered walls and light-filled foyer, the only clue that you're in an eaterie du théatre are the photos on the wall, and the voice of one or two of the frothier young cappucino sippers.

But if you choose to make your way into RADA via Gower Street, a far soberer exterior greets you. You could miss it easily enough: the only markers are the two carved stone figures that stand tall against the constant traffic, stately, yet shy. If you don't mosey past, but instead, walk through the automatic door, you're presented with a far older, grown-up, recognisably academic environment than that of Malet Street. Stairs spread left and right immediately in front; to access them, you must get past the porter, who peers from a cubbyhole to your right. Most will never climb those stairs – prospective students are given the appropriate leaflets and sent on their way; official visitors must wait until guided to wherever they should be.

Between these two entrances – one, welcoming, modern and upbeat, the other, historical and selective – lies the Royal Academy of Dramatic Art. It's an appropriate setting. RADA's distinguished past gives it weight and authority; but its present owes a good deal to its adoption of forward-looking ideas, to its deliberate search for new talent from all walks of life. Still, those who skip in through Malet Street should make no mistake; RADA is a serious institution within a serious business. This is no Kids From Fame environment, despite the propensity of over-enthusiastic students to sing show-tunes round the piano. It's not Fame Academy, either: celebrity-driven exhibitionists need not apply. Plus, anyone found dancing in the street will, well, be run over. London traffic has no truck with pirouetting jay walkers.

And RADA has no truck with time-wasters: its selection process is exhaustive and exhausting. Today's prospective students must undergo several hours of solid audition. They prepare two speeches, one Shakespeare, one modern, and perform them in front of two RADA teachers, who also give them a short interview. If they're recalled, they perform the speeches again, this time in front of four people, and also have to sing unaccompanied. Pass that, then there's an evening's work with three teachers, followed by a day's work on movement, voice and scene study. Nicholas Barter, RADA's head since 1993, insists that what he and his fellows are looking for is, of course, talent – but also the ability for its owner to work that talent, to train it and respond to instruction. "Sometimes it's just not the right time for someone to join RADA," he says. "Students have to be able to take the work on, and grow with it."

If you're one of the 33 each year who are accepted into RADA's acting degree (2000 apply; that's a one in 60 chance of success), then be prepared to knuckle down. In 2001, with RADA's designation as part of Britain's Conservatoire for Dance and Drama, as one of the country's centres of excellence, came a more intensive regime. This is vocational training, not just a couple of lectures and down the pub til next week. Students are not allowed to choose their parts, which are picked by teachers to stretch them, and they don't get to perform in front of a full audience until their third year. Then,

wham, it's two productions a term, with outside professional directors, for their final three terms.

RADA buzzes because it has three theatres (the GBS, the John Gielgud and the Jerwood Vanbrugh) and puts on 16 public productions a year – a treat for both actors and audience, as plays are staged that would never even be considered in commercial theatres. Nicholas Barter points out that in his 12 year tenure, this year (2005) is the first in which he's ever repeated a play, other than a Chekhov. "And we can do big cast plays," he enthuses, "like *Days of the Commune* (Brecht). In the past forty years, only the Berliner Ensemble, the Royal Shakespeare Company and us have put it on. Because no-one else can afford to do it."

To attend RADA is a privilege, then, and the Royal Academy of Dramatic Art is an institution with a reputation. Like Oxford and Cambridge Universities, like Belmarsh Prison, if you say you spent time there, you get a reaction. That reaction comes of RADA's elitism: elite may be a dirty word these days, but there's no denying that the academy's pickiness has meant that a high proportion of today's stage and screen stars have come through its courses and gone on to succeed. A quick glance at this book's contents page reveals just how successful RADA is: from Juliet Stevenson to Joan Collins, Ralph Fiennes to Sir Richard Attenborough, Edward Woodward, Sheila Hancock, Jane Horrocks, Sir Roger Moore, Sir Anthony Hopkins, Liza Tarbuck, Tom Courtenay, Timothy Spall, Imelda Staunton, Alan Rickman, Kenneth Branagh, Ben Whishaw. All came through RADA's unique process.

RADA was different from the start: it's the only drama school founded by a working actor, Sir Herbert Beerbohm Tree. It opened in 1904. Tree, a successful actor-manager who used his own money to found his new Academy of Dramatic Art, was an ambitious and driven man: when no suitable premises were located, he hosted the Academy in His Majesty's Theatre, which he'd built himself in 1897 (RADA's Gower St premises were found a year later, in 1905). This astonishing human said, in his inaugural address, that he wanted a National Theatre for England; he also explained that he'd set up the school as a way of improving the quality of acting in his own company. He looked forward to scholarships for poorer students, and for the Academy to be self-supporting, but not profit-making: a true visionary. Through his attitude, right from the start, RADA had a very professional and ambitious slant; and it's that continued emphasis on, and connection with, the acting profession, particularly the theatre, that distinguishes the academy today.

These days, it's possible to get a part in a television drama or a film at the age of 16, without any professional training at all. But, insists Nicholas Barter, such acting tends to crumble when faced with "scaling up" to theatre or classical acting. Which is where RADA comes in, instilling its students with techniques that will serve them throughout their career. Long gone are the days when RADA was regarded as a finishing school for nice gels; as long ago as the 1930s it was turning out students of the calibre of John Gielgud, and when, in 1941, the new theatre was bombed, a 17 year old Richard Attenborough was one of the students who helped clear up the mess. But it was the 1950s that really blew away the cobwebs: actors such as Tom Courtenay, Albert Finney, John Thaw, Glenda Jackson burst forth and RADA's standing was higher than ever: higher but not high-falutin'. More recently, over the 1990s, RADA has made great efforts to attract students from minority ethnic groups: working with local access schemes across the country to try to persuade non-white students that drama school is accessible, that there are plays written that represent them. Successful actors like Adrian Lester and Indira Varma are proof of this work.

Still, acting is a strange profession: you can be as talented, as hardworking, as qualified as possible, and yet never get the right opening for you to succeed. RADA knows this, and is careful to continue its nurturing post-degree. There's a buddy system during the course, which introduces students to recent and more mature graduates, who can ease the newbie's path into the profession. And the Academy encourages recent graduates to stay in contact after they leave, for advice and support. As Nicholas Barter says: "I don't mind if our students branch out into other creative areas – writing, directing, producing, photography – but we make such a careful choice when it comes to admittance, that it's disappointing when people completely drop out." He mentions a former pupil who moved into running hotels: "There are very good degrees in hotel management! Don't take up three years at RADA!"

Barter isn't unsympathetic: he well understands how hard an actor's life can be, subject to the whims of others, dominated by looks and luck as well as talent and graft. And it's a changing profession: RADA has had to prepare its pupils for today's life outside, where there may be no rehearsal time for TV drama, where you may earn much of your rent doing voiceovers, where early breaks are common, but a sustained career is less so. Such is the real world.

Yet, in the end, it's the real world that actors are trying to escape from; or, at least, trying to interpret in an artistic – an unreal – way. And it's passion that compels them. You could put all the obstacles in the world before the actors in this book, and they would have found a way around, a path to what some might call fame, others, respect. Let's not forget that celebrity – genuine celebrity, the kind held high by peers – is a by-product of graft. Actors are work-driven, inspired by writing and directing and other actors, forced on by fear, by desire, by delight in what they can push themselves to. They use their life experience to feed into their art; revealing and hiding as needed.

Which makes them, to use the technical terminology, a right bugger to photograph. Cambridge Jones, a portraitist who travels light, without assistants or heavy equipment, who doesn't impose, will often use found props, such as hats or hoods, to relax his subjects. He lets them play around and thus disclose themselves. So we discover Adrian Lester at the piano, Imogen Stubbs on a swing, Trevor Eve perching on a pool table. And any number of actors laughing, full face, at the camera. His pictures use contrasting textures to highlight character and characteristics: Liza Tarbuck struggles not to giggle as she leans into a convex mirror; Kenneth Branagh's beefy muscles are reflected in the wooden beam behind him; Jane Horrocks' optimistic wit is highlighted by the chandelier and sunlight above.

Jones' inspirations are "Bailey, Bown and Beaton"; he considers David Bailey and Jane Bown to be different ends of the perfect spectrum of portraiture and aims to fall somewhere in the middle. "One is stylised but reveals character, the other is unstylised but reveals character," he says. And there are many, many characters here: some household names, some up-and-coming, some known but not so that they can't walk the streets. All actors, with the skill and self-knowledge to work their talent into craft, professionals who put their RADA techniques and training into practice every day of their working lives. That's some 100th birthday present.

<div style="text-align: right;">Miranda Sawyer</div>

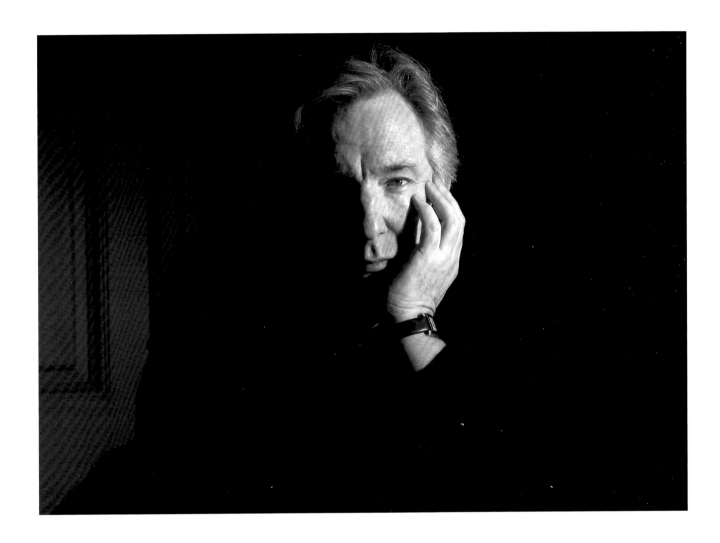

Alan was just about to head off to Patagonia in South America. Curiously enough they speak Welsh there. It turns out that Alan's family was from Wales. Alan works tirelessly for RADA and his was the very first portrait I took for this project.

I wore very 1970s clothes at my audition: a shirt with very tight sleeves (no blood flow), and trousers so flared that my shoes were invisible. I performed *Richard II*, and a piece from *A Scent of Flowers* by James Saunders. I was accepted, but had no finance, so I auditioned for a scholarship. That second letter of acceptance left me very light-headed. My life had changed with that piece of paper.

In my year were Nicholas Woodeson, Chris Fairbanks, and Patricia Drury: above was Trevor Eve, below, Imelda Staunton.

I think best and worst are two completely interchangeable concepts: you're best, in inverted commas, at some skill, one day, and worst, the next. That's the point.

My after-school delights included working as a dresser in the West End. We all worked and played hard. I remember the worst, cheapest red wine, with some affection.

Theatre
At the National: *Anthony and Cleopatra; Tango at the End of Winter;* (Edinburgh and London). For the RSC: *Les Liaisons Dangereuses; Mephisto; Troilus and Cressida; As You Like It; Love's Labour Lost; The Tempest; Antony and Cleopatra; Captain Swing.* For the Royal Court: *The Lucky Chance; The Grass Widow; The Seagull; Other Worlds*

Film
Truly Madly Deeply; Close My Eyes; Galaxy Quest; Diehard; Dogma; Sense and Sensibility; Michael Collins; Love Actually; the Harry Potter series

Adrian Lester, 1986-89

Acting was definitely the thing I wanted to do. I thought I'd try drama schools the year before my A Levels, to see what auditions were like. So I got in a year early. I did something from *Dead Men* by Mike Stott. I'd seen Iain Glen do it. I was pleased at how it went, but it takes time for RADA to make up its mind, especially during the recall sessions. You do weekend workshops and it keeps going. I was waiting for this letter to arrive saying yes or no for ages. And then I got it! But I'm one of those people who never celebrates at the moment something happens. I thought, 'Great, fantastic! I've got in' – then straight after thought, 'Right. Now I have to audition for the money.'

I wasn't very academically gifted, and it was a sticking point in my understanding of Shakespeare. Someone would talk about the protagonist and I wouldn't know what that was. And they'd talk about the ego and the super ego, and I just wouldn't have a clue. I was struggling to keep up. But the thing that released it all for me, and the thing that works with Shakespeare, is rhythm. It's not an iambic rhythm, it's like rapping. It's understanding that underneath what you're saying is a continual beat, and it makes sense at the end of a line, just like rhyme. I actually rap a lot, and that's what helped me understand Shakespeare. I had my eye on it for so long, that now, if you look at my CV, I look more like a Shakespearean actor than a TV actor. And yet, when I got to RADA, I had no idea about it really.

I was a hard worker. Oliver Neville said to me, 'It takes ten years to make an actor, and you can't rush it.' I didn't waste a moment, didn't smoke, didn't really drink or go to the pub. Lolita (Chakrobati) and I stayed in school and would work out fights with each other, or a dance routine. At home I had to sleep on a sofa, so there was no attraction to leave early. The school day would finish at 5 and I would get back to the house by 8, have something to eat, and then go to bed for the next day.

I thought to myself, 'I won't get this chance again. I won't be this age again – this will affect the rest of my life and I'm not going to muck about with it.' It's such an over-crowded profession already, I wasn't going to waste my time smoking and drinking, waxing lyrical about the training, when I know that soon I've got to try to get a job. And, it was all I could do, so I thought I'd better do it right. For people like Lolita and myself, in those days, there were very few people like us who had reached high levels in this profession. There was a determination, a clenched fist, clenched teeth approach to leaving drama school and entering the world of work.

I definitely grew up. RADA raked the ground of my belief in acting, took away everything I thought I knew, and when I left, it was this flat new fertile ground ready to plant new seeds. I wasn't so naïve anymore.

Theatre
As You Like It (with Cheek by Jowl) – Time Out Best Actor Award; *Six Degrees of Separation* (Royal Court) – Time Out Best Actor Award; *Company*, dir. Sam Mendes – Olivier Best Actor (Musical) Award; *Hamlet*, dir. Peter Brook – Carlton Theatre Best Actor Award; *Henry V* (The National Theatre)

Film
Primary Colours; Love's Labours Lost

Television
Hustle; Storm Damage

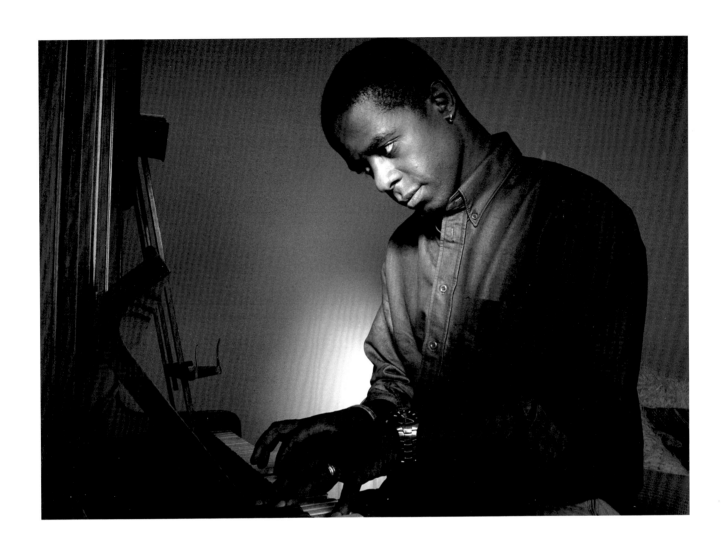

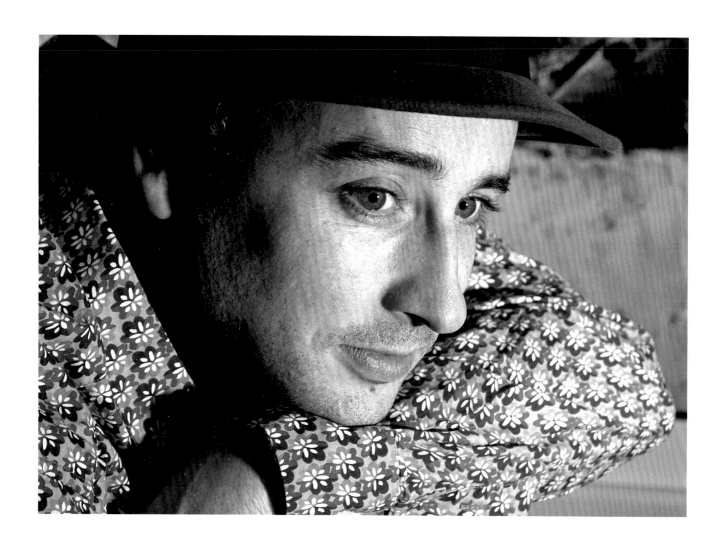

Aidan McArdle, 1993-96

Theatre
For the RSC: *Henry VI pts.1,2,3; Richard III; A Midsummer Night's Dream.*
A Prayer for Owen Meaney (National)

TV
Not Only but Always

Aidan had just filmed 'Not Only But Always', playing Dudley Moore with Rhys Ifans as Peter Cook, and I had been told he was amazing. Last time I met Aidan he was touring a play called 'Shopping & Fucking' in some God-forsaken seaside town – can't remember where – now he is clearly going places. He then had the cheek to plug my lights in to his camera and start photographing me!!

I can't really remember the audition. I'd auditioned the year before with a piece I had written myself about a lunatic asylum – big mistake, they thought I should be in one – and was rejected in the first round. I then got a year's contract at the Abbey Theatre in Dublin and so had much more confidence in myself when I went up the second time.

Oliver Neville rang to tell me I had been accepted. I think he was a little disappointed in my lack of reaction – maybe other people had been screaming and crying – but I knew that I didn't have any money, so I felt that the struggle was just beginning. I was in RADA just last month settling my final repayment – nine years after I'd left!

At RADA, I was best at being 'brooding Irishman with a chip on his shoulder', which I gave up as a waste of time after the first term (it was blocking the teachers from being honest for fear of sounding politically incorrect). Unfortunately, it took me over half the course to redefine myself in the teacher's eyes. Beware of the first term: impressions last!

I was a pretty bad dancer – dyslexic, if you like. It's not that I couldn't dance – it just took me many more hours to learn it than ordinary mortals. I did work hard. I was very aware of the sacrifice that had been made by my family and the people who had sponsored me and I knew that this was precious time. I didn't want to 'piss it up a wall'.

The skills I learnt at RADA? Well, stage fighting has always come in useful at closing time and my polka has been admired in clubs the length and breadth of Britain.

There's no such thing as a RADA style, which is why the course is so good. One gets exposed to various different disciplines, some of which seem to directly contradict each other. It is up to the individual actor to find their own way, using what is useful to them.

My favourite actor to work with was Donald Moffat who was in *The Iceman Cometh* at the Abbey, my professional debut. He was a gentleman, who was passionate about what he was doing. I hope that I learned something from him in how I approach my work both as an actor and as a man.

I had the privilege of being the youngest actor in the RSC's history to play Richard of Gloucester all the way through *Henry VI 1, 2, 3* and into *Richard III*. It had never been done in the company's history (they had always abridged the first three into two).

Alex Kingston, 1983-85

We shot Alex's portraits at her home in Austria where her family were all staying. We had a lot of fun playing Dr Zhivago in the snow while her daughter and husband made her laugh in the background. Then later we did another session inside, with Alex wearing traditional Austrian costume. I didn't really want to leave when the time came. They made me feel like a family member for my brief visit.

For my audition, I was wearing a smock and burgundy suede booties. I must have looked quite hippy-ish. I performed a piece from *The Winter's Tale* and the Sylvia Plath poem *Lady Lazarus*. I remember being fascinated by the staircase, and the death mask of George Bernard Shaw – it definitely felt like you were walking into a place where there was a strong sense of history.

I was rejected, but the directors felt I should be given a second chance, so I was re-auditioned by our principal Hugh Crutwell. I persuaded him, I guess. Because of the circumstances, I received a phone call rather than a letter and Hugh Crutwell told me personally. I was numb. I'd been working as a nanny for the actors Gawn Grainger and Janet Key and we celebrated with a bottle of champagne.

In my year was David Morrissey, who I am still very much in contact with. Also Joely Richardson, Paul Rhys and Jim Tavare. My whole year got on extremely well together. It was slightly embarrassing, because we'd even gather around the piano on breaks and sing songs from shows. A bit like *Fame*. After classes, we'd all go to the Marlborough or the bar upstairs at school. Dave Morrissey was a barman at the Marlborough for a bit.

The year above us were the extraordinary group (Ralph Fiennes, Iain Glen, Jane Horrocks et al.). We felt we were somehow in their shadow, though they had a lot of egos. The year under us was Clive Owen and Liza Tarbuck, who were more rebellious. It was a really interesting mix.

I moved out from where I was nannying, to the basement of a friend. All of a sudden I had my own place, and it gave me such a feeling of independence. I had a bike and would ride all over London on it. I really had such enjoyment going to school every day. I'm so glad I was encouraged to follow my instincts. I loved every minute.

We were always playing jokes on each other. I was doing *The Cherry Orchard* with Joely Richardson, where one of the characters comes on stage and has to down a big glass of water. Joely and I put vodka in it one time. The actor knocked it back in the scene and didn't even flinch. He stayed completely in character… but of course Joely and I couldn't stop laughing. Our joke completely backfired. We thought we were being so clever.

Theatre
For the RSC: *Cordelia; King Lear*, dir. Nicholas Hytner; *Much Ado About Nothing; Love's Labours Lost*. For Birmingham Rep: *Othello; The Alchemist; Saved; Julius Caesar; See How They Run*

Film
The Cook, The Thief, His Wife and Her Lover; Carrington; Essex Boys; Croupier; The Space Between Us

TV
The Fortunes and Misfortunes of Moll Flanders; ER

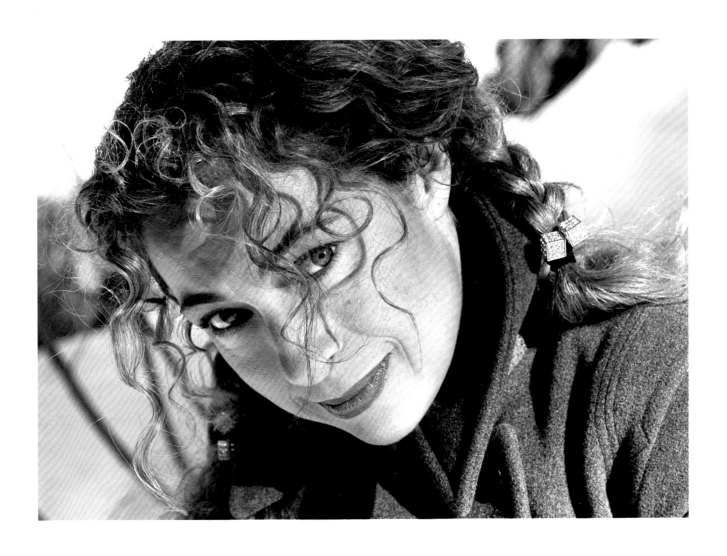

Michael Blakemore, O.B.E.,1950-52

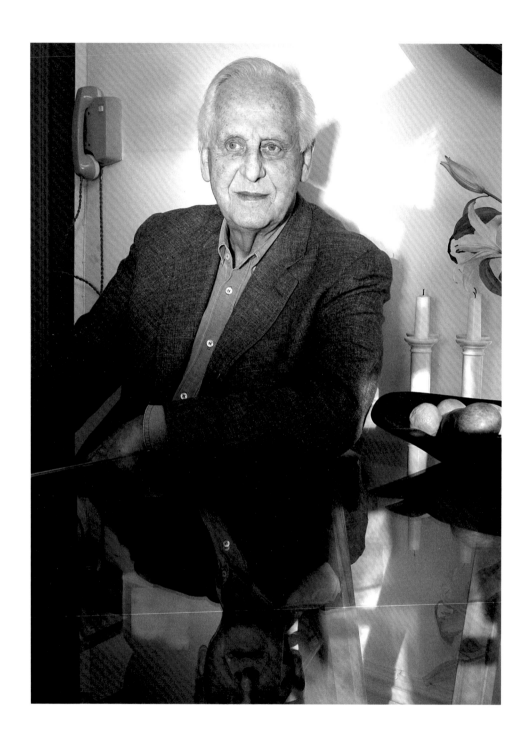

I arrived, was shown in by the maid, who spoke no English, and waited for about 10-15 minutes looking at all of Michael's beautiful objects and art work. Then the maid said in broken English, 'Are you sure you have an appointment?' – 'Yes, for Michael Blakemore, the director,' I said – 'No Michael live here,' she said. A quick exit and a phone call to Michael and all was resolved. Who were that family I never met at number 3, I wonder – I feel as though I know them quite well!

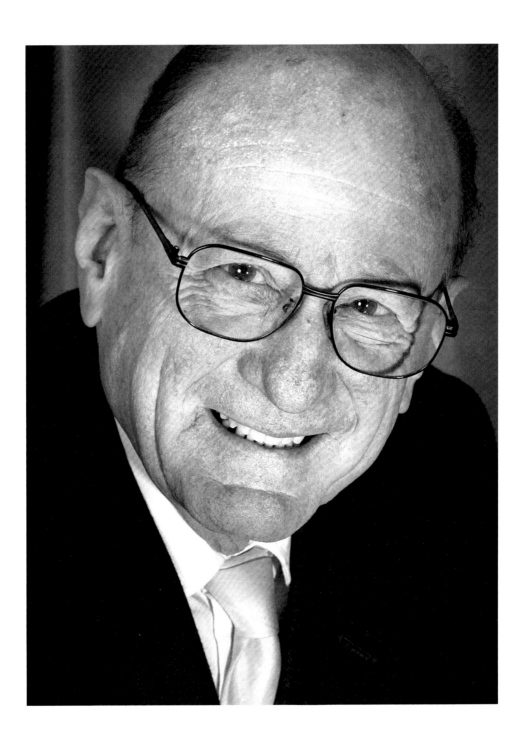

Freddie Treves said to me that his mind was beginning to go, but with such humour that I had to ask whether he actually meant it. In fact, he did, but the enormous courage and humour he showed humbled me tremendously. "Why should I mind, I won't remember that I have the problem," he said at one point. We had a big discussion about whether to have his glasses on or off. I hope we got it right.

Edward Woodward, O.B.E., 1946-47

Edward is one of the least self-conscious people I have ever photographed. He just didn't care – but in a nice way. He said something to the effect of 'You can't change the way I look anyway so you might as well just shoot'. Refreshing stuff from 'The Equaliser'.

I was one of the youngest people that's ever been there – I lied about my age. The second audition I did – 'Once more into the breach' from *Henry V* – I was terrified. When I got the letter, I was overwhelmed, nobody in my family went anywhere near the theatre. I'd never been. It was most astonishing, probably among the top five most exciting things that's ever happened to me.

Laurence Harvey was in my year and he became a great big film star. Most people there were on government grants, they'd come out of the forces, and really just wanted a good time. That's what they were there for. Not many actually went into the theatre afterwards. I was there to work.

I was terrible at what was called 'basic movement', which involved slow control of the body. I was good at the actual acting bit. Everything else sort of got in the way.

You weren't allowed to smoke. Miss Brown, the registrar, who was an astonishing and wonderful figure, a very tough lady with a heart of gold, would suddenly burst open the back doors every now and again and say, "No Smoking! Two shillings and six pence please!" She'd fine us instantly. The thing was that Richard Turner, the voice coach, smoked like a chimney. He smoked like mad and she never fined him! We all got fed up with that.

I came from Croydon and there weren't many social skills there: RADA opened my mind and my life considerably. I was very lucky and have never ceased to be grateful. Most of my children went to RADA, too: Timothy, Peter, Sarah. It became a really great family thing. And most actors I've worked with seem to have been at RADA.

Theatre
Hamlet; Cyrano de Bergerac (National Theatre); The White Devil; Private Lives

Film
Breaker Morant; The Wicker Man; Who Dares Wins

TV
Callan; The Equalizer

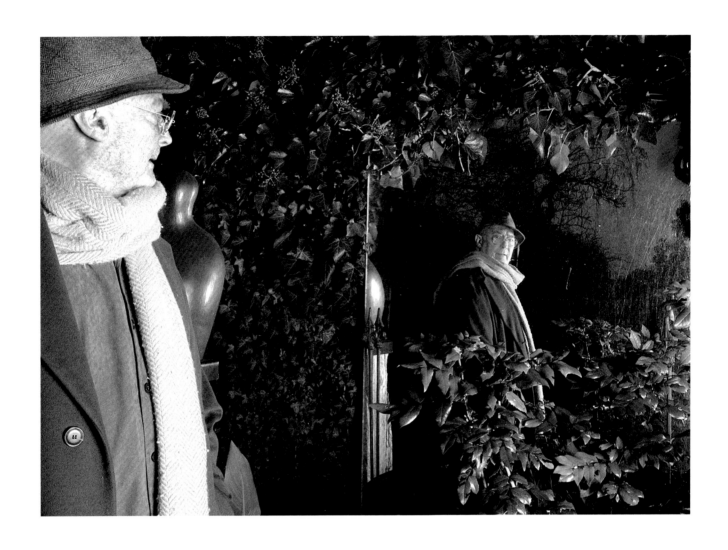

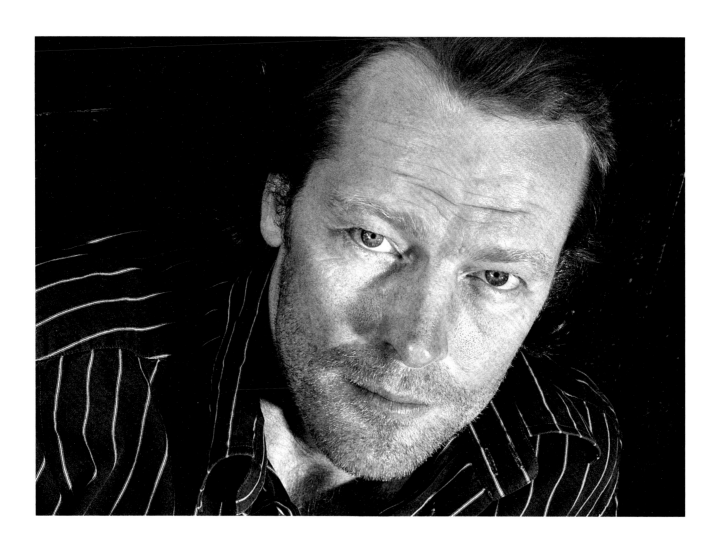

Theatre

Hedda Gabler, dir. Richard Eyre (Almeida); *The Seagull,* dir. Peter Stein; *A Streetcar Named Desire,* dir. Trevor Nunn (National Theatre); *The Blue Room,* dir. Sam Mendes (Donmar) – Olivier nomination, Best Actor, and Broadway Drama League Award, Best Actor; *Martin Guerre,* dir Declan Donnelan – Olivier nomination, Best Actor in a Musical; *The Broken Heart,* dir. Michael Boyd (RSC); *Henry V,* dir Mathew Warchus (RSC); *Here,* dir. Michael Blakemore (Donmar); *Macbeth,* dir. Michael Boyd (Tron Theatre); *King Lear,* dir Max Stafford Clarke (Royal Court); *Coriolanus,* dir. Kenneth Branagh (Chichester Festival Theatre). *Hamlet,* dir. Paul Unwin (Bristol Old Vic) – Ian Charleson Award; *The Man who had all the –,* dir. Paul Unwin (Bristol Old Vic/Young Vic); *Road,* dir Simon Curtis (Royal Court)

Film

Tara Road, dir. Gillies MacKinnon; *Man To Man,* dir. Régis Wargnier; *Kingdom of Heaven,* dir. Ridley Scott; *Resident Evil: Apocalypse,* dir. Alexander Witt; *Impact; Darkness,* dir. Jaume Balaguero; *Tombraider,* dir. Simon West; *Fools of Fortune,* dir. Willie-Pat O'Connor; *Mountains of the Moon,* dir. Bob Rafelson – Evening Standard Awards 1990 Best Actor; *Young Americans,* dir. Danny Cannon; *Rosencrantz and Guildenstern are Dead,* dir. Tom Stoppard; *Gorillas in the Mist,* dir. Michael Apted; *Paris by Night,* dir. David Hare

TV

Kidnapped; Death of a Salesman

My wife fancies Iain Glen so much that I was tempted to sabotage the portrait session. Instead I dreamt up my revenge by tackling Iain at table tennis. Only problem is, he beat me there too.

I remember collapsing off my chair after Hugh Crutwell hinted that there might be the possibility of an offer, saying something like "Please, please, it's all I want. It would make my life." He told me to sit back up and we would just have to wait and see.

I remember getting the letter of acceptance: I had never received such a beautiful formal envelope. I ran round the garden shouting for joy. My friend, and contemporary, Jason Watkins leapt in the air in celebration and landed on his cat. Killed it stone dead. He loved that cat.

I was more comfortable when acting roles seemed quite far away from myself, and that continued when I started working. It took me a while to be relaxed when I was playing close to home. I always tried to do too much to make it feel less like me, when being me-ish suited some things best.

Ralph Fiennes and I were obsessed with sword fighting. Most students cobbled a routine together in the weeks before the prize fights. But we had been at it forever, and were very frigging good.

It felt like an exciting novelty to study something I actually cared about. I was much better behaved than my track record might have suggested: I'd never really taken much interest in anything anyone had tried to teach me before. Still, there was a group of us that did like to rock and roll and recreate. We usually just ended up pissed and on the floor of one or another's digs. Not very adventurous or glamorous.

Andrew Lincoln, 1991-94

Andrew Lincoln is godfather to my eldest daughter, Amber, and I don't think I should use that privileged position to put what I know in print.

I was seventeen when I got in, and so I was very open, very eager to please, and a completely shame-free zone. I just went for it.

I remember really enjoying the whole auditioning process because it was my first attempt. People were nervous, but the workshop part was less intimidating. It worked with different disciplines, like dance and movement, trying to simulate what the course was actually like. You were observed, but you weren't in the head-lights. It was more about being receptive to direction, how malleable you were and so on.

Getting in changed my life. I was doing A-levels at the time – Physics, Chemistry, Biology. The last thing I wanted was to be a marine biologist! It was a godsend – like embarking on a new life.

My year included Stephen Mangan, who's a very good mate, Sean Parks, Sarah Preston. Two of the most talented people gave up acting. That was the biggest revelation when we started working; that talent and hard work didn't necessarily equal success. Tom Walker was one of the best actors I've seen to this day, and he gave up. It's the job: in one week you get more knock-backs than most people do in a lifetime. After a while, if people aren't responding (generally it's about what you look like, your hair colour and so on), you can understand why people stop.

At RADA, I was mediocre at most things, but could blag them anyway. The greatest thing about the course is that you have such expansive training that you can pick and chose from different ideas. The only thing I wished they'd said at the beginning is that there's no such thing as a method. I believe everyone has their own individual method that works for them.

One of my first lessons was pretending to be a starfish. They said to me, 'Andy, that was amazing! You really had the quality of a starfish.' And I'd been asleep all the time!

I burnt the candle at both ends. If you ask anyone else in my year, I used to have good parties. There was lots of debauchery, but I'm not putting it in a book that my Mum, Dad and Granny are going to read! But we worked really hard. I was still young enough to be very impressionable, and fear authority. I think I've loosened up since.

There was a whole cross section of personalities, sexualities, back-grounds and so on. What they tried to build was a great homo-genised company and I think they achieved that. There's something brilliant about working with someone who's got six years more life experience than you.

Acting for me is about imagining what it's like to be in someone else's position and if there is such thing as an 'empathetic gland', RADA definitely heightens it.

Theatre
Sugar Sugar, by Simon Bent, dir. Paul Miller (Bush Theatre); *Hushabye Mountain*, by Jonathan Harvey, dir. Paul Miller (Oxford Theatre's Touring production); *Blue Orange* by Joe Penhall, dir. Roger Michelle (National Theatre production and West End run)

Film
Love Actually

TV
This Life; Teachers

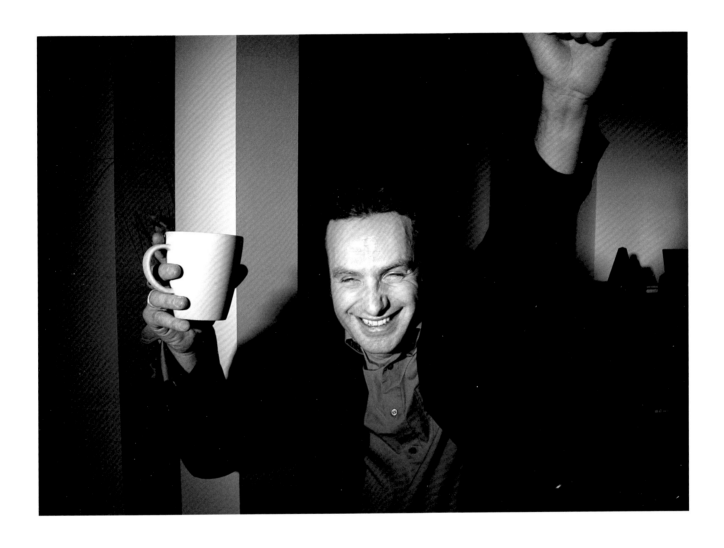

Bryan Forbes, C.B.E.,1942-44

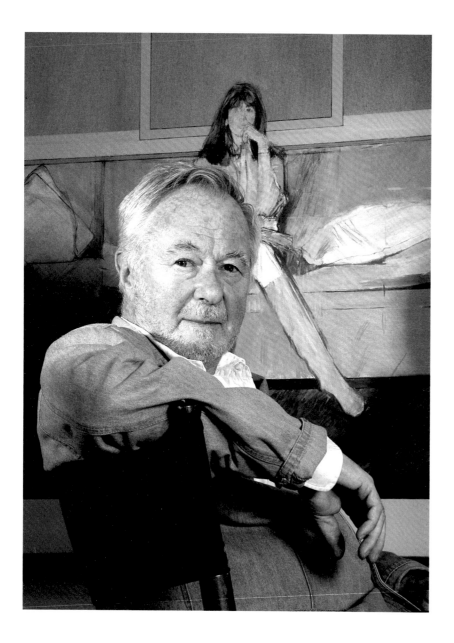

I am so pleased that Bryan didn't tell me he was a keen photographer until AFTER our portrait session. Not only does he have a series of beautiful old cameras and a darkroom, but he has also mastered the mystical world of digital photography. Since my technical knowledge could be written on the head of a pin, I tend to find such subjects rather daunting.

The audition was scary. Sir Kenneth Barnes seemed like a god at the back of the stalls.

When I was accepted, it felt like the fulfilment of a dream, especially as I was awarded a scholarship. I was at home in Newbury Park when I got the letter.

In my year were Norman Bind, Alec McCowan, Pete Murray, Mela Brown. Norman and I went into the war on the same day. He was a rear gunner, and I was in intelligence. We are still close friends.

I remember thinking I was alright as the lead in *Our Town*, and Raleigh in *Journey's End*. I was hopeless as Polonius.

I had no money and I was on the poverty line. And it was during the war, when there were few after-school delights, alas. Except lots and lots of girls! And only about 14 boys in our year! I didn't work that hard, because I knew the war beckoned.

Theatre
The Holly and the Ivy; Tobias and the Angel

Film
The League of Gentlemen; The Colditz Story; An Inspector Calls

Screenwriter
Chaplin; The League of Gentlemen; International Velvet; The Slipper and the Rose; The L Shaped Room; King Rat

Director
Whistle Down The Wind; The Stepford Wives; The L Shaped Room; International Velvet; The Slipper and the Rose – Bryan has directed 28 films

I only did the audition to keep a girlfriend company (I'd wanted to be a dancer). I did Shakespeare and a very emotional piece from *Lottie Dundass*.

I was thrilled that I got in but also very surprised: I was only 16 and living with my parents. We had no money so my father was pleased I'd got a scholarship. I hadn't told them I'd gone for the audition.

In my year were Thelma Holt, Ian Holm, and a girl called Wendy McCartney, who gave up acting, but has remained my best friend.

I didn't like voice production because I had a slight lisp that they needed to cure. Everything else I loved, although fencing was pretty low on my list of favourites.

I played the mother in *The Happy Breed*. As I was 16, I had a grey wig and a ferocious amount of make-up to make me look old. I thought I was terrific, but I'm not sure anyone else did.

We all used to meet at the local Italian café called Olivelli's. Papa Olivelli let us students take over the place, and didn't seem to mind when we had a plate of spaghetti for four, and sat for hours going over our lines.

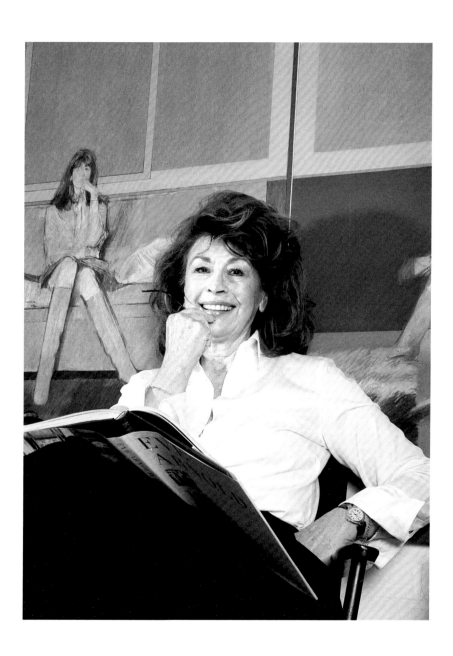

Film
Personal Affair; The Wrong Box; The Raging Moon; The League of Gentlemen; House of Mystery; The Rebel; The L-Shaped Room; Oh! What A Lovely War; The Madwoman of Chaillot; Séance On A Wet Afternoon; Man At The Top; The Stepford Wives; International Velvet; The Mystery of Edwin Drood

TV
Prometheus; The Life of Balzac; Jessie; Late Expectations

Fiona Shaw, C.B.E.,1980-82

Fiona had just come back from the States and was pleading jet lag, but I was having none of it. She looked fab and is such stimulating company. I think I will always photograph her after a long flight.

My mother rang my friend to say that I'd been accepted. She was working in a nursing home in Hounslow with another good friend, and I was with my boyfriend of the time, in Chelsea, in his flat. My friends knew the street I was staying in, but they didn't know anything else, still they drove to us anyway, in their nightdresses. We were playing music, and about midnight, there was this tap on the window. I guess they both knew that if there was a light on it would be mine! These two dressing-gowned creatures in a ropey old car gave me the news – the purest moment of pleasure in my entire life!

RADA was an ambition that I was geographically, educationally, and socially excluded from, and I jumped towards it. It was like when your reach and your grasp suddenly become one. It seems like nothing now, but actually it was the bravest, most difficult thing I did on my own. I had no mentor, or encouragement. I had no way of paying and no model. It was like changing lives. It's changed my life beyond radically. I joined a world that had no similarity to my own.

I was much encouraged by the year about me. I became quite friendly with Ken Branagh and John Sessions. They were very, very good. Kathryn Hunter dropped back to my class for a bit. Below me there was Janet McTeer. Some years above me, like the one with Mark Rylance, were literally riddled with talent.

I wasn't very cool. I wore a tweed skirt and a fawn polo neck sweater on day-one, whilst everyone else had earrings coming out of their noses.

Where I really came into my own was when we hit anything 19th century, because I was brought up in the 19th century. Ireland and my life were like the 19th century. People were still decorous. Any comedy of manners, I understood entirely. I was dedicated to comedy and might have been a stand-up. I think I just liked zaniness. Very early on, Hugh cast me as Beatrice in *Much Ado*, and I think that probably nailed me pretty well.

My body even changed when I was at RADA. I started off a fairly hefty girl, and I became this svelte creature from all the exercise! I'm very thankful for that. I started an ugly duckling, and was sort of less of an ugly duckling at the end of it.

The unique thing about that training was that you really experienced these things called 'breakthroughs', that you can't have if you work in professional theatre too early on. In the third term I was floundering, but in the fourth, I took off. In the seventh term, when I played Martha in *Who's Afraid of Virginia Woolf?*, I knew it was something I could not have done a year earlier.

London life was hard! I lived in a flat in Brixton with some friends, quite a lonely life when I think about it. We never had any money. We'd all chip in and buy a record, and head-bang to that for a while. I remember finding London quite depressing, especially the amount of poverty. It was all terribly alien.

Theatre
The Powerbook, dir. Deborah Warner (National Theatre/Paris/Rome); *Medea*, dir. Deborah Warner (Albemarle Theatre/New York) – Evening Standard Award; *The Prime of Miss Jean Brodie* (Royal National Theatre); *The Wasteland*, dir. Deborah Warner, Julia in *The Rivals*, (National Theatre); Erica Mann in *Mephisto* (RSC London); Electra in *Electra* (RSC Barbican) – Olivier Award for Best Actress/London Critic Award; Rosalind in *As You Like It* (Old Vic), Olivier Award for Best Actress; She Te/Shen Ta in *The Good Person of Sechuan* (National Theatre) – Olivier Award for Best Actress/London Critics Award; Hedda Gabler in *Hedda Gabler* (Abbey Theatre Dublin), London Critics Award; *Machinal*, dir. Stephen Daldry (National Theatre), Evening Standard Drama Award for Best Actress, Olivier Award for Best Actress; *Footfalls*, dir. Deborah Warner (Garrick Theatre); *Richard II*, dir. Deborah Warner (National Theatre, Salzburg, Paris); *Way of the World*, dir: Phyllida Lloyd (National Theatre)

Film
My Left Foot; Three Men and a Little Lady; London Kills Me; Super Mario Bros; The Wasteland; Jane Eyre; Anna Karenina; The Butcher Boy; The Avengers; The Triumph of Love; the Harry Potter series; Close Your Eyes

TV
Sherlock Holmes; For The Greater Good; Hedda Gabler; The Wasteland

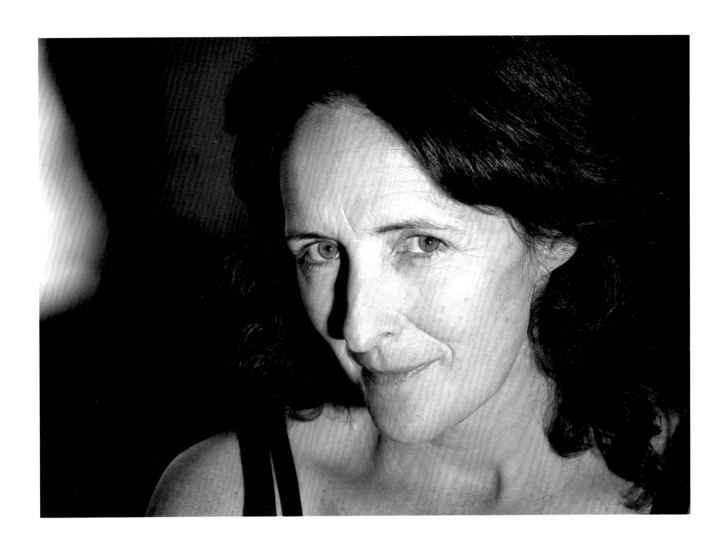

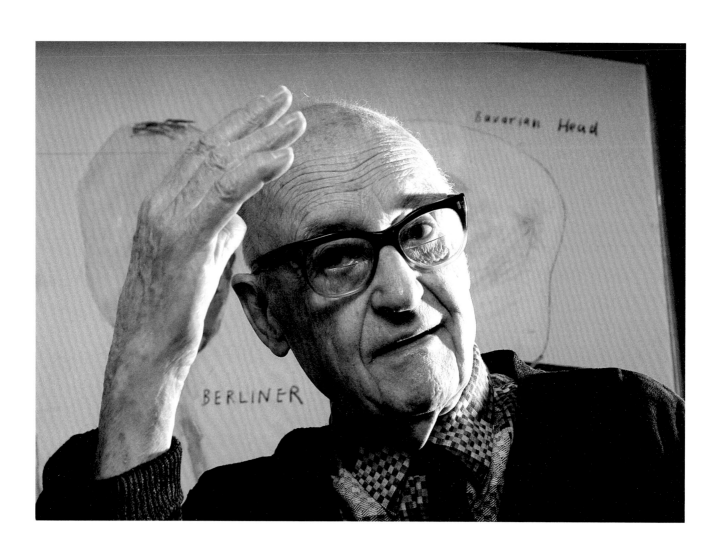

Frith Banbury, 1931-33

Theatre
Hamlet dir. John Gielgud; *Goodness, How Sad!*, dir. Robert Morley; *The Streets of London, or Poverty is No Crime; Rope; The Importance of Being Earnest; Private Lives; The School For Scandal* … and many more

TV
Look Here

Director/Producer
All The Year Round; A Chance In The Daylight; Do Not Pass Go; Flowering Cherry; Shooting Star; The Tiger and the Horse; Screamers; Major Barbara; The Winslow Boy and many, many more

If you want to be impressed by your elders and betters, pop by Mr Banbury's luxurious pad overlooking Regent's Park. His mind alone will astound you but when allied to the art and experience he possesses….

It was nearly all girls. I remember the first term: five men to twenty-something girls! All the men got the good parts, and sometimes girls had to play male parts. Especially if they were tall.

The staff then were much more school-masterly and the secretary was a very forbidding lady. There was a young girl there who was a bit of a scamp, but who was also very jolly. We used to talk and have fun when we were in the canteen. I was then sent for by the secretary and told that I must not associate with her, and that she wasn't the sort of person for me.

I wasn't very keen on German dancing, but I think that was because I was young. I remember Rachael Kempson, later Lady Redgrave, always used to laugh about how this German lady teacher would say 'Banbury. He's a moody man!' From then on, over many years, I was teased with this 'moody man' phrase.

I have very vivid memories of RADA. I enjoyed it all, had enormous fun. In those days I had a rather inflated idea of myself. It was soon knocked out of me when I left and became a professional! I was very lucky though, I got a job with the public show *St. Joan*, directed by Alice Gachet, a wonderful French woman. Within ten days of leaving that, I was rehearsing for my first London show. It was a small part, walking on and playing the piano in one scene, and being an understudy. I earned 30 shillings a week, hardly a living wage even in those days.

Many years later, I was asked by Sir Kenneth Barnes to go back and teach at RADA. I had done quite well and had a good reputation. I was having lunch with a friend of mine, and she told me she was directing a production at RADA. I said, 'Oh, that sounds quite fun.' The next morning Sir Kenneth Barnes phoned me and said,' I understand you said you'd like to come here and direct a play.'

I feel drawn to RADA. It provided me with three ways of observing the theatre. First as a student, then as a teacher, and then on the council. I'm now 92 and must be the oldest inhabitant. All the people who were students with me have left this earth. I'm the survivor!

Terry Hands, 1962-64

Director

Macbeth (Broadway); *Carrie* (RSC, Broadway); *Cyrano de Bergerac* – Olivier Award, London Critics Circle Award for Best Director; *Tamburlaine the Great* – Evening Standard Theatre Award, London Critics Circle Award for Best Director; *Much Ado About Nothing* (RSC); *The Seagull* (RSC)

Director of Clywd Theatre Cymru

Director of RSC 1978-91

I photographed Terry at his home in rural Wales. He is slowly turning an old stone cowshed into a lovely home. He had grown a beard over the holiday while the kids were away and wanted to surprise them. So we shot a few with beard and then a few post shave. I later sent him the bearded shots and commented that they looked a bit Steve McQueen like. He sent me a reply saying 'more Steptoe'. Which is a good reflection of his very dry sense of humour.

I had two auditions, one to get into RADA – 'Rogue and peasant slave' and something modern – and a second for the scholarship – *Queen Mab* and something modern.

I was at university – when I got the letter, I rushed off to see my professor and explained that my time at university would not, after all, be wasted and that I should now be able to continue working on literature, poetry and drama, and put into living practice what I had so painfully learnt under his inspired tutelage. He remarked that in the land of the blind the one-eyed might be king and returned to his book.

I had previously rushed into the Professor to announce that I had decided on a career in diplomacy. He felt that two World Wars in one century were probably enough. RADA and the theatre were very much a second, and last minute, choice.

In my year were Ron Pickup, Polly James, Angela Richards, Sarah Atkinson, Booker Bradshaw, Gabrielle Drake. We still meet very occasionally and reminisce.

I was best at movement, worst at singing. My voice didn't change, but I learnt about it from wonderful teachers: Clifford Turner and Barry Smith. And I learnt skills like how to use energy (from Toshka Fedro), the purpose of theatre (John Fernald), and relaxation.

I was a workaholic. I had no money for anything else and, after three years at university, I had a strong work ethic.

RADA does, in general, attract the best, and you learn from those you are with. The voice is, or was, central to all aspects of teaching: this once led to the RADA voice, which some decry. But all great careers, in theatre at least, are built on great voices.

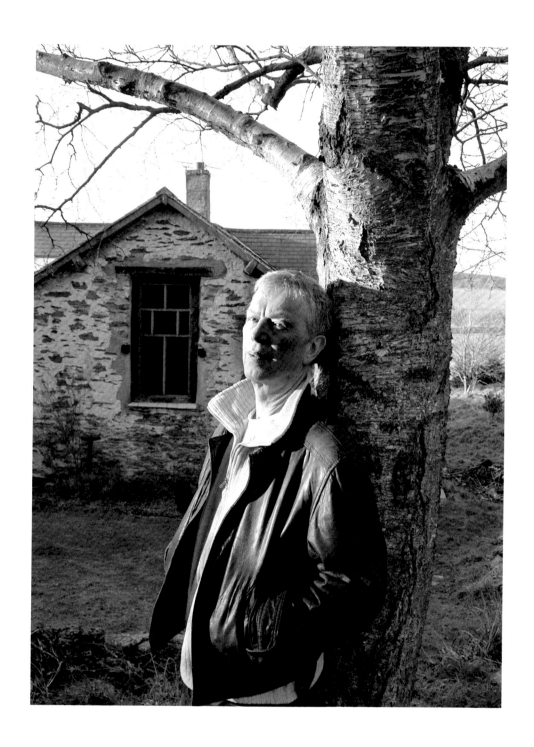

Sheila Allen, 1949-51

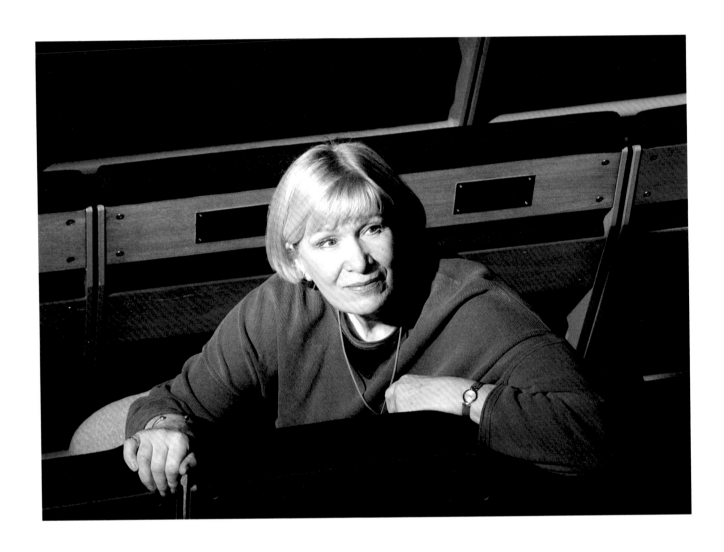

We shot Sheila's portrait in RADA's Vanburgh Theatre, which was being refurbished.
Much of the time was spent shouting to each other across the auditorium,
as some fairly noisy works were taking place.

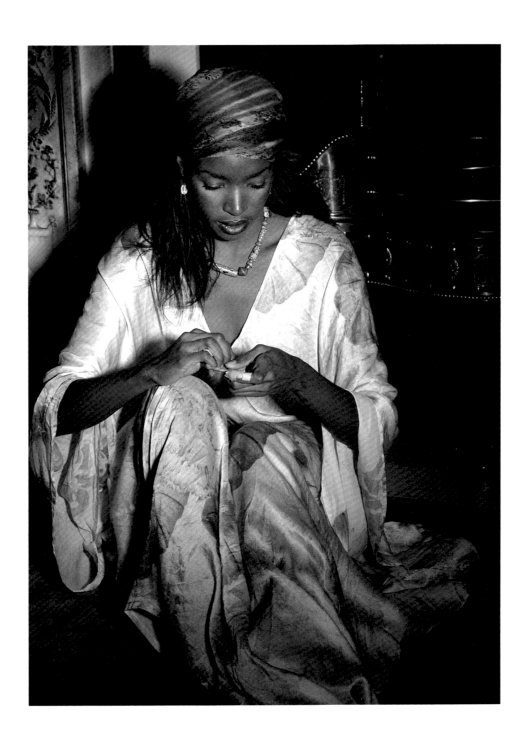

*I took this portrait for Josie some time ago, but it has never been used,
and I love the serenity captured in a moment of reflection.*

Ian Carmichael, O.B.E., 1938-39

The day that I chose to travel to Ian Carmichael, by train and then hire car from York, turned out to be the worst winter weather the north of England had seen in some time – snow, sleet & hail all challenged my mad dash. But everything went well and the sun even came out as I skidded down the steep hill into Grosmont – the beautiful and picturesque village where Ian now lives. We tried to shoot using the wonderful river views but the sun was determined to prevent that. We ended up shooting some photos in the very cold, but sunny, garden and then moved inside to the amazing portrait of him, when he was playing Bertie Wooster.

I can't remember much about my audition. It's a very difficult time to remember, if nothing else because of the approach of the war. Time alters things an awful lot. In those days, you got a piece that they chose for you and one of your own. I did Higgins from *Pygmalion*, and the Dagger speech from *Macbeth*.

My last term report came in, and showed that Kenneth Barnes had said I was miscast as *Henry V*. He said that I only got my diploma because George Arliss, one of the judges, insisted I had a talent for modern comedy. I was rather fascinated by the word 'insist'. It seemed to imply that the other judges were in complete disagreement!

I always had a bent for comedy. I enjoyed the acting and the plays that we did. There were obviously things like the technique, and voice coaching, that were very useful, but I just enjoyed acting. Except I hated Greek tragedy. I thought it was a total waste of time.

I'm still friends with Peter Fellgate. His name at RADA was Peter King. He's 85, and I was talking to him on the phone yesterday. He now lives way down on the south coast in Eastbourne, and I live way up in Yorkshire. We're both pretty antiquated and don't like long-distance travel, but we do communicate!

London was very, very new to me. I was a Yorkshire man, born in Yorkshire. My parents took my twin sisters and me to London for a long weekend once. I was a total provincial. My after-school delights were the Odeon at Swiss Cottage, or a pint at the pub round the corner. I couldn't afford the bright lights.

When I arrived at RADA the elocution tutor said, 'Where the hell did you get that awful accent from?' You were taught the King's English, to talk proper, as it were. I think it's an exaggeration to say I had an awful Yorkshire accent. I didn't think it was all that broad.

RADA used to be a sort of girls' finishing school. Girls outnumbered the boys by about 4:1 in any class. I remember even seeing a production of *The Merchant of Venice*, where Shylock was played by a girl!

Theatre
The Tunnel of Love; Say Who You Are; Gazebo; Getting Married

Film
Privates Progress; Brothers In Law; Lucky Jim; I'm Alright Jack; Heavens Above!; School For Scoundrels

TV
Bertie Wooster in *The World of Wooster*; *Lord Peter Wimsey*; *The Royal*

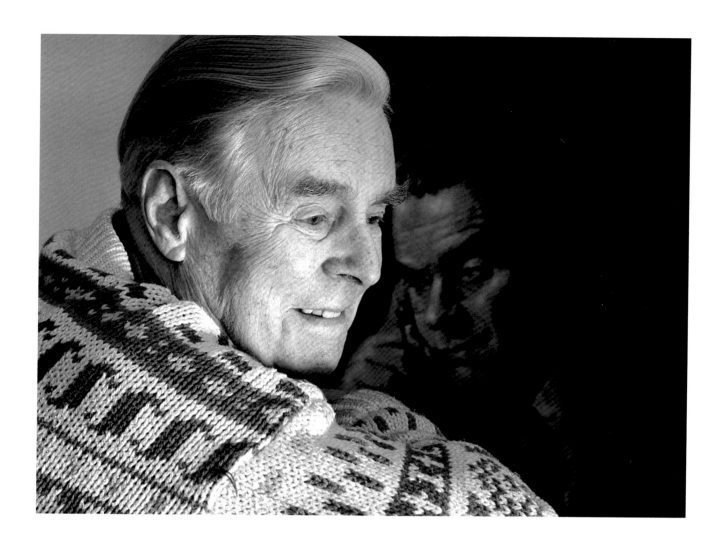

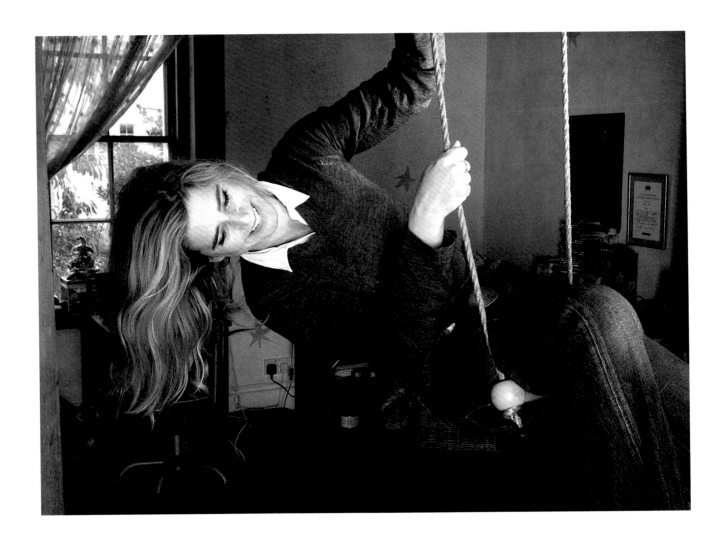

Imogen Stubbs, 1983-85

Theatre
Sally Bowles in *Cabaret*; Marcia in *The Three Sisters*; Stella in *A Streetcar Named Desire*

Film
Jack and Sarah; Sense and Sensibility; Twelfth Night; Dead Cool

TV
The Browning Version; The Rainbow; Othello

Imogen is not only an actor, a writer and a columnist, but she was also about to head off to South America to ride horses across some inhospitable region. Oh, and she is, of course, a wife and mother too. By the end of the morning we had put the world to rights between us. Or at least discussed much of what we agreed was wrong with it at any rate.

I went to Oxford and did English, and my friend was auditioning for drama school. So, I did too, on a whim. I did a modern piece about a slightly mentally retarded girl, and a Rosaline speech from *Love's Labour's Lost*. After my first audition, the secretary took me aside and said that one of the pieces I had done was absolutely dire. The problem was that I didn't know which one he meant. I was too embarrassed to ask.

I don't know what makes them choose you, because we had a very eclectic term. I think it's partly a matter of choosing a group that will work well together. I wasn't by any means the best out of those auditioning, but I was quite experienced: I'd done lots of drama at Oxford, and also at the Edinburgh festival. I'd also done a review with people like Ian Hislop.

I got the acceptance letter when I was at Oxford, before my finals. I was so excited! It was night-time, and I remember cycling around in the dark, with this letter in the basket, going 'Yay!'

When I got there, I discovered that everything I could do, Jane Horrocks could do ten times better. When I was at RADA, I tended to be classed as rather straight, which was a big shame, because I loved doing character and comedy. So I got cast very close to my obvious self, whereas Jane was often cast in character and comedic parts, and all she wanted to do was play straight parts. We both were cast against what we wanted to be.

I still think most actors work best when they are cast against type. But with casting and the reality of acting now, you're often playing a version of yourself. It's a terrible irony, because most people go into acting because they don't like being themselves.

When I was at RADA it was half in the 1950s and half in the future. I think it's very different now. They know the market that they're feeding. We were chosen to feed a market – theatre, rather than film and TV – that was dying off a bit.

Ralph Fiennes and I both had to pay our fees because we'd already had grants for university beforehand. I worked nights in a trendy London restaurant. Because of that I took it seriously. It makes a big difference if you're paying for yourself, because you're slightly intolerant of people mucking around.

When you're at RADA, you see each other grow up, and people take great pride and joy in other past students' success. You feel great pity for their failures too: there were some really talented people in my year who didn't end up doing very well. It's an important spirit to keep alive. It's very important to learn early on, to be pleased for people. If you didn't have that, it would just be a training ground for arseholes.

39

Indira Varma, 1992-95

I didn't know about drama school. I'd done my A-levels and applied to go to university. I was only 17, so it was very exciting, yet terrifying as well. We had to do a song and I did *All that Jazz*, with actions. I got a phone call from Oliver Neville. I couldn't believe it, it was the most exciting day of my life. Then, of course, you go there and think you're it and within a couple of weeks realise your mistake.

Ioan Gruffud was in my year. We had a real motley crew. Three people were in their 30s, though the majority of the people there were 25-26. I was still 17 when I started. I'd just left home, and was coming to London and renting a flat for the first time. When I first lived there, I lived down the road from a Quakers' meeting house and I used to subsidise my rent by helping with the washing up. I then moved into a flat in a disgusting manor house with several other people from my year, and had parties every weekend. It was brilliant. Bedrooms and hallways – fantastic.

I wish I hadn't been so lazy and excited about being just in London. I hated learning Shakespeare's speeches. I couldn't understand them and couldn't see the point. I loved doing the dancing and the movement, and I loved doing the animal project because it meant you could sleep for the afternoon.

I always thought I was a character actress. I kept trying to play all the old ladies. I remember the first play we did, I played an old man, and I thought that that really was what acting was, being able to transform into a hunchback twice your own age. I was so proud at the time because one of the third years said to me, 'We didn't know who it was for the first act.' I was being a twat, really.

I grew up, psychologically and emotionally. You were constantly asked to delve deep into yourself. You know, method acting and all that. In 'Improv', you'd think to yourself, 'Right. My character's been raped, and beaten up, and now she's tied up in this room.' And you'd say to people, 'Ooh. Could you throw me down the stairs before my improvisation and tie me up?' It wasn't a case of acting, it was where you became the person. Ridiculous, but really good fun.

I was really quite young, and not really formed as an adult. I didn't know who these writers were and I didn't really know who I was. I think I spent most of the second year crying! Terribly self-indulgent. You broke yourself down, trying to make yourself better in drama. You were really quite exposed.

My fondest memories are of friendships. My favourite toilets that are no longer there. They were in the old building, and were all wooden. They were amazing. The gossip and the drama that happened in those toilets was brilliant.

We had such a blessed time at RADA. When we did plays, it was really joyful, we weren't doing it for money. It was different when you started working, and a director was telling you that you'd hate the way your belly wobbles on film when you're running downhill.

Theatre
One for the Road (Broadway); *Celebration* (Almeida); *The Country* (Royal Court); *The Vortex,* dir. Michael Grandage (Donmar); *Ivanov* (National)

Film
Karma Sutra; Mad Dogs; Bride and Prejudice

TV
Psychos; Other People's Children; In a Land of Plenty; The Whistle-Blower; The Canterbury Tales; Reversals; DNA; Rome; The Quartermass Experiment

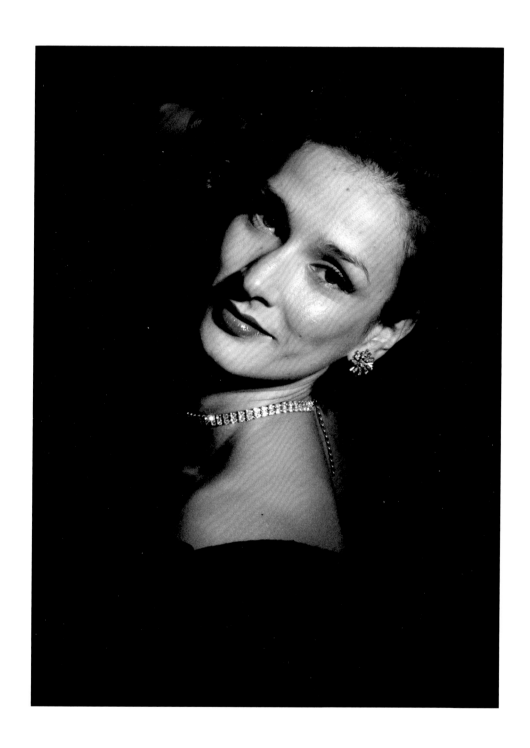

John Alderton, 1959-61

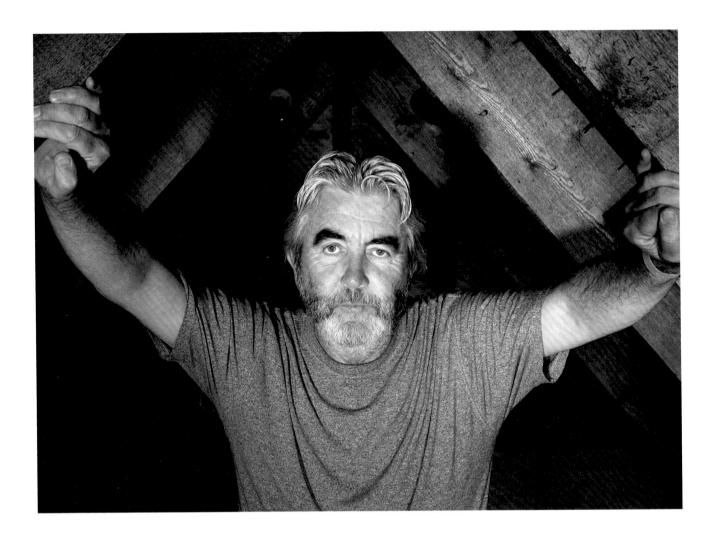

John and his wife, Pauline, are so well known to me through the screen that it felt as if they were just old friends. They must have wondered who this over-familiar photographer was though.

For my audition, I did Lord Foppington in my best posh Hull accent. I wore my smartest C&A terylene slacks and drip-dry nylon shirt.

I was surprised to get in but my family were absolutely shocked as I was supposed to go to university to study architecture. I had to miss my A-levels in order to start RADA in the spring term. I burned my bridges, but built many more.

In my year were Ken Campbell, David Halliwell, David Cook, Alan Lake, John Hurt, Ian McShane. Occasionally we collide.

I wasn't any good at anything up until the end of the year weed-out when John Fernald, principal, said 'Ah yes, John Alderton. Comedy acting is not a succession of funny hats!' I suddenly realised how to digest a character and spit it out!

With a grant of £4 per week, the after school delights were half a pint and shagging practice, at which I did work hard.

Theatre
Estragon (National); *What The Butler Saw* (National); *Spring and Port Wine* (Apollo); *Dutch Uncle* (Aldwych); *The Birthday Party* (Savoy); *Waiting For Godot* (West Yorkshire Playhouse)

Film
Zardoz; Clockwork Mice; Calendar Girls

TV
Please Sir; Upstairs, Downstairs; My Wife Next Door; It Shouldn't Happen To A Vet; He Knew He Was Right

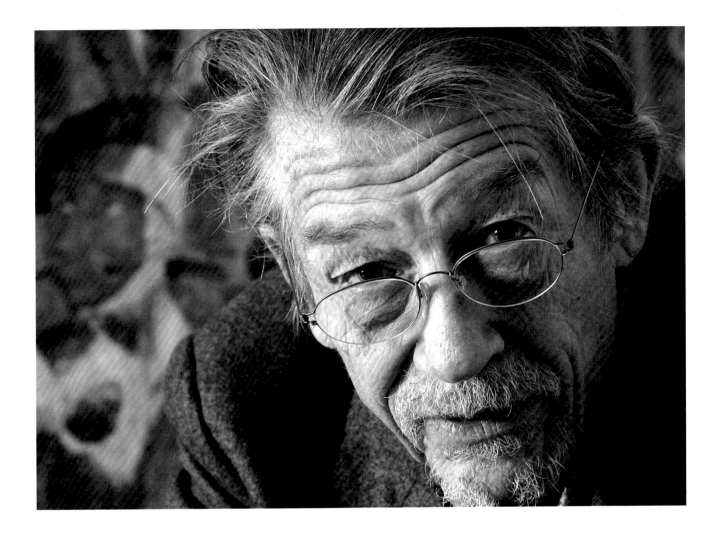

This man gets more debonair and suave by the year, I swear. John was so alive and full of enthusiasm and stories that I could happily have gone on shooting all day. He is also the only person I know who has a PA in one country while living in another.

I tried several times to get into RADA. At my successful audition, I wore an old pair of plain cords, a worn out knee length sweater. Which was all I owned.

Getting in was the red letter day of my life and remains so to this day. In my year were David Warner, Ian McShane, Gemma Jones.

I thought I was terrible at everything. Fortunately, this was not an opinion shared by others.

I burnt my candle at both ends. It will not last the night. But ah, my foes and oh, my friends, it gives a lovely light.

Theatre
The Dwarfs; The Caretaker; Shadow of a Gunman; Travesties (RSC); A Month In The Country; Chips With Everything; Inadmissable Evidence; Krapp's Last Tape (Gate)

Film
Alien; Heaven's Gate; The Elephant Man; Midnight Express; 1984; White Mischief; Scandal; Love and Death on Long Island; Captain Corelli's Mandolin; Harry Potter and the Philosopher's Stone; Dogville

TV
The Naked Civil Servant; I, Claudius; Crime and Punishment; Who Bombed Birmingham?; The Alan Clark Diaries

Jane Horrocks, 1983-85

One of the fascinating things about doing this collection of portraits was discovering that virtually no one knows all the other great names who trained at RADA. This often included pairs of people who work regularly together but never bothered to boast to each other about their illustrious training. Neither June Whitfield nor Jane Horrocks knew the other had been at RADA. They are far from alone.

For my audition, I did a speech from Oscar Wilde's *Salome*. It's the last speech she gives when John the Baptist's head is taken off. It's very passionate and difficult to do out of context. Hugh Crutwell said, 'Hmm, that was a bit OTT'. I wore a bright broderie anglaise two-piece. I was rejected from all the other drama schools.

There was such a mixed group of people in my term, and quite a lot of northerners. It was very reassuring. Serena Gordon is still my best friend. Ralph Fiennes, Imogen Stubbs, Iain Glen and Neil Dudgeon.

I had a great time. I came from a very parochial little place, so to come to London was very overwhelming. I wanted to have a ball, which I did, so the course-work came to nothing really. There were students who worked really hard – at things like the Alexander technique – but I just treated it like a good massage. Lean back and enjoy.

I was quite lazy. I was terrible at dance, and in the dance class, you had to get your leg up on a bar. I was the only one who couldn't do it, so on Easter break I practised on the banister rail at home. When I got back I couldn't wait for my teacher to see that I could get my leg up on the bar, and she never even noticed. So I thought 'Sod it! I'm not going to try any more!'

I had to play an awful lot of old people. When I left drama school, one of my first jobs was playing a 17 year old and I didn't know how to do it! It was a bit unfair in that respect – if you were good at character, you got cast as a lot of old people. I could never understand why they couldn't find more plays with young people in them.

I shared a house with the in-crowd, which was in Crouch End, with a girl called Claire Hackett and Angela Connelly, and Tim McCudry. Everyone seemed to come round to our house for weekends. It was really good fun. There was always something going on.

I was totally obsessed with Iain Glen, so that took up most of my thinking time at RADA. He was my after-school delight! But he was very popular with all the girls, so I had to take my turn.

Theatre
For the RSC: *The Dillen; Mary After The Queen; As You Like It; The Good and Faithful Servant;* Sally Bowles in *Cabaret*, dir. Sam Mendes (Donmar) *The Rise and Fall of Little Voice*, dir. Sam Mendes (Donmar); Doreen in *Tartuffe* (Cottesloe); Lady Macbeth in *Macbeth*, dir. Mark Riley

Film
Life Is Sweet; Bring Me The Head of Mavis Davis; Memphis Belle; The Witches; The Dressmaker; The Wolves of Willoughby Chase; Little Voice; Chicken Run; Wheeling Dealing

TV
Bubbles in *Absolutely Fabulous; Never Mind The Horrocks*

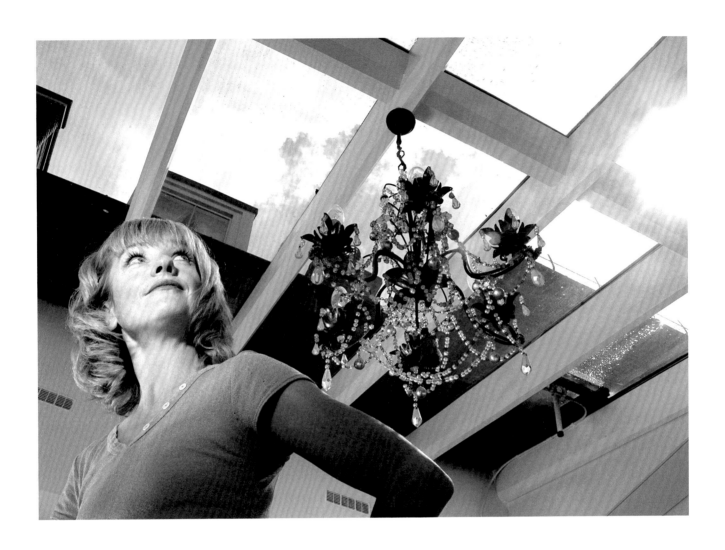

Matthew Rhys, 1993-96

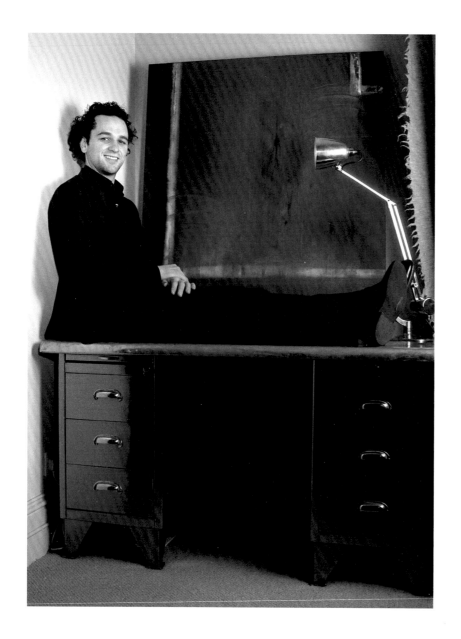

I have known Matthew for many years and even stormed into his class when he was a student at RADA to ask his teacher if I could borrow him. Both the teacher and Matthew obliged and he gave me the most exquisite impression of Richard Burton into a tape machine, something I needed for reasons too complicated to bore you with. I suspect if Burton were alive, I would be calling on him in a year or two for an impression of Matthew Rhys.

I did *Henry VI part III*, and *Under Milk Wood* for my audition. I remember being told that the latter was a rather obvious choice for a Welshman.

I remember being telephoned by the then principal Oliver Neville. After whooping for joy, my parents then asked me if I was sure he said, 'can offer you a place' or 'can't offer you a place'. I was then convinced he'd said, 'can't' until the letter came.

Martin Ledwith was in my year and yes, we're still friends. My crowning moments at RADA were the prize fights – Martin and I won many of the prizes. I was terrible at song and verses.

I believe that I was a hard worker who occasionally was tempted from the path by the delights of the Marlborough Arms.

Theatre
The Graduate (West End); For the RSC: Romeo in *Romeo and Juliet*

Film
House of America; Whatever Happened to Harold Smith; Heart; Titus; Peaches; Tabloid; Very Annie Mary; Shooters; The Abduction Club; Fakers

TV
The Lost World; Metropolis; P.O.W.

Sian Phillips, C.B.E.,1956-57

One of the joys of this work was meeting the grandes dames of British acting in such an informal setting. Sian is one of the most elegant of them all and the informality was accentuated when I fused the electrics in her her house, setting off the alarm system more than once.

I wore an unrelievedly black Left Bank outfit for my audition. I did 'The Willow Song' from *Othello* for my scholarship. I was told by the bursar that I'd got in and burst into tears.

In my year were Caroline Blakiston, Charles Kay, Edward De Souza, Helene Van Moeurs. And we're still friends.

I was best at improvisation, mime and Shakespeare. Though, still not very good.

I was worst at fencing and ballet: worst in the whole school ever!

And I worked very hard!

Theatre
Hedda Gabler (West End); Marlene in *Marlene* – Olivier Award, Tony Award, Drama Desk Award; Mrs Alving in *Ghosts* – Welsh Artist of the Year; Hannah Jelkes in *Night of the Iguana* – Society of West End Theatre Award; Alma in *Summer and Smoke*

Film
Becket; Young Cassidy; Goodbye Mr Chips; Murphy's War; Dune; Clash of the Titans; Under Milk Wood; The Age of the Innocence; House of America

TV
Lady Windermere's Fan; Jennie, Lady Randolph Churchill; How Green Was My Valley; I, Claudius; Heartbreak House; Warrior Queen; Tinker, Tailor, Soldier, Spy; Crime and Punishment; Smiley's People; The Two Mrs Grenvilles; Barriers; A Killing On The Exchange; Vanity Fair; Red Empire; The Borrowers; Heidi; The Return of the Borrowers; Ivanhoe; Alice Through The Looking Glass; Cinderella; Attila; The Murder Room

Joan Collins, 1949-51

I was exceptionally nervous at my audition. I was only about 15, and it was the only audition I'd ever done. I did the 'You are a funny old gentleman' speech from Shaw's *Caesar and Cleopatra*. And I wore a white dress with blue polka dots.

There were five or six judges, including John Gielgud and Kenneth Barnes. There was no reaction. It wasn't like *Pop Idol*. People controlled their emotions in those days!

I got the letter of acceptance when I was in the south of France, with my aunt and uncle, on holiday. I was totally over the moon with delight and excitement because I knew how fierce the competition was and I was the youngest entrant.

RADA was the epicentre of where I wanted to be. It was also a short walk from my home. I was 16, so my parents kept me on a tight leash. Olivelli's Coffee Bar and the Jazz Club in Oxford Street, presided over by Humphrey Lyttleton – they were my hangouts. David McCallum was in my year, also Susan Stephen, who is no longer with us, and Trevor Baxter, Gerald Harper and David Conville.

I liked making people laugh. I always felt to myself that I was more of a comedian and character actress than anything else. In actual fact, in my career, it's turned out that those are the things I've been best at.

I found it very difficult to learn Shakespeare. I couldn't understand it at all. It just didn't interest me, and still doesn't, actually. You feel like you're expected to like it, but I much preferred Shaw and Noël Coward. I found Shakespeare overly wordy and incomprehensible to my 16 year old brain.

I was offered a movie role after I'd been at RADA for a year and a half. This movie was going to take 12 weeks. It had Laurence Harvey, Celia Johnson, Cecil Parker in it, and would've been very good for me. I went to Sir Kenneth practically on my knees, and said that I really wanted the time off to do the movie, and he said, 'Absolutely not. You've come to RADA to be an actor on the stage, not in films'. They really looked down on film and television. I think that was very sad. I was only 17, and would have loved to have done it.

In my end-of-term report, Sir Kenneth Barnes said, 'Joan has personality and stage presence, but her voice is weak, and if she doesn't watch her voice projection, it will be films for her, and that would be a great shame'. So I've always been quite conscious of my voice, and worked on it a lot.

Theatre
Amanda in *Private Lives* (Aldwych, Broadway); Sabrina in *The Skin Of Our Teeth*; *The Last of Mrs Cheyney* (West End); *Over The Moon* (Old Vic)

Film
Our Girl Friday; I Believe In You; The Good Die Young; Girl On a Red Velvet Swing; Rally Round the Flag Boys; Esther and the King; The Stud; The Bitch; The Road To Hong Kong; Virgin Queen; Decadence; In the Bleak Midwinter

TV
Alexis in *Dynasty; Pacific Palisades; Will & Grace; The Love Boat; Starsky and Hutch; Tales of the Unexpected; The Man From Uncle*

Jonathan Pryce, 1969-71

I kind of fell into RADA and acting. I'd been to art school, then teacher training college to teach art. A tutor there thought I'd be a good actor. He'd been one himself, so he sent off for the audition papers and gave me two pieces to do – from *Two Gentlemen of Verona* and *Little Malcolm*.

And because I fell into it, I had nothing to lose. I was due to sit my final exam at college, and the letter came saying that RADA had given me a place, so I didn't bother going to sit the exam. I remember lying in bed, while all the other students were parading past, and just staying there. It was great.

I responded most to the improvisation classes with Keith Johnson, and mime. It was that freedom of expression that probably gave me the confidence that I was lacking. In retrospect, I value everything I did there though. I had no money, just about enough money to live on. I had to debate whether to have a cup of tea or buy a newspaper every morning. I was hard-working, but I had a good time.

My accent changed considerably whilst I was at RADA. I had a

North Wales accent, not particularly strong, and I was able to flatten it out, but retain some of the vowels that the teachers were trying to squeeze out of me.

Theatre
Comedians (National, Wyndhams, Broadway) – Tony Award; *Miss Saigon* (Broadway) – Tony Award; *Oliver!* (Broadway); *Hamlet* (Royal Court); *My Fair Lady* (National)

Film
Breaking Glass; Brazil; Jumpin Jack Flash; The Adventures of Baron Munchausen; The Rachel Papers; Glengarry Glen Ross; Evita; Carrington; Tomorrow Never Dies; Pirates of the Caribbean; De-Lovely; The Brothers Grimm

TV
Comedians; Roger Doesn't Live Here Any More; Murder Is Easy; Martin Luther; Heretic; Mr Wroe's Virgins

Paul has such a stylish existence that to have completed the session in 30 minutes or so would have been an insult to his aesthetic and his home. We kept thinking of new and more creative ways of shooting the portrait. In the end, of course, it is Paul not his house that went to RADA, so here you go....

At my audition, I remember sitting in an NHS-style chair, staring at a portrait by Sickert of Edith Evans. I wore fairly vivid pink clothes – I was very into this then – and was trembling.

My mother told me over the phone that I had not got in: which was more a reflection of her own expectations of me than my own. Then, on closer inspection by my sister, it turned out that I had!

In my year were Trevor Penton, Alex Kingston, David Morrissey and Joely Richardson.

Standard English proved a mystery and I constantly failed in it. I loved doing the enormous apocalypse-y plays.

I was a very hard worker. I had done too much drinking in my previous life.

Theatre
Design For Living (Donmar); *A Woman of No Importance* (Glasgow Citizens); *Bent* (National); *King Lear* (National); *Invention of Love* (National); *Hamlet* (Young Vic); *Long Day's Journey Into Night* (Young Vic)

Film
Absolute Beginners; The Heroes; Little Dorrit; Vincent and Theo; Chaplin; From Hell

TV
My Family and Other Animals; Tumbledown; Opium Eaters; The Healer; Gallowglass; King Lear; Anna Karenina; I Saw You; The Innocent; The Cazalets; The Deal

Juliet Stevenson, C.B.E., 1975-77

Juliet showed me all the rooms in the house where we might want to shoot the portrait. To her surprise, I chose her daughter's bedroom where she has a princess bed complete with drapes. I just loved the effect of seeing Juliet's beauty through the material – lending a mixture of eastern mystique and nuptial bliss.

RADA was the only drama school I'd heard about. I so didn't think I was going to get in. I knew no actresses, had no training. I went to the audition with my brother, and there was a person who had a bright satin trouser suit on, and a masseur was massaging her shoulders. There was another who'd come with her agent. They all seemed much more cosmopolitan than I was, and I felt like a baby.

We'd auditioned and all gone back to a room, where I ended up sitting by a phone. The phone rang and the person read out a list of names. My name wasn't on that list, so I got my coat and left the building. The guy on the front desk – a burly ex-copper called John – came running after me and shouted, 'Where do you think you're going? Come back in here!'. That list was a list of people they wanted to let go.

A girl called Gerda Stevenson was my huge friend there. We were such close friends that I didn't have a large number of others. We shared a flat, did everything together, and discovered London. We ate it up, devoured museums and galleries and concerts, using it to the full. It was a mind-blowing time. No responsibilities. We really burned out the days and nights.

I wasn't very good at all when I started. The biggest problem was that I didn't know who I was, and since you're dealing with your emotional life, your psyche, your history, your sexuality and all those things, I wasn't really ready to work. I was just really lost.

It wasn't until the end of the second term that something very fundamental clicked. I was playing Cleopatra and really struggling. The director was incredibly rude, criticising me in front of everyone else. I suddenly got very angry, and something about that anger just fed into the scene. I realised I was right inside her! It was like a quantum leap moment.

I just realised that everything internally was being channelled into the words I was saying. That's what acting is. You find the shape of the person you're playing, and you feel it with your own feelings. From that moment I gained confidence.

And I realised that if you're going to try and act people, you needed life experience. But I was very inexperienced in all sorts of ways, very naïve. Sexually, for example, it was strange to play some parts. I remember deliberately setting out to try and broaden my experience, or otherwise I'd be drawing on an empty tool kit!

There were some terrible lows. Because you are the stuff of your training, you are the tools of your trade. Your mind, your heart, your soul, your history, who you are, that's the stuff of your trade. When that comes under heavy criticism, as a 19 year old, it's very tough.

Also, there's lots of stress on how you look, and trying to do make-up to glamourise yourself. I never thought that was anything to do with acting. I couldn't understand why people said I should take my hair out of my face, and that I looked good when I had lipstick on. Acting was a completely different impulse for me, about telling other people's stories, and experiencing other people's lives.

Theatre
Other Worlds (Royal Court); *Death and the Maiden* (Royal Court); *Les Liasons Dangereuses* (West End); *Hedda Gabler* (West End); *The Country* (Royal Court); For the RSC: *Troilus and Cressida; As You Like It; The Tempest; Antony and Cleopatra*

Film
Drowning By Numbers; Emma; Truly, Madly, Deeply; Bend It Like Beckham; The Secret Smile; Nicholas Nickleby; Mona Lisa Smile

TV
A Doll's House; Oedipus at Colonus; Antigone; Life Story; Treasure Island; The Politician's Wife; Cider With Rosie

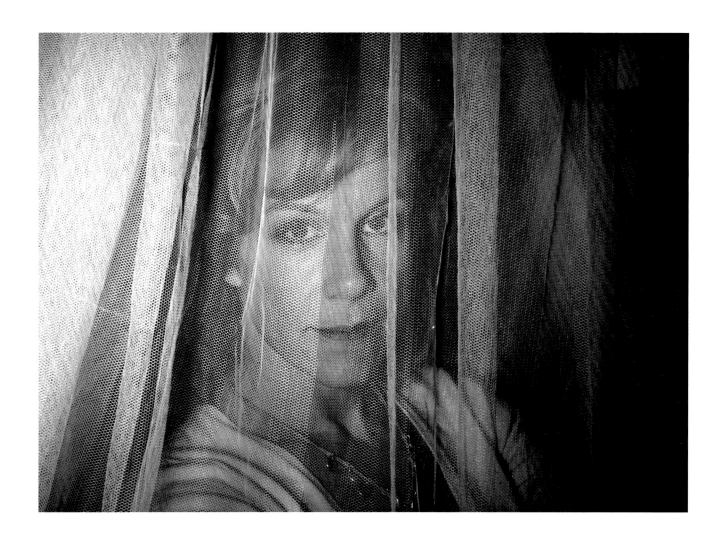

June Whitfield, C.B.E., 1942-44

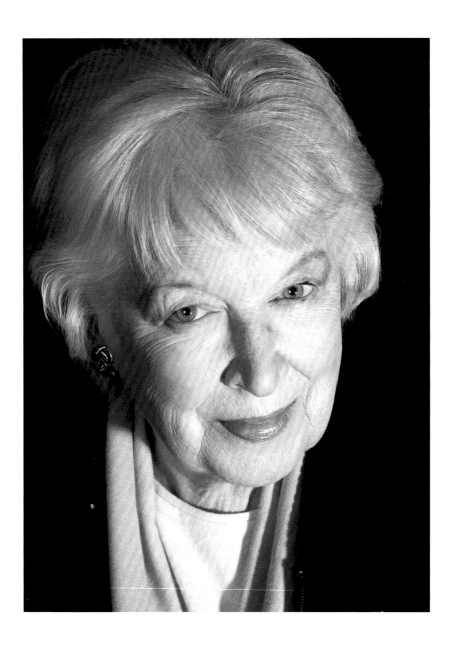

I don't remember much about my audition other than Sir Kenneth Barnes sat in the box, and the sound of rattling teacups.

In my year were Pat Lawrence, Bryan Forbes, and Pete Murray. Richard Attenborough was in his last term. For some reason, I remember that Richard and I sang a carol at the Whitfield Tabernacle. We did excerpts of *Midsummer Night's Dream* for schools. I was desperate to play Puck, but was cast as Peter Quince. I had to wear a bald bladder wig every morning, which I didn't enjoy. My idea of Peter Quince was to do a rather raspy voice, and I did it so much I ended up with a nodule on my vocal chord. I couldn't say anything for two weeks. Not a great success.

It was during the war, so it was all quite exciting, wondering if there'd be an air raid, that kind of thing. I lived in London and went back home every day. Getting there sometimes was a bit tricky. There was a great shortage of boys there. The girls were often playing boy's parts. I always was given character parts. The boys used to take it in turns to go fire-watching on the roof, and would invite various girls to go and watch with them. Sadly, no-one ever invited me!

I was very happy playing character parts and comedy, probably because I wasn't terribly self-confident. I always thought they were going to laugh at me anyway, so I should probably do something where they were meant to laugh. My mother was an actress, and I would join her sometimes. I would often be going home to rehearse some play that we'd then take round to fire stations. We were in a company called the Belfry Players. I was rather wrapped up in that.

I don't know if there's such a thing as a RADA style. At one time I think RADA was rather looked down on by various producers. They did try to teach you to speak properly and be understood.

Theatre
Ace of Clubs; Bedroom Farce

Film
Carry On Nurse; Jude; Carry On Abroad; Carry On Columbus

TV
Hancock's Half Hour; The Arthur Askey Show; Benny Hill; Steptoe and Son; Frankie Howerd; The Dick Emery Show; Bless This House; Morecambe and Wise; It Ain't Half Hot Mum; Minder; Terry and June; Friends; Days Like These; Absolutely Fabulous; The Kumars at No 42; Family Money

When I photographed Julian he had just come back from filming 'Troy', which he said involved spending a lot of time in a caravan surrounded by sand waiting for something to happen. If you've seen him in 'Troy', you'll know this is something of an under-sell.

I was only there one year because I was going to National Service. The custom was: do a year at RADA, do a year of national service, and then come back and do another year. I couldn't afford my second year because I didn't get a scholarship.

I auditioned once but didn't get in. But they had a scheme then called 'PARADA', which was in Archway somewhere, and was a preparatory academy associated with RADA. You took a second audition then, and hoped you got in. I got in the second time.

In my year was a lovely actor called Arthur Cox, who's still with us. A woman called Angela Crowe, who was on *Coronation Street* for a while. It was just after I left that the vintage time started, the Albert Finneys and so on. I don't know if that was cause and effect: "Oh good, he's gone. We can get in now!"

I thought I was best at everything. Disillusion comes later! I suppose I thought I was better at comedy. God, I was so young.

The extent of our debauchery was to go to a coffee bar called Velotti's down the road. We didn't drink. Nobody drank then. Coffee was the thing. No-one had any money!

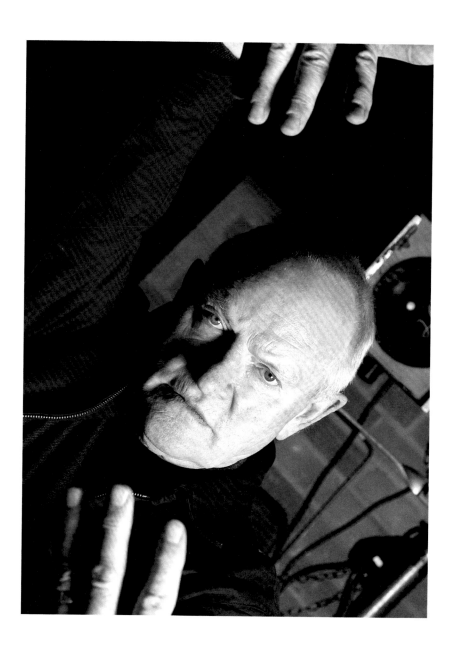

Theatre
Six seasons at the RSC: including *King Lear; Henry IV* – Olivier Award; *Waiting for Godot; Macbeth; The Dresser* (All in the West End)

Film
Tom Jones; Wuthering Heights; Nicholas and Alexandra; Antony and Cleopatra; Dead Cert; Juggernaut; Gulliver's Travels; Star Wars Episode V: The Empire Strikes Back; For Your Eyes Only; Mandela; Cry Freedom; The Secret Garden; Indiana Jones and the Last Crusade; Harry Potter and the Chamber of Secrets

TV
Age of Kings; Out of this World; The Saint; Doctor Who; The Sweeney; Henry VIII; Henry V; Ivanhoe

Kenneth Branagh, 1979-81

Ken came around to my house in Chelsea and, for some reason, I was expecting a cavalcade and entourage. Instead, he walked in off the street and said, 'Hi'. This, for no explicable reason, made me more nervous that I have ever been for any other portrait session ever. I basically thought I had made a fool of myself although I knew the pictures were fine. Imagine my surprise when a few weeks later, Ken's PA calls to say 'Ken really likes the way you work and wonders if you would like to do something with him for his new film.' Relief was not the word.

I did the obvious things. I did a bit of *Hamlet*, and a bit of Edmund from *King Lear*. You had to wait in a common room at the top of the building, and that itself was quite exciting because you got to walk up the main steps with awards on the walls going back to 1905.

It was snowing the day the letter arrived. We had a very over-excited dog called Ben, who was prone to chewing up the mail. It arrived and I was at home. I just remember jumping for joy, and then taking the dog out for a long walk for miles and miles.

I was most drawn to the classics and Shakespeare. I liked the stage fighting and the dancey stuff. I remember I wasn't very good at being an animal. We had be an animal for a long time, and I wasn't great at it. Mime, I wasn't very good at, either.

It was exciting because I went when I was 18, it was the first time I'd moved away from home and London is London. I was a grafter though, I really worked hard. I was excited to be there, and couldn't get over the feeling of 'being there', of that building, with all those famous names everywhere. We worked hard and played hard. Most people did both.

My accent changed. They have a very important test on Academy Standard English – news reader English, basically – and they were very damning about how they judged that. You ended up working on that a great deal. I was pretty neutral when I went, pretty suburban. I suppose it just got polished up. You were also doing speech classes about twice a day.

I think that first group dynamic, when you're all living away from home is very important. Learning how to get on inside a group. Living in this world where your emotions are very close to the surface. That's all as memorable as what you learned about acting. It was an intensive experience. I think the life skills I learned were people skills.

I really enjoyed being in a Woody Allen film called *Celebrity*. When I got the job he wrote me a letter that began, "Dear Ken, When I wrote this, I knew that there was only one actor in the world who could play this part: Alec Baldwin. But he's not available, so I picked you."

Theatre
Henry V; Golden Girls; Hamlet and *Love's Labour's Lost* (RSC); *Romeo and Juliet*, actor and director (Lyric Studio, Hammersmith); *Public Enemy*, actor and writer (Lyric Theatre, Hammersmith); *As you Like it; Hamlet* and *Much Ado about Nothing* (The Renaissance Shakespeare Season); *Look Back in Anger* (on tour, Lyric Theatre and Thames Television); *A Midsummer Night's Dream; King Lear*, actor and director (World Tour); *Hamlet* (RSC); *Richard III* (Sheffield Crucible); *Edmond* (National Theatre)

Film
Henry V, actor and director; *Peter's Friends; Much Ado about Nothing; Mary Shelly's Frankenstein,* actor and director; *Othello; Celebrity; Rabbit Proof Fence; Harry Potter and the Chamber of Secrets; Hamlet,* actor and director; *Love's Labour's Lost* actor and director

TV
Ghost; Coming Through; Fortunes of War; Strange Interlude; The Lady's not for Burning; Shadow of a Gunman; Conspiracy; Shackleton

Direction
John Sessions' *The Life of Napoleon; The American Story* (for Renaissance, tour and West End); *Twelfth Night* (for Renaissance at Riverside Studios, London); Co-directed *Uncle Vanya* with Peter Egan (Renaissance UK tour); *The Play What I Wrote* (Wyndham's Theatre and on Broadway).

Writing
Plays – *Tell me Honestly* (performed in London, Newcastle and Oslo); *Public Enemy* (performed in London, New York and Los Angeles).
Autobiography – *Beginning*, (Chatto & Windus).
Adapations – Shakespeare's *Henry V; Much Ado about Nothing;* and *Hamlet* for the screen (Chatto & Windus).
Screenplay – *In the Bleak Midwinter* (Newmarket Press).

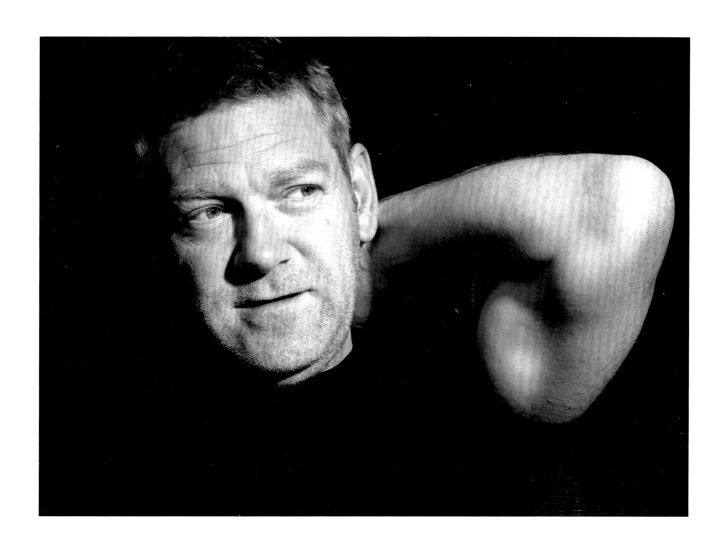

Lloyd Owen, 1985-87

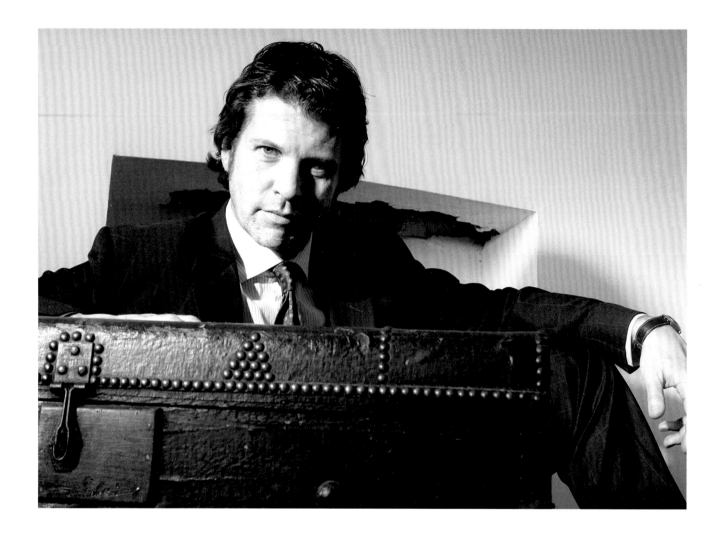

Lloyd Owen sounds about as un-Welsh as I do when he speaks. But that didn't stop either of us being proud of our heritage. I wanted to photograph Lloyd the ladykiller and Lloyd the cowboy, both of whom I suspect live in Battersea…

For my audition, I did Iago from *Othello*, and Bamforth from *The Long and the Short and The Tall*. When I got the letter, I was in my mother's kitchen. I remember the turquoise ink. I had to re-read it to be sure. I felt elation and relief, because I had been accepted into Guildhall and Bristol Old Vic, but due to RADA's eccentric term structure, had been forced to take a gamble and let those places go. All my hopes rested on being accepted.

I took a lot of stick from Lena in the canteen: she was the foul-mouthed dinner lady, server to the stars of the future. A legend.

The Marlborough Arms and University of London Union Bar were home from home. Most of us came out two stone heavier than we started!

You can't be taught to act. You can learn techniques for voice projection, physical awareness through movement and dance, text analysis, and also how to deal with twenty megalomaniacs in the same room. Learning all of this proved invaluable.

Theatre
Nick in *Who's Afraid of Virginia Woolf?*, dir. Howard Davies (Almeida/ Aldwych); Dan in *Closer*, dir. Patrick Marber (Lyric); Mortimer in Marlowe's *Edward II*, dir. Michael Grandage; (Sheffield Crucible); Brutus in *Julius Caesar*, dir. David Lan (Young Vic); George in *The York Realist*, dir. Peter Gill (Royal Court)

Film
The Republic of Love; Between Dreams

TV
The Young Indiana Jones Chronicles; The Cinder Path; Get Real; Coupling; Wire In The Blood

Maxine Peake, 1995-98

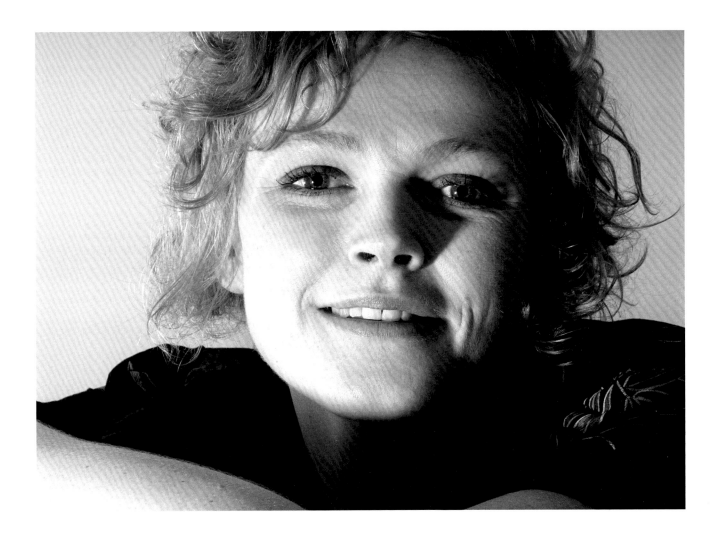

I'm convinced that Maxine, 'the Michelle Pfeiffer of South London', had forgotten I was coming that morning, but she says not. Either way most of the flat was just getting up and had to suffer Maxine and I taking over the only available space – the dining room table – on which we sat her rather precariously astride a chair.

I remember my final workshop. I wore a tracksuit my Grandad had bought me, in case I had to 'move', which was my worst fear, as I only do so comfortably when I'm under the influence! My piece was from Debbie Horsfield's *Red Devils Trilogy*. I played Alice. My main memory was of Marshall Lancaster singing a 'Temple of the Dog' number for his vocal audition.

I got a phone call from Mr Barter himself. I was working as a lifeguard at Horwich leisure centre when I got called to go to the staff room, as 'there was a posh bloke on the phone asking for me'. I thought it was a wind-up for quite a while, until I rang home and my Grandad said he'd phoned there first.

I still see Gary Cargill as he's my fella! And Andy Bone who's his flat mate, and Vissey Safavi. I hear from Candida Benson and Sally Hawkins when she's not too busy being a movie star! I'm quite proud that I introduced Joanna Page to her husband James.

In my year I was the best at bottling out of things. We weren't a very social year, except for Fridays in the Marlborough, followed by a couple of cheese toasties when we were worse for wear in ULU. Vissey Safarvi and myself used to hit the delights of Camden on a Saturday, going down to the Good Mixer, then on to *Blow Up* at the Laurel Tree or The Monarch. (Only though, after getting teary while watching *Stars in Their Eyes* in my room at Bonham Carter House.)

Theatre

Miss Julie, dir. Michael Boyd (Theatre Royal); *Luther* (National); Ophelia in *Hamlet*, dir. Ian Brown (West Yorkshire Playhouse)

TV

Linda Green; Clocking Off; Dinnerladies; The Way We Live Now; Shameless; Faith

Barbara Jefford, O.B.E., 1947-49

As the gate swung shut after John Hurt had left me, Barbara walked in, it was like a conveyor belt of talent. She said she used to like being photographed but had got to an age where she didn't any more. I have sympathy with this, but Barbara looked great and had a lovely wistful look in her eye I thought.

It was a long time ago. I was young and apprehensive. We were in the little theatre in the Gower Street basement, which was then the only one. Kenneth Barnes was the principal. After I got in, I remember my father and mother, who were both very supportive, filling out a form. It said 'Can you afford to support your daughter through her course?' and they were very honest, and said they could. My father could just manage it on his bank salary. Luckily, after the first term, I got a scholarship anyway, awarded to the most promising pupils in the first year.

Robert Shaw, the actor and writer, was in my year. We both jointly won the Kendall prize.

I'd spent some time after leaving school at a studio in Bristol, where I had the most amazing teacher called Eileen Hartly-Hodder. Before I went to RADA I'd achieved my Licentiateship at Guildhall, which gave me the title LGSM. That included lots of technical work on speech, diction and voice production, so when I got to RADA I was quite a bit ahead of other people. The movement classes I hadn't done before, but being young and supple it came to me rather easily.

The most astounding thing for me was that there were men there… MEN! I'd never acted with men before. I'd been at an all-girls school, and then the studio in Bristol was all female. It was a revelation. Some of the men were proper ex-army, and had been to war. They were very… interesting, let's put it that way. I think I was too scared to be attracted! We were very juvenile in those days. We were very green indeed.

I stayed with my aunt in Leytonstone. I was very firmly chaperoned. It was my first time in London. I'd grown up in the West Country and visited only once before.

I was a very hard working student. I wish now that I'd taken more advantage of it. When I was at last let loose… I did.

There were some pretty terrifying tutors. Especially the women! There was a famous actress of the day called Fabia Drake, and she was a real taskmaster. There was a wonderful sister of Kenneth Barnes, who gave a class on how to laugh. I've never forgotten what she said. She taught you to let all your breath out before you laughed. If you laugh with a full steam of breath you sound like you're crying. I've never had any trouble laughing since!

In those days, there were a lot of women who went there as a sort of finishing school, to polish the rough edges. They learnt to speak nicely and to walk. They had no intention of making a career in the theatre. They tended to emerge with what was known as the famous 'RADA' voice. Now I don't know what the RADA style is. I would think it is much more liberating.

Theatre

For the National: *Power; Sanctuary; Tamburlaine the Great; Hamlet; Fathers and Sons; Six Characters in Search of an Author; Ting Tang Mine;* At Stratford on Avon: Isabella in *Measure for Measure*, opposite John Gielgud, also played Hero, Lady Percy, Desdemona, Rosalind, Calphurnia, Katharina; For the Old Vic: Imogen, Isabella, Portia, Rosalind, Tamora, Ophelia, Lady Macbeth, Viola, Beatrice. Barbara has played in 54 Shakespearean productions, including three roles as Cleopatra. She has appeared in all but four of his plays. Joan in *St Joan*. In the West End: *Ride A Cock Horse; Filumena; Mistress of Novices; A Dark Horse*

Film

Ulysses; The Shoes of the Fisherman; And the Ship Sails On, dir. F.Fellini; *Reunion; Where Angels Fear to Tread; The Ninth Gate,* dir. R.Polanski

TV

Lady Windermere's Fan; Walter; Edna; The Inebriate Woman; Porterhouse Blue; The House of Elliott; A Village Affair

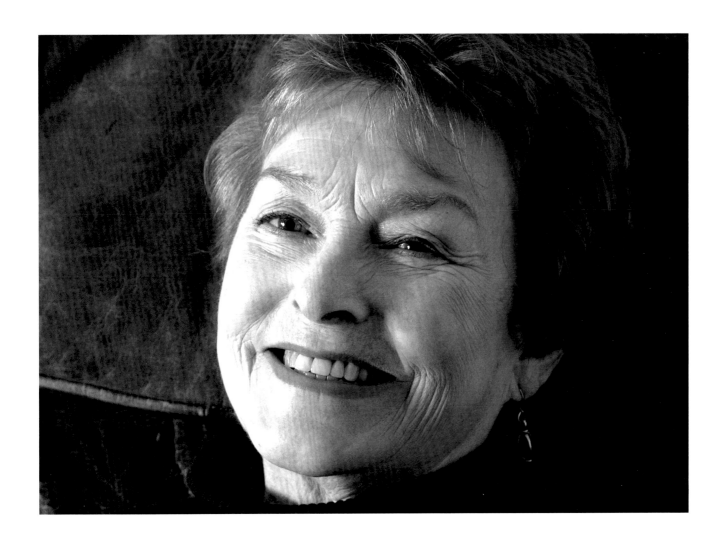

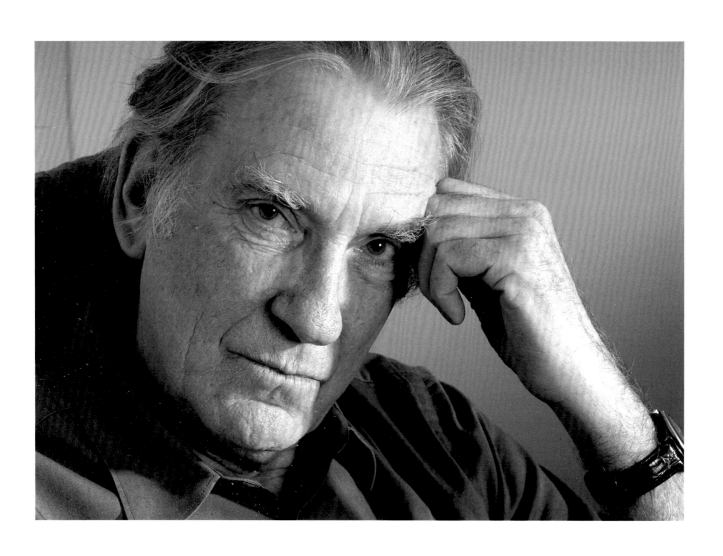

David Warner, 1960-61

Theatre
Hamlet; Major Barbara; King Lear (Chichester Festival)

Film
Tom Jones; Morgan! A Suitable Case for Treatment; Straw Dogs; The Omen; Tron; The Man With Two Brains; Titanic; Masada

David was clearly deeply suspicious of anyone called something as preposterous as Cambridge. So once I arrived and appeared normal (-ish) I could sense the relief. Although I know David from TV it was one of those occasions where my unfamiliarity with British TV meant I didn't know, for instance, that he'd worked with Ioan Gruffudd on 'Hornblower'.

I was handed a letter just as I got on the train to come down to London to audition. It was from a teacher who'd been helping me prepare. The letter said he didn't think I'd get in. I went into the audition feeling very nervous! It was a very strange thing to do really.

The year was split into two terms, the A stream and the B stream. The people in my stream I can't remember: John Hurt was in my year though, and Ian McShane, a wonderful actor. They are the only two that I remember. People like Tom Courtenay and John Thaw had both left.

I was very good at small parts. You either get cast in the small parts or the leads. The only big part I got in the finals was as an old man. I knew I was going to be a character actor from the age of twenty.

The one thing that I remember, was that every part I was given, I was sitting down. I only found out later from the teachers that it was because my movement was so bad I could've been kept down a year. They were on my side, and didn't want me being held down by poor movement.

We played a lot of poker, went to the pub, skipped a few movement classes – that's why I wasn't too good at it. It was my first time in London. I wasn't a bad student, but there were certainly times when I skived off. We used to go to the Marlborough Tavern, a great place.

You don't learn to act as such, you just learn what not to do. You learn techniques: how to move, project your voice, technical stuff like that. But you have to have a spark of something, you can't be taught the talent of acting. It's like art school: you can't go without some form of existing talent. At that time, a lot of people then went as an entry into society.

I'd been a pretty mixed up teenager when I went. RADA didn't make me any more un-mixed up.

I'm the kind of actor who never expected to have a career. I did go to drama school, but I really just hoped I would be able to make a living. Everything I've done since leaving RADA has been a bonus. I'm just a character actor.

Lolita Chakrabarti, 1987-90

I was greeted by Lolita pointing out that I was late, and that she was trying to prepare food (which smelt great) for a christening party for their latest addition. I checked my diary, and insisted I was spot on time – later email-checking confirmed it was Lolita, and not me, who was right. My point here is that despite initial trepidation on my part, we had one of the most relaxed and productive sessions of my trip.

I did a piece from *The American Clock* by Arthur Miller. I wore my black practice skirt. It must have been bizarre, an Asian girl from Birmingham playing this 40-year-old black American woman.

I was going to university. The only reason I tried for RADA was that my friend was auditioning and my drama teacher had said she wasn't ready. They had the application form, though, and asked if I wanted to have a go. So I thought 'Fine, I won't get in and I'll go off happily to university'. I didn't want to get through the first round because I didn't want the dilemma. Then I did the workshop for the day, and it sold me. I thought, 'This is a magical place. I want to go here!' and it all turned completely on its head.

I didn't know anything about drama school. When I turned up on the first day and we got our timetables, with dance, dialect, and singing on them, I thought, 'My God! Do we not write any essays?' I had no idea what I was getting in to.

I was good at voice and stage fighting, but terrified of tumbling. Running up a wall, falling off a piano and so on. I couldn't even do a forward roll. I was useless! My Dad's an orthopaedic surgeon and so I'd always been very aware of bones breaking.

I was a very hard worker. I've never been a pub person – probably cultural, because my family are Indian. Adrian (Lester) didn't do it either, and I think that's probably why we hung out a lot. I'd just stay at college and work, practising what we'd been doing in the day. Adrian and I met in my first term, and we got together very quickly, so I'm sure that that made up for the fact that I wasn't going to parties.

It took me a bit of time to love London. I was from Birmingham and I found London very unfriendly and isolating. My first digs were with this pair of Balham yuppies and they didn't like me very much. It was really odd, finding my feet, away from home, no money. I remember my dad came to drop me off and I was almost in tears. I had no idea where I was! It was a real education.

Theatre
Hippolyta in *A Midsummer Nights' Dream* (National); *The Waiting Room* (National); Olivia in *Twelfth Night* (Salisbury Playhouse, Edinburgh Lyceum, tour of China); Goneril in *King Lear* (Talawa Theatre Company); *Grimm Tales* (The Young Vic touring Hong Kong, Australia, New Zealand); Rosalind in *As You Like It* (USA tour)

TV
The Bill; Forty Something; Amnesia

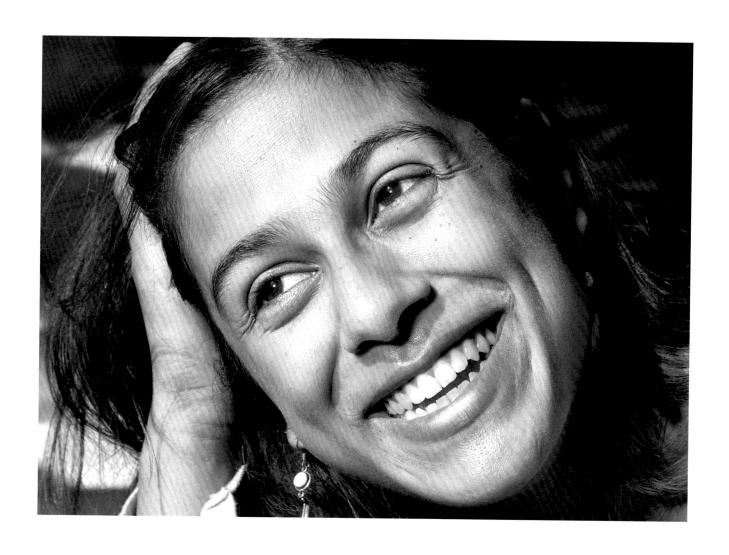

Mark Rylance, 1978-80

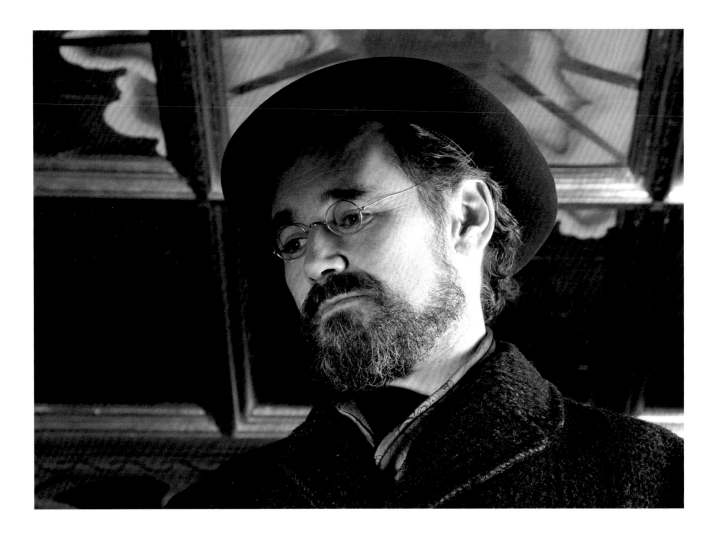

We shot this portrait at The Globe Theatre (where Mark was Artistic Director). Just below us we could see the guided tours of school children. I spotted a group of handicapped kids getting involved in some demonstrations on the stage. If you ever want to see the power of theatre in full flight just go and watch one of those sessions. Their involvement and energy was humbling.

My audition was in New York City, at the UN building, with Hugh Crutwell and a Christmas tree. It snowed so much that day that I couldn't fly home and stayed in a hotel. I did Hamlet's 'Rogue and peasant slave' speech, and a breakfast scene from Ayckbourn's *Norman Conquests*.

I was away lighting a show in Minneapolis when the letter arrived – so my family opened it and then had to pretend they hadn't when I returned. They were very surprised and so was I. It seemed very unlikely.

There were 22 of us in our term and I still know about half. It is

always very friendly when we meet, which we do from time to time, to have dinner and catch up.

I was a loner and a workaholic. I went to the theatre and movies as much as I could afford. I changed my accent consciously, from American to English. I learnt life skills at RADA. They tried to help me stop acting! I don't know if there's a RADA style. I always wore hats. But I remember Hugh Crutwell loving truth and what you are yourself.

Theatre
For the RSC: *Hamlet; Romeo and Juliet; The Tempest.* For the Globe: *Hamlet; Henry V; The Merchant of Venice; Richard II; The Tempest; Twelfth Night. Gamblers* (Tricycle)

Film
The McGuffin; Hearts of Fire; Prospero's Books; Angels and Insects; Intimacy

TV
Leonardo; Richard II; The Government Inspector

Artistic Director of The Globe Theatre until 2005

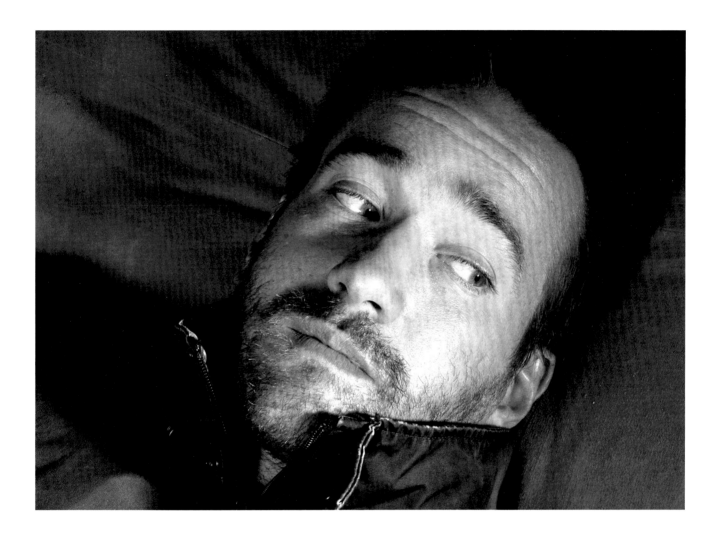

This photo is of Matthew lying on my bed. Not a position that I encourage all my subjects to take, but it seems to have worked well enough here.

The initial audition was terrifying. I did a bit from Albee's *The Zoo Story* and some *Henry V*. Afterwards one of the panel told me that, at 17, I was too young anyway and really shouldn't have been auditioning. I was so crushed. Then I got a recall about a week later.

Oliver Neville, the then principal, phoned me at my school. I was taking exams at the time and I remember him asking me quite detailed questions about my A-levels for ten minutes. Eventually he offered me a place, starting in September. I couldn't believe it. He then very gently enquired as to whether I would accept. I just laughed and burbled hysterically. Such a relief and excitement.

I don't know what I was best at. I knew I didn't want to be anywhere else. I remember great highs and deep lows, but feeling constantly engaged, engrossed. Some subjects I found pretty mystifying, like Laban. Quite early on in the first term, in a voice class, I remember being asked to breathe the colour blue through my vagina.

Theatre
The Duchess of Malfi; Much Ado about Nothing (Cheek by Jowl); *The School for Scandal* (RSC); *Henry IV* (National)

Film
In My Father's Den; Maybe Baby; Pride and Prejudice

TV
Wuthering Heights; Warriors; Perfect Strangers; The Way We Live Now; The Project; Spooks

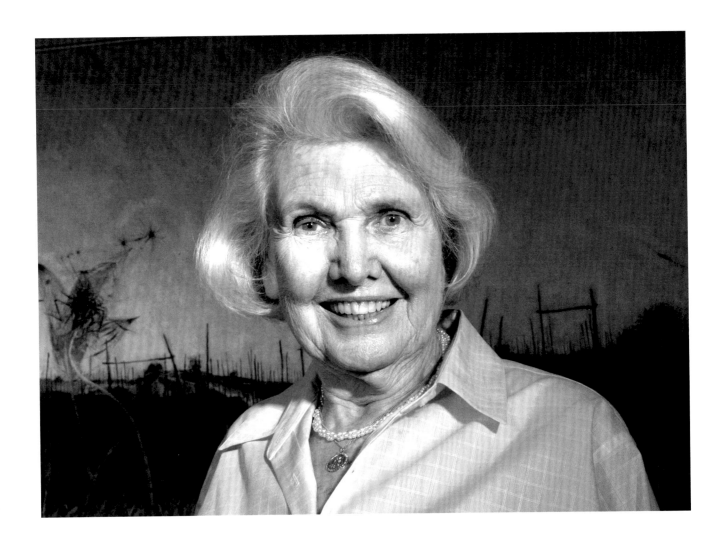

Sheila Sim, 1940-42

Theatre
St Joan in *St Joan* (Intimate Theatre, Palmers Green); *To Dorothy, a Son* (West End); Mollie in *The Mousetrap* (first cast); *Double Image* (Savoy)

Film
A Canterbury Tale; A Great Day; Dancing With Crime; The Guinea Pig; Dear Mr Prohack; The Magic Box; Pandora and the Flying Dutchman; West of Zanzibar; The Night My Number Came Up

Lady Attenborough met her husband while at RADA and I have photographed them both individually and together. When you see them together, you may well ask whether they met at RADA yesterday.

I left school when war broke out, though, thankfully, I'd achieved Matric. My father was staff manager at Baring Brothers, where he took me to work in the postal department sticking on stamps – I remember reading Shakespeare's *Henry V* in any spare moments.

At that period of the war (1939), the home front was very quiet and my father let me apply to RADA. I performed a speech of Titania's in *A Midsummer Night's Dream* and the other was a poem, the first six lines of which I still remember. I wore a bright wool dress which my mother bought for the occasion: it was handmade, with embroidered flowers at the neck and cuffs. It required eight coupons, because of the rationing.

I started my training the spring term of 1940. I adored my time there and, looking back, it was among the happiest periods of my life. I recall so fondly those in my class, including Alan Badel, William Squire, John Blatchley and Myrtle Rowe, who I still see very often, as she is a close friend.

We were very fortunate to have among our tutors Stephen Haggard, one of the most distinguished and accomplished actors – thought by many to have been the greatest Fool in *KIng Lear* of all time – and a hugely charismatic teacher. He introduced us to Chekhov and Stanislavsky.

One day he appeared at class in battle dress and told us he had joined the army. It was during the Summer Term in 1940. He relayed that reports had come in that the Germans had taken Paris and were already marching down the Champs Elysées. I clearly remember being very moved by his considerable distress. I did not comprehend the enormity of the dreadful news. We never saw him again, as he died on active service.

During that part of the war, school children were evacuated out of London and RADA took a group of us students to entertain them. We went by a large coach, taking our costumes and scenery to South Wales and performed *A Midsummer Night's Dream* at their schools. It was remarkably good training for our future. Nothing could be harder than to play Shakespeare to an audience who seemed continually on the move and chattering loudly.

Nevertheless, we took the performance very seriously and I was allowed to play Peaseblossom – and guess who played Snug the joiner? A chap who I married some four years later! (Richard Attenborough)

Lord Attenborough, 1941-42

When I first photographed Lord and Lady Attenborough I had been told that I would simply adore my time with them. If you're anything like me, this will make you begin to expect the very opposite. How wrong could I have been. I won't say how, or why, but these people are truly special.

I attended an audition for the Leverhulme scholarship in December 1940 in the middle of an air raid. I remember I wore a pair of grey slacks and a sports jacket. Consequently I must have looked fairly ridiculous performing the De Stogumber speech in Shaw's play – he's just witnessed St. Joan being burnt at the stake. I followed that with Ormonroyd, the tipsy photographer in Priestley's *When We were Married*.

I received a letter in the first week in January at my parent's home in Leicester. I learned it had arrived, following my return from a night's duty at an ARP depot, when my brother, David, came hurtling down the hill, ringing his bicycle bell, shouting 'It's come, Dick, it's come!'

In my year were a number of distinguished players, including Harold Lang, Miriam Brickman, John Blatchly and a young actress who was a year ahead of me, who I married four years later.

I love parts that require different accents, with the exception of the French class which I hated, since I couldn't speak a word of the language.

Knowing that I had to go into the air force, I worked like a slave.

Theatre
Richard Miller, in Eugene O'Neill's *Ah! Wildernesses* (Intimate Theatre, Palmers Green); Ralph in Clifford Odet's *Awake and Sing* (Arts); Sebastian in *Twelfth Night* (Arts); Leo in *The Little Foxes* (Piccadilly); Pinkie in *Brighton Rock* (Garrick); Coney in *The Way Back* (Westminster); Roger MacDougall's *To Dorothy a Son* (Savoy, Garrick); *Sweet Madness* (Vaudeville); Sergeant Trotter in *The Mousetrap*; *Double Image* (St James); Theseus in *The Rape of the Belt*

Film
In Which We Serve; Brighton Rock; The Guinea Pig; Morning Departure; The Ship That Died of Shame; Dunkirk; The Angry Silence; The League of Gentlemen; The Dock Brief; The Great Escape; Séance on a Wet Afternoon; Guns at Batasi; Flight of the Phoenix; The Sand Pebble; Dr. Dolittle; The Bliss of Mrs Blossom; The Severed Head; Loot; 10 Rillington Place; Brannigan; The Chess Players; Jurassic Park; Miracle on 34th Street; Elizabeth; The Lost World: Jurassic Park

TV
David Copperfield; Tom and Vicky; The Railway Children

Director
Oh! What A Lovely War; A Bridge Too Far; Gandhi; Cry Freedom; A Chorus Line; Chaplin; Shadowlands; In Love and War; Grey Owl

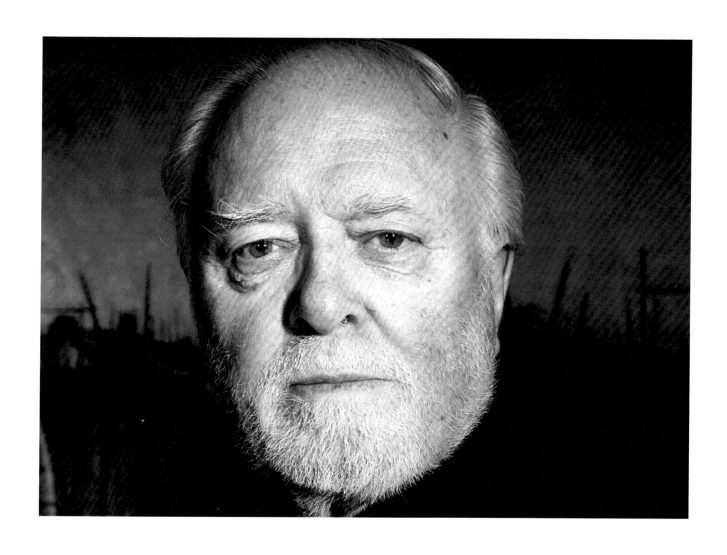

Isla Blair, 1961-63

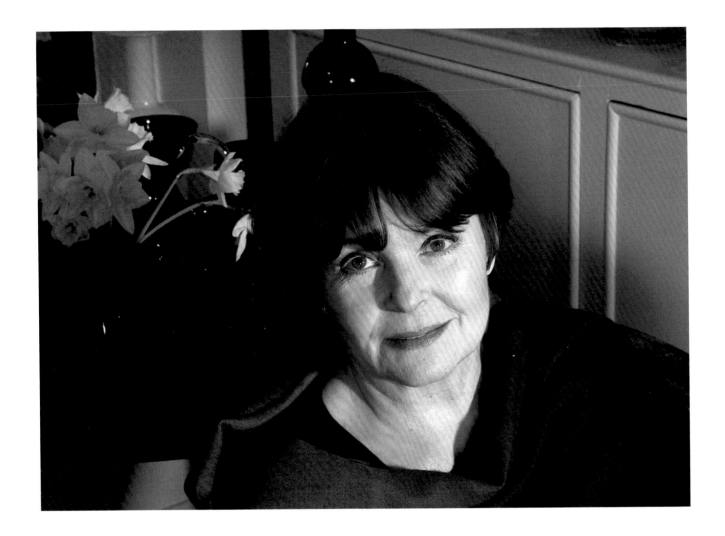

*I managed to try and line up Isla Blair and Julian Glover on the same day in different locations,
without realising that they are, of course, husband and wife.*

Sibu's rise to fame has come as a writer as much as an actor. He is originally from Zimbabwe and his writing often touches on the troubles that his country is going through.

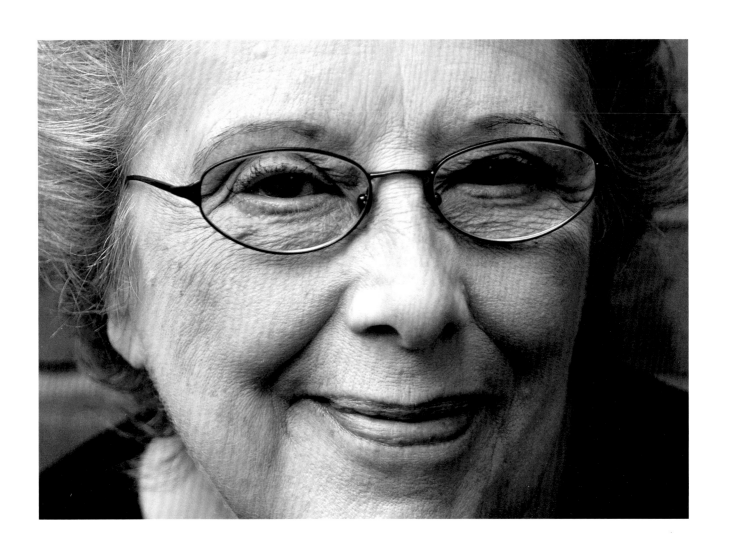

Margaret Tyzack, O.B.E., 1949-51

Theatre
Martha in *Who's Afraid Of Virginia Woolf?* (National); Mrs Alving in *Ghosts*; Eliza in *Pygmalion*; *The Flowering Cherry*; *The Silver Box*. For the RSC: *The Lower Depths*; *Macbeth*; *The Ginger Man*; *The Family Reunion*; *Tartuffe* (West End); *Auntie and Me* (Wyndhams)

Film
Ring Of Spies; 2001: A Space Oddity; A Clockwork Orange; Quatermass; Prick Up Your Ears; Mrs Dalloway; Bright Young Things

TV
The Crimson Ramblers; Angel Pavement; The Passenger; The Forsyte Saga; Cousin Bette; I, Claudius; The Young Indiana Jones Chronicles; Our Mutual Friend

I had a lovely morning with Margaret, including a trip to the local coffee shop, but what I found most endearing and attractive is the little girl that lurks behind the lady. You see it most while photographing and I hope you see it in the end result.

At my audition, I wore my school uniform and I did Eliza, Higgins and Col Pickering, all in the same scene. I also did Juliet and fell off the 'balcony', which was a bent-wood chair.

The next thing I knew, I'd got a letter saying I'd got in. I was at home. I was a bit overwhelmed – I'd just left convent school. I know when I got the note about the audition I was a bit fed up, because I'd got a date with someone. I think it took me a long time to grow up. When I left, I wasn't even twenty.

I remember who gave me my diploma: Vivien Leigh. She didn't say much, but she looked divine! She had a little navy blue suit on with a lovely delicate straw panama hat with a gardenia on the ribbon round it. I just remember this utterly beautiful little creature handing me whatever it was they gave you.

I remember Joan Collins and Gerald Harper. So many of the men had been in the army. We had quite a few Americans. After the war, the American government said to any GI, 'If you can get in anywhere, we'll pay for it.' That was the deal.

West Ham Council paid for my fees, for which I've been eternally grateful. I went to audition in front of the chairman of the West Ham education committee, and he said to me 'Have you brought any of your drawings with you?'

I didn't like doing fencing much, because the teacher didn't think women ought to do it. So, I spent most of my time out in the corridor disinfecting the masks! Ballet was the same, the teacher preferred to teach the boys.

I remember one report I had said 'Margaret must, by all means, take her work seriously, but not solemnly'. I thought, 'Oh golly! Where did that come from?'

I didn't drop my H's because I had an upper-middle-class grandma. And I was never allowed to go to any street parties. I was in classes, though, with girls from South Kensington, who had voices that were so strangulated you couldn't hear anything at all!

There's a debate about RP (Received Pronunciation). I spoke with an actor recently who described it very well. He said, 'It's a wonderful neutral gear, from which you can go in any direction.'

I used to live at home and come up on the number 15 bus. The social life was non-existent because I didn't have any money. End of story. My mum and dad gave me some, but I remember I couldn't afford to go to the Milk Bar in Charing Cross.

Steve McFadden, 1985-87

Funnily enough, it was David Neilson, of *Coronation Street*, who auditioned me on the first round. I bumped into him recently at the Soap Awards and said, 'Thanks very much. If it wasn't for you, I wouldn't be here'. And then, like a vain actor, I asked him, 'What did you see in me anyway?' I was thinking he'd say, 'Your amazing presence, your staggering talent', you know. And he said, 'It was because you'd been a plumber'. He felt sorry for me!

I'd auditioned for every drama school going, but most turned me down. When RADA accepted me, I couldn't believe it. I turned up the first day with my letter saying 'I am pleased to inform you…' in case anyone said, 'There's been a mistake'. Because I could have showed them the letter and said, 'Legally, you've got to take me!'

Everyone kept saying, 'What's my cue?' and I didn't know what a cue was, and couldn't work it out, because it seemed like it could be anything: something visual, a sound, a light.

In my year were David Westhead, Adrian Allen, Melanie Thaw, Troy Webb, Paul Dixon. It was fun. The first term, I was out every night on the tiles. But the second, I set myself a regime, and I've stuck to it ever since: if I'm working, I don't drink during the week at all, just at weekends.

Oliver Neville was the very first person who ever directed me, and it was an incredible experience, which has stayed with me ever since. I always think it's like horse and rider: if you're the horse, you're really free, you can roam anywhere, but you might end up in the wrong place. A good rider will steer you right, you'll make better progress, on the right path. And if it's someone you don't like, you can buck them off!

I was 25 when I went there: I'd worked on the doors, in street markets, in the building trade – where people haven't got an ear to how you're feeling. Your personal development: nobody gives a monkey's about that in the real world. But in RADA, it was incredible. A place where your talent was honed, where people cared and were bothered about you.

What I liked was when the penny would drop, the door would open, something was unlocked inside you. Like when the teacher asked, 'When do you have the thought of what you're about to say?' And I went, 'Dunno'. And he said, 'On the in-breath'.

I won both the awards for stage fighting, but that was the street side I brought in with me.

My sight-reading was embarrassing: it was physically uncomfortable for people to be in the same room as me when I was doing it, because I was so bad. It took me half an hour to read a poem.

Being an actor is allowing yourself to think things you wouldn't normally. Like, shagging my brother's wife isn't something I'm about to do in real life, because I haven't got a brother, and if I had, I wouldn't get off with his wife. But in acting, you have to go on this journey of discovery, trying to understand someone psychologically. It definitely made me more open to ideas. You can't be narrow-minded. You can be opinionated, but you can't be closed off.

I'm very proud of the place and proud to be associated with it, and eternally grateful to it. Without RADA, I wouldn't have got anywhere with my life.

Theatre
The Widowing of Mrs Holroyd (tour)

Film
Buster; The Firm; Provoked

TV
Minder; Bergerac; The Bill; Law and Order; Vote For Them; Saracen; Eastenders

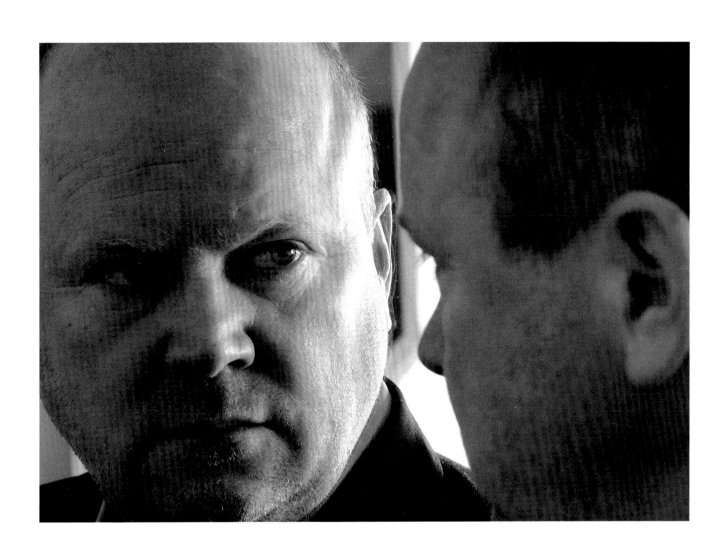

Michael Kitchen, 1967-69

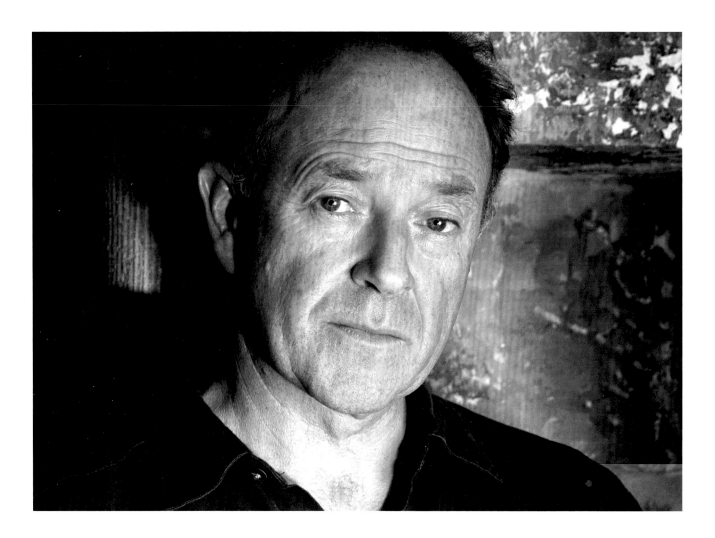

Michael is by far the most reluctant star I have ever met. A lovely bloke but not a man who enjoys playing the star and publicity game. We laughed at how he had originally not replied, then replied saying 'yes sure' but giving no contact details to arrange an appointment. I felt I was very privileged to be asked to his rather wonderful home in the circumstances. The stone staircase is all his own work and built of local stone by the way!

For my audition, I read Khlestakov from *The Government Inspector* and Bottom from *A Midsummer Night's Dream*.

In my year were Miles Anderson, Duncan Preston, Stuart Wilson – and we're still friends.

Theatre
Charley's Aunt (Young Vic); *Rough Crossing* (Lyric); *The Homecoming* (Oxford, Garrick). For the RSC: *The Art of Success; Romeo and Juliet; Richard II*

Film
Breaking Glass; Out of Africa; GoldenEye; Mrs Dalloway; The World Is Not Enough

TV
The Brontes of Haworth; Brimstone and Treacle; King Lear; Love Song; The Browning Version; Kidnapped; A Royal Scandal; Sunnyside Farm; Oliver Twist; The Railway Children; Lorna Doone; Foyle's War; Falling

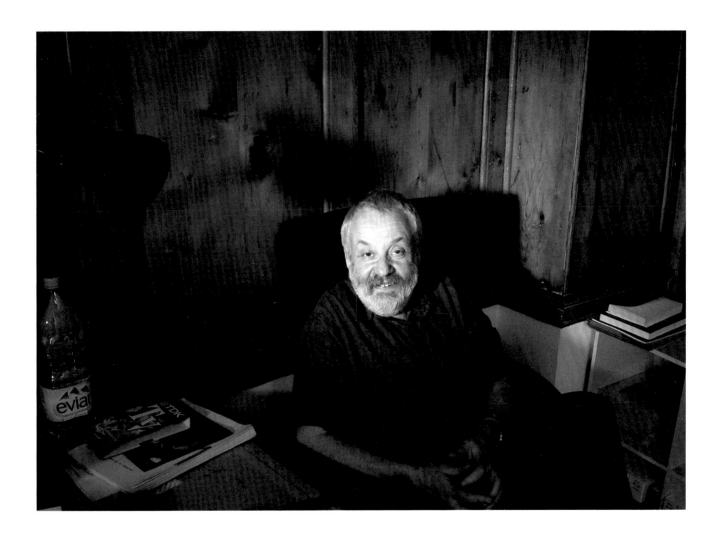

I would never have guessed that Mike Leigh went to RADA. Not only did he go there, but he now actively supports a lot of the young talent that comes out of the Academy.

I was awful in my audition, I dried up completely. I did Cassius whinging to Brutus about Caesar. I wore a corduroy lumber jacket and so-called kid's khaki drill slacks – trendy at the time.

I heard that I'd been accepted when I was in the bath on a Saturday morning. My kid sister read it out to me through the closed door. I'd been given a scholarship. I was utterly amazed.

In my year were Sheila Gish, Roger Hammond, Martin Jarvis, Gemma Jones, Richard Kane, Lynda La Plante, Ian McShane. I haven't seen most of them for ages.

I was good at mime, rubbish at fencing, although I scored a great hit with a joke version of Macbeth vs. Macduff, complete with kilts and tam-o-shanters, as my submission to the otherwise famously po-faced fencing competition.

I was deeply lazy in classes, but worked hard in rehearsals. I spent a lot of time at the NFT. I still do.

Theatre
Custard in *Love's Labours Lost;* Dubois in *The Misanthrope*

Director
Nuts In May; Abigail's Party; Meantime; High Hopes; Life Is Sweet; Naked; Secrets and Lies; Career Girls; Topsy-Turvy; Vera Drake

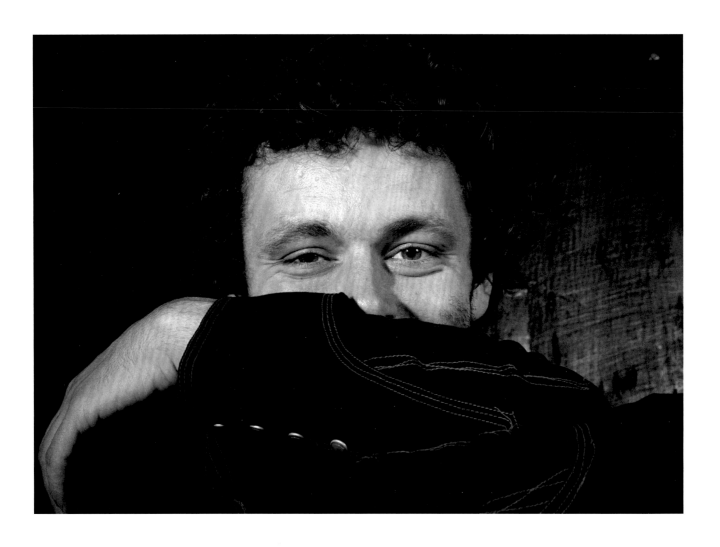

Theatre
When She Danced (West End); *Romeo and Juliet* (Manchester Royal Exchange); *Peer Gynt* (world tour); *Caligula* (Donmar); *Look Back In Anger* (Manchester Royal Exchange, National); *Amadeus* (Old Vic, Broadway)

Film
Heartlands; Bright Young Things; Time Line; Underworld; Kingdom of Heaven

TV
The Deal; Dirty Filthy Love; The Queen

Michael lives in LA and is not an easy man to track down. When you do finally locate him, he appears to have all the time in the world for you. I remember him particularly saying that he couldn't stand it in America when photographers come in and say, 'Hey, I've got a great idea, you run and jump....' He just wants to be photographed, which is lucky because I didn't have any great ideas.

I did a speech from *Torch Song Trilogy* – a drag queen bemoaning her lot – and the dagger speech from *Macbeth*, with a rather dodgy Scots accent. I remember being very intimidated by a guy in the waiting room, wearing a posh suit, and seeming the most confident person in the universe. I never saw him again.

I was at home in Wales when I got the acceptance letter. My parents were at work so I had to wait all day to tell them. I knew that they were probably more nervous than me, so it was very exciting. They came to see all the performances I did at RADA. I didn't realise how fortunate I was in this, until I saw how other student's parents didn't seem to feel that this was important.

I made some wonderful friends in my year. My closest was Julian Mitchell, now Julian Kemp, who became a director. Another was Tamsin Weston whose daughter I'm godfather to, Jason Cheater, who is indispensable to RADA, Wendy Ronald, Maria Jackson, John-Paul Connolly and Jane Robbins, who I've subsequently worked with twice, were all good friends from my year.

I was good at processing lots of seemingly contradictory points of view. There were lots of very different schools of thought amongst the staff. I was able to find out what helped me and build up my own process in that way, whereas some people could get a bit confused. I kept my sense of enjoyment for acting and the feeling of play, when there was always a danger of feeling bogged down.

I wasn't quite so good at keeping my ego in check, and it took me a long time before I could tell the difference between acting as a way to try and impress, and acting as a way to serve something more important than yourself.

I worked quite hard, though it never really felt like work. I was completely obsessed with acting and theatre. It was all I ever really thought about or wanted to talk about, a 24-hour preoccupation. And, of course, a lot of that work was done in the pub...

Philip Voss, 1956-58

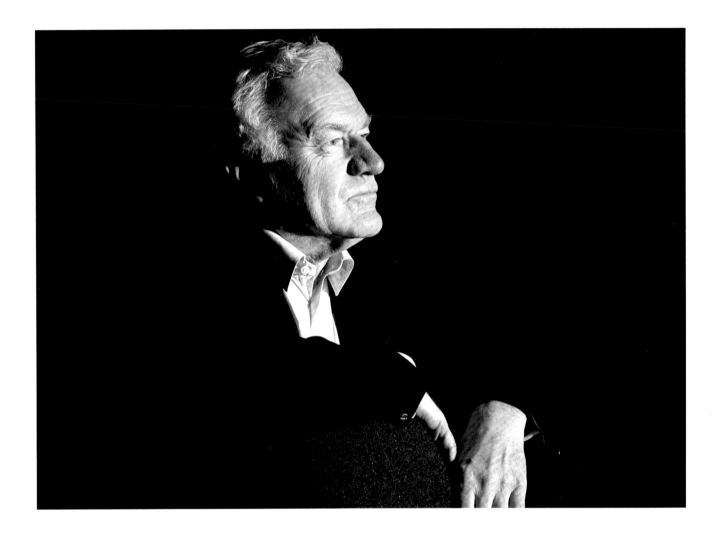

I remember sitting with other applicants in the RADA vestibule in a check sports jacket and flannels and tie. Jeans hadn't been introduced into the UK then. My Shakespeare was the Exeter speech from *Henry V*, Act IV Sc. VI – usually cut. I remember agonizing whether I should kneel or not. I think that movement of any kind was a problem for me.

The letter of acceptance was the fantastic winning of a parental battle, but the beginning of another hurdle. I needed money to attend and I didn't get a scholarship, so I had to obtain a grant from Nottinghamshire County Council. I went before a panel of five people and they all questioned me about the profession, and then I had to go into a room and write an essay on 'The Delights and Dangers of a Career on the Stage'. For the dangers I plunged into a lengthy discussion about the threat of homosexuality in the theatre. I was awarded the grant.

In my year were Hugh Whitemore, Ellen Sheean, Peter Laird, Piers Stephens, Peter Shoesmith, Maroussia Frank. I'm in touch with them

all still and we're friends, except for Piers who is long dead.

I was not a hard worker. I think I thought just getting to RADA was the achievement in itself. I did, however, with Piers Stephens, see every London first night during my stay at the Academy.

I was best at playing animals. Of my bear in André Obey's *Noah*, Winifred Oughton, the director, wrote in my end of term report that she never saw in Philip's eyes any more intelligence than she would expect from a bear.

Theatre
The Seagull (Shared Experience); *The Wandering Jew* (National); *King Lear* (Oxford Stage Company). For the RSC: *The Merchant of Venice*; *Twelfth Night*; *The Tempest*; *As You Like It*, dir. Peter Hall (Theatre Royal, Bath)

Film
Octopussy; *Four Weddings and a Funeral*

TV
Crossroads; *Elizabeth R*; *The Dwelling Place*; *A Royal Scandal*; *Fish*; *The Brides in the Bath*

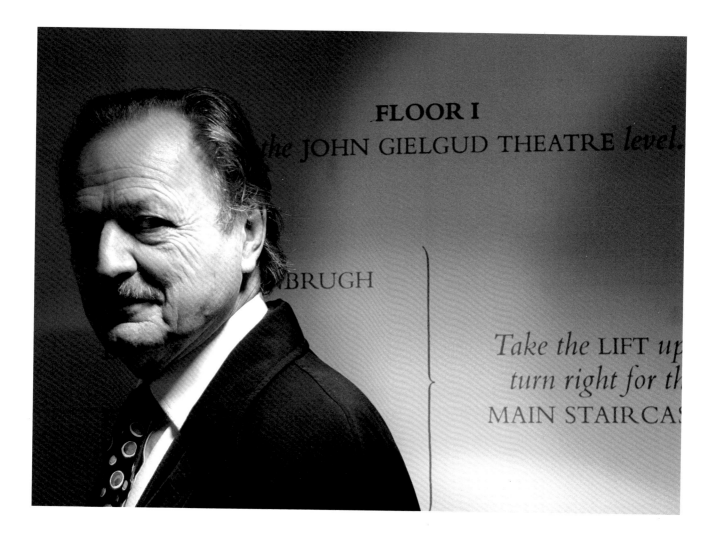

Peter had an enormous sense of fun while managing to look dignified whatever crazy ideas I threw at him. There was one RADA actor we didn't manage to photograph and I knew Peter was a friend. Since Peter had taken me out for a coffee, I thought I'd chance my arm and see if he could succeed where we'd failed. He quite rightly and very politely intimated that this might not be quite the proper thing.

In the middle of my RADA course, I left to join the army. But I failed the medical and came back. My parents could only afford to send me for one term. So I had to win the only RADA scholarship, and if I failed, leave. I got it – but it was reviewed every term, so I worked hard and played hard. I fell in love and washed dishes all night.

Other actors were Alan Bates (who I had met at elocution lessons before RADA), Richard Briers, Peter O'Toole, Tim Vernon, Albert Finney (who I shared a room with for a year), Brian Bedford, John Stride, Sian Phillips and Susannah York.

When I went, the intake was well over 100 students, who were whittled down to about 26 at the end of 2 years.

I won the Kendall Prize, as the most outstanding student of my year, but my agent said 'You won't really make it, until you are over forty'. He was right.

Theatre
The Entertainer, dir. Peter Hall (Old Vic); *School for Wives,* dir. Peter Hall (West End); *The Old Master,* dir. Harold Pinter (Birmingham Rep, West End); *Hedda Gabler,* dir. Frank McGuinness (West End)

Film
Blow Up; The Charge of the Light Brigade; Endless Night; Tumbled; Gangster No 1

TV
The Irish R.M.; To the Manor Born; Rumpole of the Bailey; Space 1999; The Avengers; The Prisoner; Perfect Scoundrels

Paul McGann, 1979-81

Paul and I met at the Alphabet Bar in Soho and had fun. It's as simple as that. He is a terrific person to photograph.

I did Clarence's speech from the tower in *Richard III*, really badly. This priest at my school had jimmy'd me on to apply, so he chose my pieces for me, and the only modern piece he had on his shelf was *My Fair Lady*. Not *Pygmalion*, but the film script. So I ended up playing the dad. I did the worst cockney accent they'd ever experienced at RADA, plus I kept forgetting it, and needing a prompt. It was really embarrassing!

After the embarrassment was over, I just thought 'sod this' and legged it, ran out of the building. This lad who had been helping with the auditions followed me into the street and shouted, 'Where are you going?' and I said, 'I'm going home, I've had enough. This is horrible!' And he said, 'Yes I know you were crap, but they've seen something!' So I went back in the afternoon and the principal was there and he told me I had to do it properly. I did it again for him and got in.

I was really in two minds. I didn't know if I wanted to be an actor or not. When you're a teenager you're always thinking 'I dunno'. It would be great to think that we all had this religious acting zeal, but we didn't.

I think I came from a real non-vintage term. The term below us were considered the best for years and years. That was the term with Ken Branagh and Fiona Shaw, people like that. The best actor that was there, the actor's actor, was Mark Rylance. A fantastic actor. Even then, everyone could see that he was the one. We'd all go and see him when he performed.

What I think RADA is good at is sending out level-headed actors. It's a really practical place. It tried to simulate real – albeit ideal – working conditions. They taught you how to speak, you could have a sing, and there was a piano in every room. I learned to play piano there. I could sing really well. I think I was a better singer than I ever was an actor.

I didn't work very hard. If it had been an academic course, I would have scraped a 2:2. There were one or two high-fliers, of course. I remember I used to stand at the bar with my fourth or fifth pint and stagger across the fire escape to see that there was still a light on in one of the rehearsal rooms: Ken Branagh or someone, working after hours.

At RADA they insisted that you learn to speak Standard English. I was terrible! I remember the voice coach saying, 'You are the only person to leave here with a stronger regional dialect than when you started.' I think I wore my scouser-hood as a kind of badge, fearing these jazz-handed Southerners were going to steal my soul. I couldn't be posh. I was the home-grown, grim-up-North type.

I fell madly in love with my Juliet when I was Romeo. And I was crap, because every time she'd come on stage I couldn't breathe. I couldn't speak the lines. The most insipid Romeo in RADA history.

I wanted to be in movies, that's all I ever wanted to do. Most of us became actors to be in the movies. The day I got in a movie, it was one of the happiest days of my life. It was *Withnail and I*. If I'd never done another picture I'd have died happy.

Theatre
The Genius (West End); *The Seagull* (Liverpool Playhouse); *Sabrina* (Bush); *The Little Black Book* (Riverside); *Mourning Becomes Electra* (National); *The Gigli Concert* (Finborough)

Film
Withnail and I; *The Empire of the Sun*; *The Rainbow*; *Dealers*; *Alien 3*; *The Three Musketeers*; *The Merchant of Venice*; *Queen of the Damned*; *Gypo*

TV
The Monocled Mutineer; *Drowning In The Shallow End*; *The Merchant of Venice*; *The One That Got Away*; *Our Mutual Friend*; the *Hornblower* series; *Blood Strangers*; *Lie With Me*; *Kidnapped*

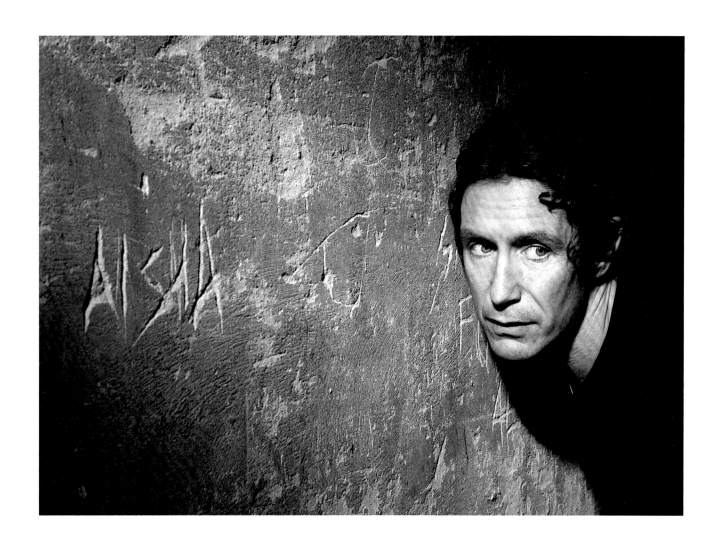

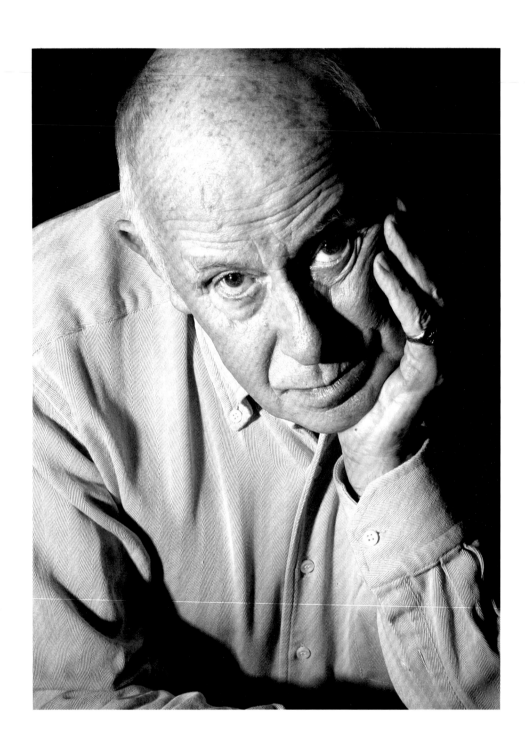

Richard Wilson, O.B.E., 1963-65

My modern audition piece was written by a friend of mine. People said to me, 'Oh, you mustn't do that. You have to do a proper modern play.' But doing this monologue they'd never heard of before worked to my advantage. They laughed! It took me by surprise, and caused much pleasure. I was told later that I'd been squeezed in by the skin of my teeth.

RADA was the only drama school that I tried for, because I was 27 and not many drama schools would take people over 25. I had been a voluntary medical technician, but I always wanted to be an actor. I had a girlfriend who was a doctor at the time, and we broke up. I just thought, 'Well, if I don't try it now, I'll never know.' So I tried. I was living and working at Paddington General Hospital.

I remember Peter Barkworth came back to RADA and that was great for me. He did improvisational stuff, and was someone that I could empathise with more than anyone before. I got on very well with Madame Fedro, the classical movement teacher. She was incredibly kind to me, because I was always doing comedy. She took me aside and told me I had other qualities that I should try and develop.

Comedy was my natural bent. I was very bad at singing. We had a singing test in our first term, where if you were good you got lessons. If you weren't, you didn't: I didn't. When it came to finals, we were doing *The Beggar's Opera* and the cast-list went up saying 'MacHeath: Richard Wilson'. I went straight to the bursar's office and said, 'Look. There's been some mistake.' She said 'No, no. That's correct.' I said, 'What about singing lessons?' and she said, 'I think you start tomorrow'.

I remember we had great games. We used to act a great deal outside the Academy, in fact. We'd assume characters in pubs, and try and stay in them. We also visited the theatre a lot. We went to the Marlborough, too. It was a very tough course though. Very hard work.

They try and teach you RP. I remember one of the voice teachers there, Barry Turner, saying to me, before a trip home to Scotland for New Year, 'You'll have to try and keep your vowels open, and try and keep your RP up while you're there.' I got to Victoria coach station and the bus driver said to me 'Is that yer case, Jimmy?', and I said, 'Aye'. I hadn't even left London and I'd reverted!

Theatre
Waiting For Godot (Royal Exchange Manchester); *What The Butler Saw* (National)

Film
A Passage to India; How To Get Ahead In Advertising; The Trouble With Mr Bean; Carry On Columbus; The Man Who Knew Too Little

TV
The Flight of the Heron; A Sharp Intake of Breath; Only When I Laugh; The Last Place on Earth; Tutti Frutti; The Four Minute Mile; One Foot In The Grave; Gulliver's Travels; Ted and Ralph; Brave New World; High Stakes; Dick Whittington; Jeffery Archer: The Truth; Born and Bred

Associate Director at The Royal Court Theatre

Director
For the Royal Court: *Under the Whaleback; A Day In Dull Armour/Grafitti; Where Do We Live; Nightingale and Chase; I Just Stopped By To See The Man; Mr Kolpert* – TMA Best Director Award; *Toast and Four; The Woman Before. Playing The Victim* (Royal Court, Traverse, tour); *The Lodger* (Hampstead, Royal Exchange Manchester); *Women Laughing* (Royal Exchange Manchester, Royal Court); *Imagine Drowning* (Hampstead) – John Whiting Award; *Primo* (Cottesloe)

Polly James, 1962-64

I met Polly's mother at the door, she is 91 and going strong. She later went out socialising, clutching a bottle of champagne. This must be where Polly gets her dynamism from. I loved Polly's description of how taxi drivers approach her in different ways as 'the bird off the Liver Birds' and how she can tell by their opening remarks what level of respect she will get. Her maternal grandfather was the trainer of Blackburn Rovers no less.

I did *The Entertainer* and *As you Like It* at my audition: both character pieces. I was never your typical lead. I went down to the audition with my drama group and they all got called back for the afternoon, and I went outside and waited on a wall for them. I just thought, 'Oh well, they've probably got in,' and came home and got a job in a convent. I then got a letter saying that I'd been awarded the Ivor Novello scholarship. It was a bit of a shock really!

In my year were Nicola Pagett; Terry Hands, I've worked a lot with Terry over the years; Mona Hammond, the Jamaican lady in *Desmond's*, I keep in touch with her; Ronald Pickup; Tom Courtenay was younger than me, but I'm in touch with him.

Terry Hands was never an actor. He was always more of a director. He always had that in him, keeping us up all night, going over our pieces. We were completely dedicated to changing theatre, and had complete tunnel vision. We thought of ourselves as 'artists'. In hindsight, we were a bit stupid, a bit pretentious really.

I won an awful lot of prizes – mind you, there were an awful lot of prizes to win! Everyone I meet, it seems, has one for something or other. I got the Bancroft award.

I was very good at comedy, but not at vocal work. I was continually pulled up on my accent. I was terribly good at movement. Marcel Marceau came to RADA and I was offered a place in his mime school and I didn't take it. It was one of those moments – there have only been two in my life – where I could have taken a completely different direction. It could've been a very different life.

If there's one thing I think we didn't learn, it was how to handle the career. How to handle money, for a start. I never ever had any idea what to do. They thought we'd all go out and that our careers would develop very gradually, but, in my case, it didn't. My first job was *Half A Sixpence* in New York, an amazing start. Lots of people got into terrible trouble when they earnt a lot of money very quickly. I had absolutely no idea what the world was about at all.

It's not so much the parts I've played. I can't remember, unless I physically haven't been able to do it, ever turning down work. I'll do anything. I'm not really interested if it's a million dollar job.

Theatre
Half A Sixpence (Broadway); *Anne of Green Gables* (New Theatre); *I And Albert* (Piccadilly); *Saratoga* (Aldwych)

TV
Send Foster; The Liver Birds; Private Lives; East Lynne; A Divorce; Our Mutual Friend; Baal; The Worst Witch

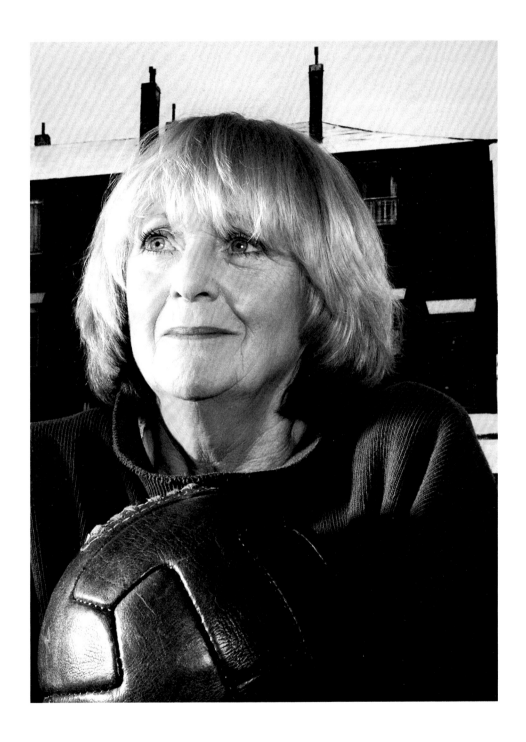

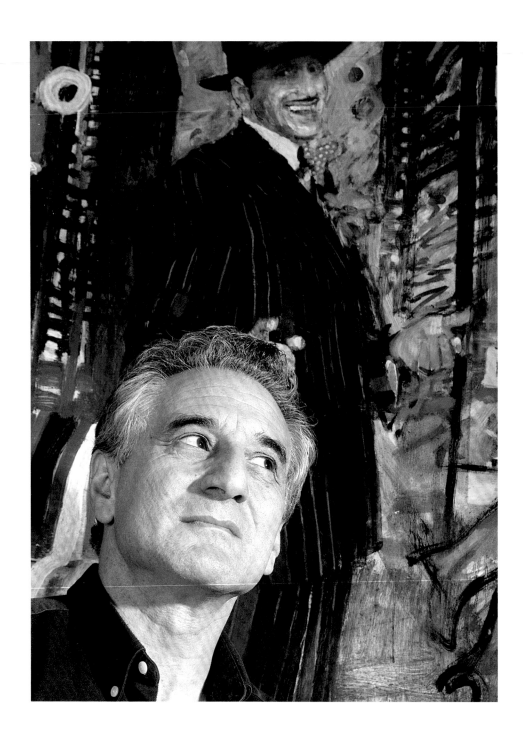

I was feeling so good about how this session was going when I discovered my camera was faulty – I now know what a cold sweat feels like. We shot another mini session in the garden just in case. Then I drove Henry into the West End, as he was late for a meeting about a film in LA. Need I say it… appalling traffic. Henry had to get out at Vauxhall and run for the tube. That was the last I saw of him. I hope he got the movie… The portrait of him as a gangster in the background was painted by Jim Russell.

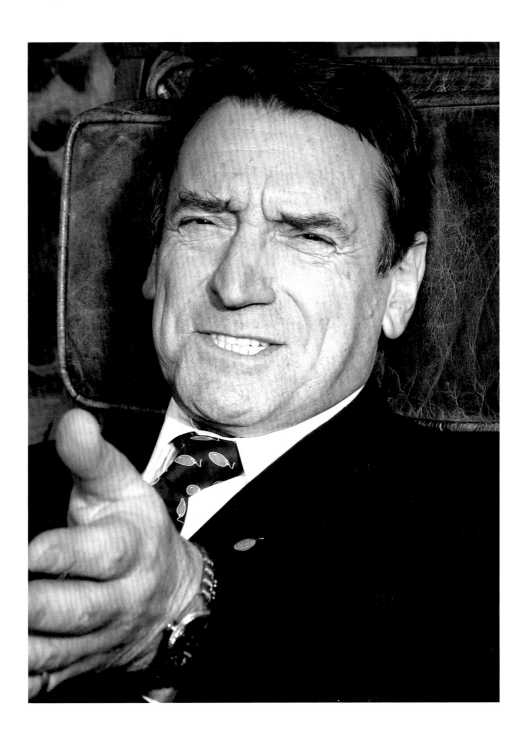

*This portrait was taken at my wife's mother's house. I later sent Stephen
my choice of shot, which he expressed surprise at. He'll be surprised yet again
when he sees this, as I changed my selection for reasons known only to me.*

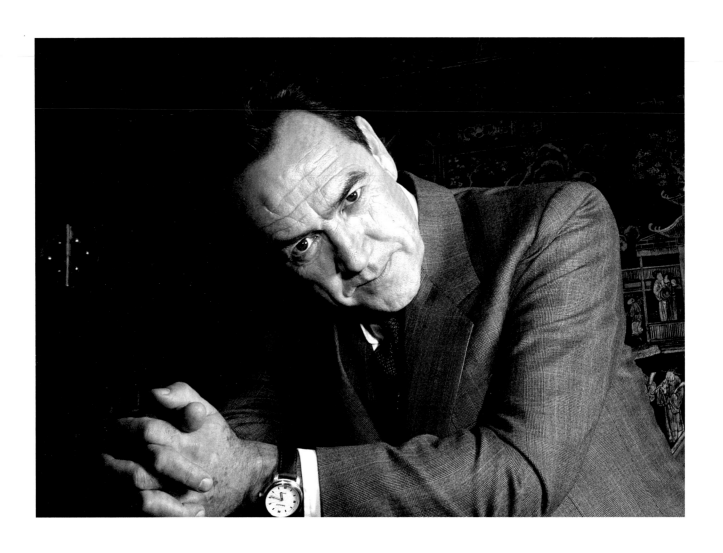

I tracked Robert down to a set in darkest Uxbridge where he was filming in full 1950s costume. We were in an old Manor House down a muddy and isolated track. He came straight off set and into a room where I had set up using old props and furniture. He asked where the pictures might hang and when I told him the likely gallery venues he straightened his hair, his tie and his stance – but with immaculate comic timing.

I knew I'd done well at the audition because I got into a dialogue with the lady who turned out to be my personal tutor. I knew, by the way she was reacting to my speech, that I'd got at least one person on my side.

I remember getting the letter, jumping in the air, running off to find my dad who was working for the local school as a carpenter. I was shouting to the neighbours all the way, 'I've got in! I've got in!'. I went for my first pint that night with my dad. I was under age.

I got mugged on my first day in London. I stayed with an aunt in Edmonton and I had a huge suitcase that was my dad's. It was massive, far too big for what I needed. I remember lugging it out of Manor House tube station. I knew I had to catch a bus. There was a gang of guys who got my suitcase and threw it in the middle of the road and I got roughed up. I was from the North, so I knew how to take care of myself. I'd been on a council estate all my life. It was a bit of a baptism of fire though.

My first day at RADA, I got off the bus from Edmonton and a Rolls Royce pulled up and this staggering girl got out. She was being dropped off. She was South African and was a daughter of an hotelier. She was very wealthy. By that point RADA was a real mix though, of working class and richer kids.

I really loved the idea of being there. I loved anything to do with movement and mime. I was very good at mime. Ben Bennison was teaching there, but he's subsequently retired. I've still used him on a couple of things I've worked on. In fact, I did a commercial with Beatrice Dahl, many years ago, where me and Ben both star as mime artists in Covent Garden. It was the ultimate irony. I was employing my old teacher from RADA.

At the end of term plays, I did very well actually, but at that point I was Mr Confidence. I had my own flat in London and had got myself together. I was loving it.

It was the late 1960s, the time of the Beatles and flower power. There were parties every weekend. There was also a lot of marijuana around. I don't think there was anyone in London who wasn't doing it. It was the cool thing to be doing it. You didn't go and listen to *Sergeant Pepper* at a party on a Saturday night and not.

For me it was like a real growing up period. I dealt with all those things that you do when you're that age. The thing I remember vividly was the complete lack of money. I lived on five pounds a week. I used to run out by Friday afternoon.

We used to be in an improvisation group called 'Theatre Machine'. There was a sequence we always did with a park bench, where you did a scene with an improvised former student character. It went something like, 'What are you doing now?' and then the reply would be 'Oh I gave it up years ago. Now I run a cemetery,' and so on. All those improvisations have come true. All my former colleagues I've run into, with the exception of three, have stopped working.

Theatre
For The Royal Exchange, Manchester: *Leaping Ginger*; *The Three Musketeers*; *Beaux Stratagem*; *Philocetes*. *Trelawny of the Wells* (Old Vic); *Me and My Girl* (Palladium, Broadway) – Olivier Award and Tony Award for Best Actor in a Musical; *Becket* (Haymarket) – Variety Club Best Actor Award; *Cyrano de Bergerac* (Theatre Royal, Haymarket); *Richard III* (Savoy)

Film
Bert Rigby; *You're A Fool*; *Strike It Rich*; *Goodbye My Love*; *Fierce Creatures*; *Divorcing Jack*; *Wimbledon*

TV
Citizen Smith; *Twelfth Night*; *All's Well That Ends Well*; *Seconds Out*; *A Midsummer Night's Dream*; *Cymbeline*; *King Lear*; *Much Ado About Nothing*; *Nightingales*; *Jakes' Progress*; *GBH*; the *Hornblower* series; *Oliver Twist*; *My Family*; *Jericho*

Richard Briers, C.B.E., 1954-56

*The scupture of the actor in front of the actor is the actor's actor
that this actor most admires. I wish I could remember who it was.*

In those days you didn't have 1200 people coming in for 14 places
like they do today. They had about 200 to 300 applicants. Kenneth
Barnes was the principal. He said, 'Well, boy, you haven't got
enough points to make a scholarship'. I got 62%, which was about
the pass mark. He said, 'Your family are not well off', and I said,
'No, Sir', and he said 'Try again for the Middlesex County Council
and if you pass that, you'll get a grant'. They gave me my fees,
my fares, and about £8 a week allowance. Sensational!

In my year there was Albert Finney, who I'm a friend of still.
Wonderful man. O'Toole, Peter Bowles and I are still great mates.
Tom Courtenay, who I love.

I lived at home. The people who had the fun were people with
digs in London. Bates, Finney, O'Toole, all had accommodation
in London. In a way it stopped any weaknesses, because I was
working like hell. I was reborn at RADA. It was my entire life.

I had a gift for comedy timing, which stood me in good stead.
I was so nervous, and spoke so fast though, that no one could
understand a bloody word I said! I needed a drama course and
school, to help me control my speech and the speed of it, to try
and control my nerves because I was desperate to get on. People
like Finney and O'Toole did not need drama school because they
were born naturals. I was never a born natural. I had to learn to
be natural.

Kenneth Barnes left, and we got John Fernald. He took a great
shine to me, which was just wonderful. He liked Albert (Finney)
as well. He gave us the same parts, in fact, though we were so
different, as you can imagine. He's from Salford, I'm from
Wimbledon. I was as thin as a rake, he was stocky. He was very
male and I was sort of dreamy. We couldn't have been more
different physically and mentally. We used to alternate the same
parts.

I wasn't very debauched, because of getting home. My mother
and father would have said, 'What are you doing?'. I wasn't really
interested either. I mean, I fell in love unsuccessfully of course:
I was a human being! I wasn't in the piss-artist's section, not
because I was good but because I had to get home. Most actors
after a long day went straight to the pub, but I had to go straight
to the station!

My mother always spoke southern English, and so I always was
able to say A.E.I.O.U., which very few people can. I know it's
unfashionable now to speak BBC and RADA English, but in fact
I'm very proud of it. I get really picky now I'm an old man, about
diction.

It's a very narrow profession and you can get very self-obsessed.
It's vital that you don't take yourself too seriously. A great friend
of mine said to me 'You must remember, it's only play acting. If
you get big-headed, I'll kill you'. And that's become my motto.

Theatre
Relatively Speaking; Bedroom Farce (Aldwych); *The Tempest; A Christmas
Carol,* dir. Neil Barlett (Lyric Hammersmith); *A Midsummer Night's Dream,* dir.
Kenneth Branagh (world tour); *Twelfth Night,* dir. Kenneth Branagh; *King
Lear,* dir. Kenneth Branagh; *Absent Friends* (West End); *The Chairs,* dir. Simon
McBurney (Royal Court, Broadway)

Film
*The Amazing Adventures of Mr Bean; Henry V; Peter's Friends; Much Ado
About Nothing; Frankenstein; In The Bleak Midwinter; Hamlet; Spice World;
Love's Labours Lost; Unconditional Love; Peter Pan*

TV
*Marriage Lines; Hay Fever; The Old Campaigner; Birds on a Wing; Roobarb
and Custard; The Good Life; Noah and Nelly; Goodbye Mr Kent; Twelfth
Night; The Adventures of Mole; Monarch of the Glen; Victoria and Albert;
Dad*

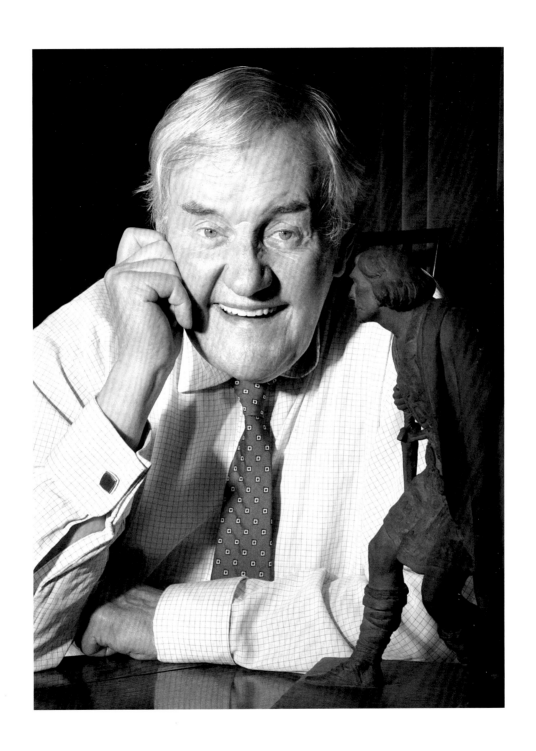

Ronald Pickup, 1962-64

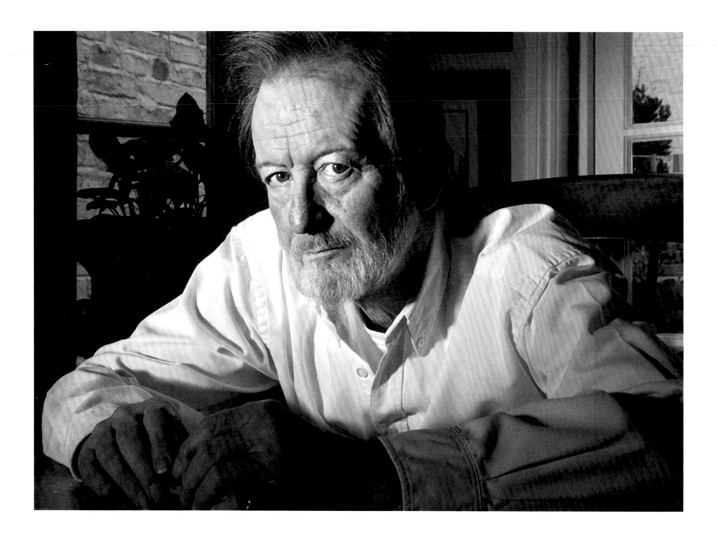

The Pickup family is one of several acting dynasties with more than one generation who have attended RADA. The beautiful, Rachel Pickup being the latest addition.

For my audition, I did a speech from *Hamlet*, in a T-shirt, jeans and jacket.

I got my letter of acceptance when I was at Leeds University – I felt complete joy.

In my year were Anthony Hopkins and my wife.

I was awful at singing. Worked hard and played hard.

Theatre
Oedipus (National); *As You Like It* (National); *Amy's View* (West End, Broadway)

Film
The Day of the Jackal; Mahler; Forbidden Passion: Oscar Wilde; The Thirty Nine Steps; Never Say Never Again; The Mission; The Fourth Protocol; Bring Me The Head of Mavis Davis; Lolita; Secret Passage

TV
Much Ado About Nothing; Romeo and Juliet; The Tempest; St Joan; Three Sisters; Long Day's Journey Into Night; The Fight Against Slavery; King Lear; Tropic; Ivanhoe; The Letter; Verdi; Fortunes of War; The Rivals; The Hound of the Baskervilles; Danny: The Champion of the World; Jekyll and Hyde; Absolute Hell; A Time To Dance; Ivanhoe; Hornblower; Cambridge Spies; Cherished

Brian Murphy, 1954-55

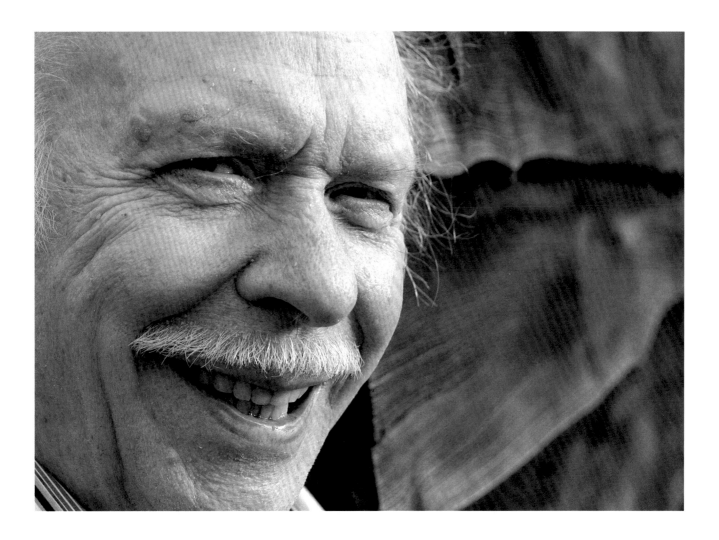

Brian has one room in his house which is just a cinema – it has gone through film, video and DVDs and he now has all the old movies on DVD – a great place, in which we did most of the session.

When I was accepted into RADA, I was on leave from national service, staying in a hostel in Waterloo Road. For my audition, I played Quince from *Midsummer Night's Dream*, and did a Hamlet soliloquy.

Edward Hardwicke and Richard Briers were both there at the same time as me. I was best at comedy. I had trouble overcoming the regional Hampshire accent, which was not then suitable for serious dramatic roles!

I walked to RADA from my digs in Holland Park to save on fares. In 1954, I did receive a grant. Very few were available then.

Theatre
Sweeney Todd; Oh! What A Lovely War; Arthur Lucan in *On Your Way, Riley* and *The Life of Riley: The Musical*

TV
Man About the House; George and Mildred; Last of the Summer Wine

Rosemary Harris, 1951-52

We had limited time to shoot Rosemary's portrait as we had to move her husband out, and stop him writing for the duration. Throwing a writer out into the street can only last so long.

In October 1950, I'd been playing The Player Queen in a production of *Hamlet* at the Margate Hippodrome. A splendid young actor called Peter Fawcett was The Player King. Peter had just left RADA with the Bancroft Gold medal, and he suggested I should try and get into RADA and kindly spoke with Sir Kenneth on my behalf. On November 13th I received a letter from Mary Pilgrim, Sir Kenneth's secretary, to say that Sir Kenneth could see me on Wednesday November 22nd at 12.30 prompt!

I remember the audition well. It was in Sir Kenneth's tiny office. I was very nervous as we were almost face-to-face, but he tactfully turned his chair around to face Gower St, and I was able to perform my two audition pieces, (Leonora Fiske from *Ladies in Retirement* and The Girl in *The Girl Who Couldn't Quite*) to his back!

I was accepted for the spring term of 1951, but, unfortunately I had to leave at the end of the term, as my funds had run out. I applied to the West Sussex Council for a scholarship, which I received. So I was back again, on October 3rd, but with a different group this time. I think, they thought I'd dropped from the sky. This group included Michael Blakemore, David Conville, Diane Cilento, Sheila Hancock, and Josephine Tewson.

I worked very hard. The first term I was living with my grandmother and great aunt near Bognor Regis, so I had two one hour forty minutes train journeys every day to practice my voice exercises. The next two terms I was invited to share a flat in Ebury St with a wonderful girl from Philadelphia called Amanda Steel, and we mostly saw our friends at home. Amanda was killed in a car crash a few years later in New York City, and a RADA scholarship was set up in her name for many years.

I don't think there is, or was a RADA style, but I will always be grateful, especially, to one of the teachers. Miss Mary Duff – she wasn't everyone's favourite, but she taught me so much and went on teaching me, as I worked with her through the years, whenever geography permitted.

I loved being at RADA. My sister, Pamela Harris, was there in 1939 but War started and she was called up the next day, so wasn't able to finish. Several actors in her class were killed. So sad. A whole generation swept away.

Ralph Fiennes is my favourite RADA actor that I've worked with. Peter O'Toole as well. (We were Hamlet and Ophelia at the opening of the National Theatre in 1964.) I have also had the great good fortune to be directed, twice, by Michael Blakemore: in *All My Sons in England*, and *Tales from the Hollywood Hills*, the USA TV show.

Theatre

Elizabeth Proctor in British première of *The Crucible* (Bristol Old Vic); *Peter Pan*; *Desdemona and Cressida* (London Old Vic); Zelda Fitzgerald in *The Disenchanted* (Broadway); *You Can't Take it With You* (Broadway); *School for Scandal* (Broadway); *The Wild Duck* (Broadway); *Man and Superman* (Broadway); Natasha in *War and Peace* (Broadway); Eleanor in *The Lion in Winter* (Broadway) – Tony Award; *Plaza Suite* (West End); *Old Times* (Broadway); Blanche in *A Streetcar Named Desire* (Broadway); *The Royal Family* (Broadway); *All My Sons* (West End); *Heartbreak House* (West End); *Heartbreak House* (Broadway); *Pack of Lies* (Broadway); *Hay Fever* (Broadway); *The Petition* (National Theatre and West End); *The Best of Friends* (West End); M`lyn in *The Steel Magnolias* (West End); *Lost in Yonkers* (Broadway and West End); *An Inspector Calls* (Broadway); Hecuba in *The Women of Troy* (National Theatre); *A Delicate Balance* (Broadway); *Waiting in the Wings* (Broadway); *All Over* (off Broadway)

Film

Beau Brummel; *A Flea In Her Ear*; *The Boys From Brazil*; *The Ploughman's Lunch*; *Crossing Delancey*; *Tom and Viv*; *Hamlet*; *The Gift*; *Sunshine*; *Blow Dry*; *Spiderman*; *Spiderman 2*; *Being Julia*

TV

Othello; *Twelfth Night*; *Blithe Spirit*; *The Royal Family*; *Holocaust*; *The Chisholms*; *To The Lighthouse*; *Heartbreak House*; *Tales From The Hollywood Hills*; *The Camomile Lawn*; *Death of a Salesman*; *The Little Riders*

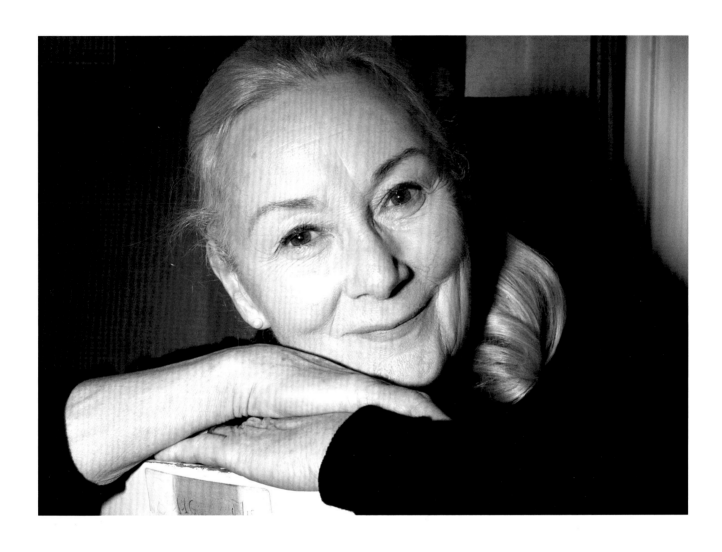

Sir Ian Holm, 1949-53

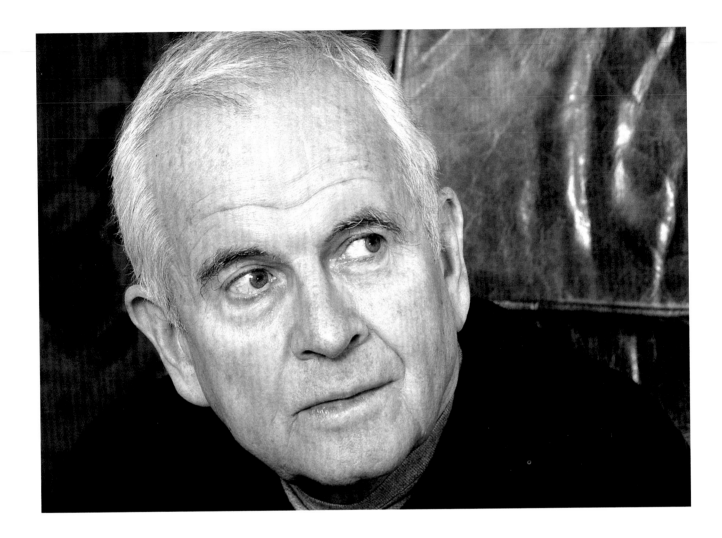

Sir Ian was one of the subjects we had found hardest to contact and every time I was in the UK, he was filming on some distant continent. For some reason I'd expected him to be slightly diffident. I could not have been more wrong. He came to my mother-in-law's house in Chelsea and was relaxed, informative and entertaining in equal measure.

Though it says I spent four years at RADA, in fact it was two, interspersed with National Service in the USA.

For my audition, I read from *A Jewish Easter* – a play by Israel Zangwele.

I worked hard, but no-one could make me any good at fencing.

Theatre
For the RSC: *King Lear; Richard III; Henry V; The Home Coming; Lenny*, dir. Peter Hall; *Max*, dir. Robin Lefevre; *The Iceman Cometh*

Film
A Midsummer Night's Dream; Frankenstein; Oh! What A Lovely War; Nicholas and Alexandra; Mary Queen of Scots; Young Winston; All Quiet On The Western Front; Alien; Chariots of Fire; Henry V; Naked Lunch; The Madness of King George; The Fifth Element; eXistenZ; Big Night; The Sweet Hereafter; Lord of the Rings (Fellowship of the Ring, Return of the King); Garden State; The Aviator

TV
The Body Snatcher; The Borrowers

Fenella Woolgar, 1996-99

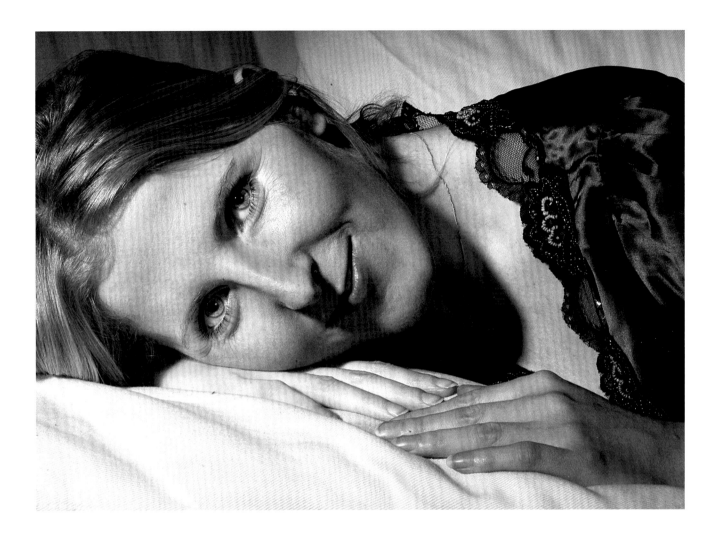

I think Fenella must have tired eventually of my requests for her to angle her head one way or the other. This portrait may have been her resting between takes.

I'd had 'go to RADA' as part of a slightly embarrassing life plan I wrote in my diary when I was 13. So when I got a phone call from Nick Barter, I cried. I'd auditioned in secret and hadn't told my boyfriend, best friend, family or anything and suddenly the enormity of what I'd done hit me.

For my audition, I did Margaret from *Henry VI, part II* and a piece I wrote. I said an Irish cousin had written it. Nick Barter asked about it, either because he was astonished by how bad it was or liked it – I still don't know, but I felt too shy to be judged as a writer and an actor at the same time.

In my year was Eve Best who I see occasionally. I'm very good friends with Nia Gwynne, Patrick Moy and several from other years – Sally Hawkins, Tobias Menzies and Michael Sheen. I think I

worked very, very hard, but by god we partied on Friday night. Partying that had a demented energy to it.

Sometimes I look back and can't believe how brave we were at RADA – the constant physical and emotional challenges. I loved it, was totally stimulated and stretched. I buddy people in their final year at RADA now, which I love. It's a good reminder for us who are several years into the profession of the level of commitment, energy and attention to detail that you have at drama school. It always re-inspires and reminds me why I'm in this game.

Theatre
Adela Quested in *Passage To India* (with Shared Experience)

Film
Agatha in *Bright Young Things*

TV
Arabella in *He Knew He Was Right*

Sheila Hancock, 1950-52

I have always been a Sheila Hancock fan. Now I am a huge Sheila Hancock fan.

I did *A Midsummer Night's Dream* for my audition, playing both Titania and Bottom. I sprawled on the floor for Titania and stood up for Bottom, doing two different voices. It was appalling. I didn't know anything about anything. I was a working class girl.

I didn't enjoy RADA. In my day, it was run by Sir Kenneth Barnes who, by then, was old and tired. It was like a finishing school, because it was mainly fee-paying. I was one of the scholarship girls – a few ex-servicemen were on grants, but other than that, there were just very rich girls. The few of us who had managed to get scholarships were fish out of water. We were all taught RP. In retrospect, the training was not very good.

In those days, you could get a prize for anything, including Grace and Charm, which you got for merely walking across the stage. I am one of the few students from that time that left without getting a single award. Quite an achievement, really.

We were a very unillustrious year. The girls did rather better than the boys. Zena Walker was in my class – she's dead now. She went straight to play Juliet at the RSC. Shani Wallis was one of the most talented. Joan Collins and Diane Cilento were the year ahead of me, both very beautiful. Dick Vosbrugh became a writer, Peter Yates, a film director and Colin Graham, an opera director.

There was a gang of working class people who hung together. I was very fond of a gay guy called Tony Beckley, who also, sadly, is dead. He was ex-navy who sent the place up something rotten. I think we sort of ganged up against it, and that's how we survived.

I was worst at elocution. I was the despair of all the voice coaches. I couldn't understand it. I remember all the girls in the class shrieking with laughter at me. But my accent eventually became posh!

I worked my arse off and didn't have a single penny to my name. Any spare time, I worked in Woolworth's, the Savoy kitchen and did cabaret at night – not much of the high life about it. The most glamorous it got was Olivelli's or the Tottenham Court Road Lyons Corner House. A pot of tea and a bowl of sugar between us, and three hours eating the bowl of sugar and listening to the organ.

You're only as good as the part you get. I suppose my biggest achievement is that I've kept working since I left RADA. Rather than any particular role, just take the fact that I'm still here.

I learnt to hold my head up when I felt inferior. I'm not awestruck by anyone now. Some of the posh girls turned out to be very kind to me. I remember there was one really lovely girl called Eve Shand Kydd. I was an awfully unattractive, spotty creature and she organised getting me some cosmetics, and taught me how to clean my face without using cheap soap. She was deeply kind. That was an enormous lesson: not to do with RADA necessarily, but class. RADA bought me in contact with these people. I learned not to be scared of them.

Theatre
Under the Blue Sky, dir. Rufus Norris (Royal Court); *In Extremes*, dir. Trevor Nunn (Royal National Theatre); *Vassa*, dir. Howard Davies (Albery Theatre); *Then Again*, dir. Neil Bartlett (Lyric Hammersmith); *Harry and Me*, dir. James MacDonald (Royal Court); *Prin*, dir. Richard Wilson (Lyric Hammersmith & West End); *Bed Before Yesterday*, dir. Lindsay Anderson (Lyric); *The Cherry Orchard*, dir. Mike Alfreds (National & tour); *The Duchess of Malfi*, dir. Philip Prowse (National); *The Winter's Tale*, dir. Ronald Eyre (RSC); *Titus Andronicus*, dir. John Barton (RSC); *Peter Pan*, dir. Trevor Nunn (RSC); *Entertaining Mr. Sloane* (New York, Alan Schneider); *Sweeney Todd*, dir. Hal Prince (Drury Lane); *Annie*, dir. Martin Charnin (Victoria Palace)

Film
Yes, dir. Sally Potter; *Love and Death on Long Island*, dir. Richard Kwietniowski; *Three Men and a Little Lady*, dir. Emelio Ardalino; *Making Waves*; *Buster*, dir. David Green; *The Anniversary*, dir. Roy Baker Ward

TV
The Rag Trade; *The Bed-Sit Girl*; *Simply Sheila*; *Scoop*; *But Seriously*; *It's Sheila Hancock*; *The Rivals*; *Bait*; *'The Happiness Patrol'*, *Dr.Who*; *Buccaneers*; *My Kingdom For A Horse*; *Brighton Belles*; *Alice In Wonderland*; *Kavangh QC*; *Royal Enclosure*, (actor and writer); *The Thing About Vince*; *The Russian Bride*; *Bedtime*; *Featherboy*; *Fortysomething*; *Bleak House*; *Eastenders*; *Grumpy Old Women*

Director
The Constant Wife; *Dandy Dick*; *In Praise of Love*; *The Soldier's Fortune*. For Cambridge Theatre Company: *A Midsummer Night's Dream*. Artistic Director of RSC Tour; *The Critic*, (Olivier Theatre, RNT)

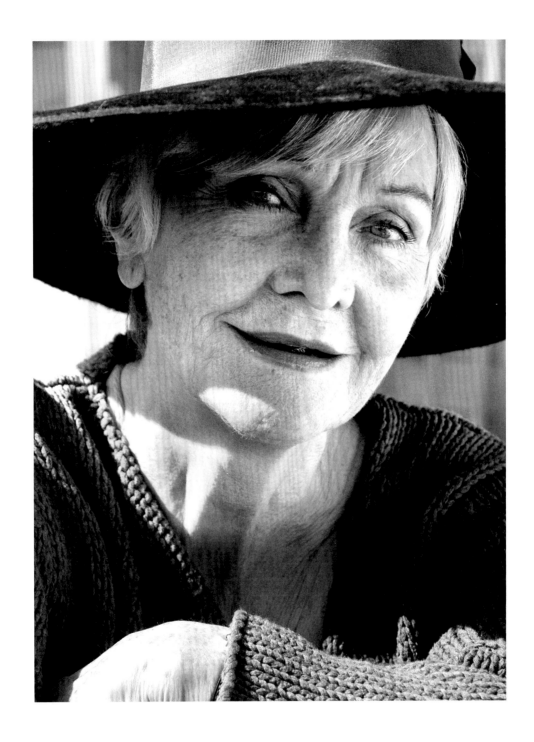

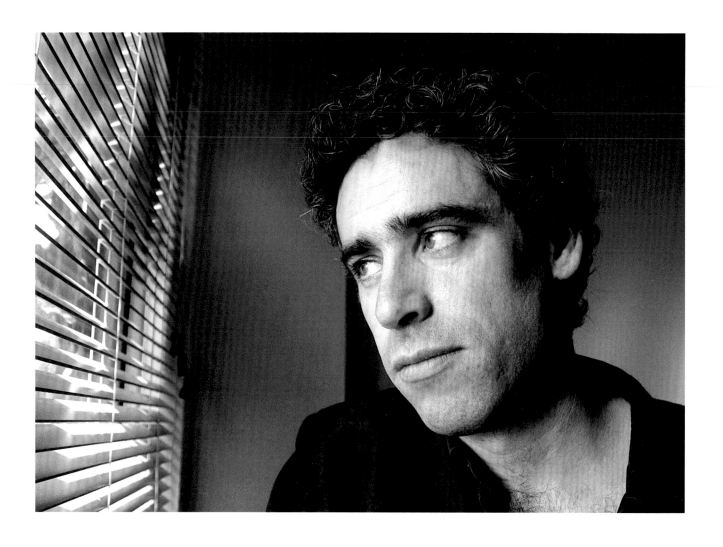

Stephen Mangan, 1991-94

Theatre
The People are Friendly and *Noises Off,* (Royal Court Theatre); *Midsummer Night's Dream* and *School for Scandal* (RSC)

Film
Birthday Girl, dir. Jez Butterworth; *Billy Elliot,* dir. Stephen Daldry,

TV
Green Wing; Adrian Mole: The Cappuccino Years; Sword of Honour; The Armando Iannucci Show; Big Bad World; Party Political Broadcast

We tried many locations for Stephen's portrait. In the end, him staring out the window of his flat works for me.

As a child I didn't know any actors, and I didn't dare think that I could become one. It was something that other people did, like being an astronaut. It just didn't happen to people like me.

I remember very little about my auditions: there were three, and the last one lasted a whole day. My mother had been ill from the end of October 1990, and I'd spent the whole winter looking after her. She died about eight or nine days before that final audition, so I'd just been to the wake and the funeral. I was glad to get out of the house and have something to do, but it all seemed a bit trivial compared with what I'd just been through.

I do remember I'd spent months preparing this speech, and Jonathan Slinger had prepared the exact same one. Only one of us could do it for the big finale at the end of the day, so I said he could do it.

When I got the letter, I felt a massive feeling of relief that I could look forward to something. That I could do something with my life. Things seemed to have ground to a halt for me. I'd been to Cambridge, and got a law degree, but there was no way I was going to be a lawyer, and I'd had this year of going back and forth to hospital. I remember thinking that the rest of my life could begin now.

In my year were Andrew Lincoln, Sean Parks, Sasha Hales, Jonathan Slinger and I'm great friends with all of them. We were pretty close-knit, especially the blokes.

I was terrible at anything to do with chiffon scarves and pretending to be pixies. We did seem to spend an awful lot of time in grottoes.

We also did quite a lot of stuff pretending to be animals, being an iguana or a mole. I was disappointed, because I read somewhere that Marlon Brando was brilliant at doing animals when he was in drama school. I thought this was a sign I was going to be rubbish. I just couldn't be a convincing dung beetle.

I was actually spectacularly talented at Elizabethan dance, for some reason. I used to enjoy that. And I enjoyed poetry. I will always be grateful to RADA because we did a lot of it, and I hadn't really read much before.

I was a hard worker but I definitely enjoyed London. There was a big difference in my year between those who went straight from school, and those who'd done something else before. If you're 18 and it's your first time away from home, you have a very different attitude. Still, I found it difficult that at drama school you had to be there for every class, and be in at 9am. They were probably right, though.

Rosemary Leach, 1953-55

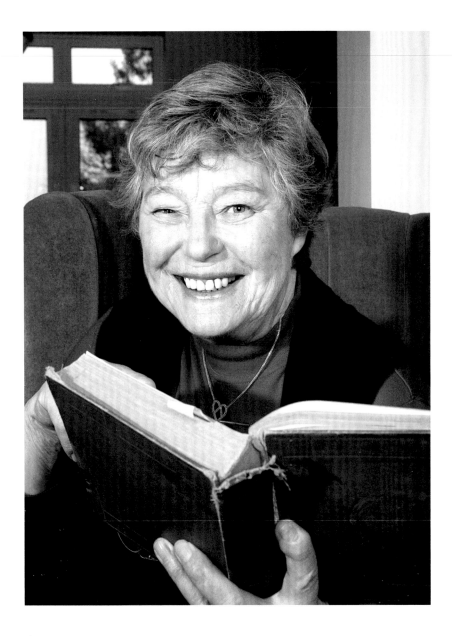

Rosemary confirmed a long-held view of mine that actors often relish acting on the stage because once the director has got them to opening night, with rare exceptions, they are left to get on with it. Relating to the audience and the other actors as they see fit, without the intrusion of directors, cameras or anything else. In the portrait session we used the original Shakespeare book Rosemary had used at RADA.

I did Phoebe in *As You Like It* for my audition. I was told immediately I'd got in, because I needed to apply for a grant from Shropshire County Council. My sister and I went to Lyons Corner House in Tottenham Court Road to have a knickerbocker glory as a celebration.

In my year were John Stride, Gary Raymond, Claudine Morgan, Pat Shaw, Alan Bates, Brian Pringle, Frank Finlay, Albert Finney, Roy Kinnear, and Margot Jenkins.

I was told I had a 'pretty little pink voice', and that it was a shame I had stayed in Shropshire.

I also was told I had a good temperament for the theatre, because I was resilient.

I worked hard. I went to the cinema once or twice a week.

Theatre
Hamlet; *Charing Cross Road*; Mrs Bell in *Separate Tables*; Adelaide in *Guys and Dolls*

Film
Face of a Stranger; *Ghost in the Noonday Sun*; *Cider With Rosie*; *That'll Be The Day*; *A Room With A View*; *The Mystery of Edwin Drood*; *The Hawk*; *Whatever Happened To Harold Smith?*; *Breathtaking*

TV
The Power Game; *A Breach In The Wall*; *Birthday*; *Germinal*; *The Wild Duck*; *Bermondsey*; *The Adventures of Don Quixote*; *Tiptoe Through the Tulips*; *Life Begins At Forty*; *Disraeli*; *All's Well That Ends Well*; *Othello*; *The Jewel In The Crown*; *Swallows and Amazons*; *When We Are Married*; *The Charmer*; *The Winslow Boy*; *An Ungentlemanly Act*; *The Tomorrow People*; *Stick With Me Kid*; *The Buccaneers*; *Berkeley Square*; *Tilly Trotter*; *Perfect*; *Prince William*; *Odd Socks*

I arrived at the exquisite Manor House, where Sarah lives, to find no-one in, and no sign of life. I parked my gear at her door and wandered around the garden wall looking for reception on my mobile. I'd left one message when a figure appeared in the distance tethered to several dogs. I wasn't sure who was leading who but they were definitely heading in my direction. It was worth the wait.

I did Rosalind and *The Ideal Husband*. I asked for five chairs. Only two were on stage. There was a great kafuffle while they found three more – but I never used them. So I got remembered as the beatnik in the mini skirt, who wore long wooden beads, purple rouge and yellow lips and who demanded all those extra chairs she never used!

I was at home with my parents in the country when I got the letter. My mother wanted me to go there – she even lied about my age! I had been expelled from four schools, Roedean and Crofton Grange School for young ladies among them, so Mother was tearing her hair out with worry. I had never taken an exam in my entire life. I wanted to be a show jumper or a tennis champion, so I didn't really want to go.

Eddie Fox was a year ahead and we are still friends. Tracy Reed also. But in my class: Tom Courtenay, Jennifer Hilary and John Thaw. An inseparable gang we were.

I was best at acting and fencing, worst at theory. So frustrated was I, that I lost interest and rarely turned up. I didn't want to talk about acting, I wanted to act! John Fernald, the Principle, expelled me, but my mother went down on her knees to him and I got re-instated. Whereupon, I was given the starry role of the step-daughter in Pirandello's *Six Characters in Search of an Author* at the Vanbrugh Theatre. Sir John Gielgud happened to be out front and I went straight into the West End, in a new play directed by him.

I was and am a perfectionist. When I work, I work. Hard and long hours. But I always have been a sucker for adventures. Always more keen on life than a career.

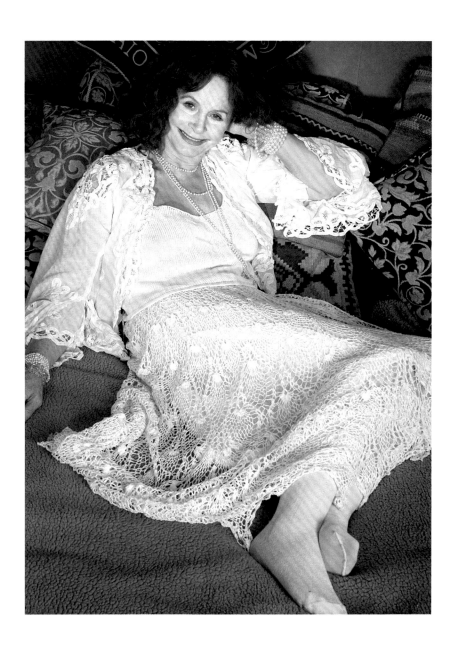

Theatre
Dazzling Prospect (West End); *The Servant* (West End). For the National Theatre Company: *The Recruiting Officer; The Crucible. Vivat! Vivat! Regina* (Chichester Festival, West End); *Sarah Miles Is Me* (San Francisco American Conservatory); *The Widow Smiles* (Brighton, Islington King's Head)

Film
Term of Trial; The Servant; Those Magnificent Men In Their Flying Machines; Blow Up; Ryan's Daughter; Lady Caroline Lamb; The Hireling; The Sailor Who Fell From Grace With The Sea; Priest of Love; The Big Sleep; Ordeal By Innocence; Steaming; Harem; White Mischief; Hope and Glory; The Accidental Detective

TV
Great Expectations; Dynasty; Walter and June; A Ghost in Monte Carlo; Dandelion Dead; Poirot: The Hollow

Sir Roger Moore, 1944

*Roger invited me to take the portrait at his home in Monaco.
I had got confused and thought it was Morocco, which though
appealing, didn't seem very practical at the time. I caught up with
him in a hotel in London, where he was staying in his role as
ambassador for UNICEF. He regaled me with stories that I can't
even repeat to my wife, let alone here.*

I only went to RADA for one term: for my audition, I recited *Silver Box*, and Tennyson's *The Revenge*. The only things I ever bothered to learn. It had been a Bank Holiday the day before and I'd had a drink or two…

There were more girls than boys I remember: Lois Hooker, who became Maxwell and my Miss Moneypenny – we were, and are, great friends and share a similar sense of humour. Also, Yootha Needham, who became Joyce, Ann Rawsthorne, with whom I correspond, John Whittaker, who I saw just recently at Lewis Gilbert's Academy Tribute, John Scott.

I couldn't afford to take advantage of the delights, though I do remember we would sometimes treat ourselves in Taylor's Tea Rooms, above Goodge Street Station, to a pot of tea and doughnuts. Oh, such indulgence.

They wanted us all to sound the same, with what they called 'a West End actor's voice'. We weren't to have any accent whatsoever. Coming from South London, I had a little cockney in my voice, and that wasn't acceptable. I worked hard to lose all traces of it and then, a few years later, the kitchen sink dramas came in and it was all the rage! I was too posh for them!

I can't say I learnt to act, as I've never acted, but I did learn discipline. And I learnt about working together in a team too, and acting is teamwork. All have proven valuable in later life.

In my day, there certainly was a RADA style: we all had to sound the same for a start. There was a great emphasis on theatre, and little on film, or TV. I think that's changed a lot.

From my class I worked a lot with Lois Maxwell later on. We did a few episodes of *The Saint* together and then went on to do seven James Bond films. During Bond, we'd often reminisce about our days at RADA – happy memories.

Theatre
The Play What I Wrote

Film
The Last Time I Saw Paris; The Main Who Haunted Himself; This Happy Breed; The Cannonball Run; Curse of the Pink Panther; Bullseye!; Spiceworld; Lord Brett Sinclair in *Mission: Monte Carlo; Sporting Chance; London Conspiracy.* James Bond in *Live and Let Die, The Man With The Golden Gun, The Spy Who Loved Me, Moonraker, For Your Eyes Only, Octopussy, A View To A Kill*

TV
Ivanhoe; Maverick; Simon Templar in *The Saint* series; Lord Brett Sinclair in *The Persuaders; Sherlock Holmes in New York; The Dream Team; This Way Up*

UNICEF Goodwill Ambassador

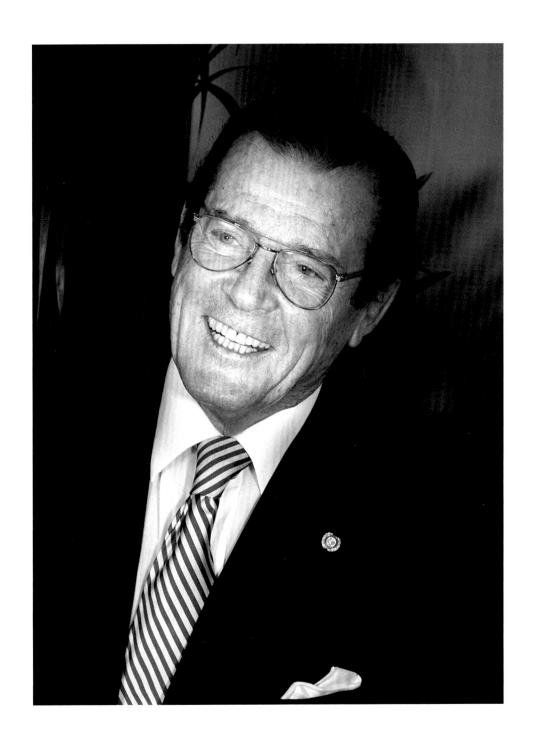

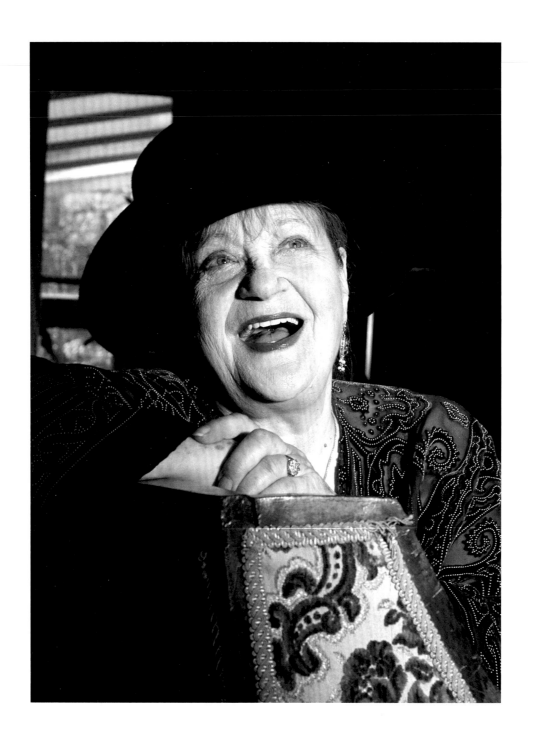

Sylvia Syms, 1951-53

Theatre

The Apple Cart (Theatre Royal); *The Rivals* (Croydon); *The Beaux Stratagem* (tour); *The Ideal Husband* (tour); *The Doll's House* (tour); *House Guest* (Savoy); *Dead Ringer* (Duke of York); *Entertaining Mr Sloane* (Manchester Royal Exchange); *The Entertainer* (Shaftesbury); Gertrude in *Hamlet* (National); *Who's Afraid Of Virginia Woolf?* (Birmingham Rep); *Antony and Cleopatra* (Birmingham Rep); *Ugly Rumours; The Queen and Margaret Thatcher* (Tricycle)

Film

My Teenage Daughter; Ice-Cold in Alex; Bachelor of Hearts; Expresso Bongo; The World of Suzie Wong; Victim; The Quare Fellow; The Punch and Judy Man; East of Sudan; Hostile Witness; The Desperadoes; Run Wild, Run Free; The Tamarind Seed; Absolute Beginners; A Chorus of Disapproval; Shirley Valentine; Shining Through; Dirty Weekend; What a Girl Wants; I'll Sleep When I'm Dead

TV

Bat Out Of Hell; My Good Woman; Nancy Astor; Miss Marple; Thatcher: The Final Days; Natural Lies; The Glass Virgin; Original Sin; Neville's Island; At Home With the Braiththwaites; The Jury; The Poseidon Adventure

Sylvia forgot I was coming round to photograph her and walked down the street to find this unexpected man scouting her house. With a well-trained and well-directed voice, she shouted, 'What do you want?' Several cups of tea later, and much the wiser about her family and life, we had great fun taking the photograph that I was there to take.

Sir Kenneth Barnes, the principal, knew that I hadn't got any money to stay, and that it was difficult to get grants out of Croydon. (Croydon only wanted you to be teachers.) He found me a grant called the Shakespeare Grant. I must say he was marvellous to a lot of us working class kids. We weren't the back end of beyond, but we definitely didn't have loads of money.

I was terrified at my audition! Teachers were more distant in those days. They weren't friendly or encouraging like the people at RADA are now.

In my year there was a very pretty girl called Jeanette Sterk. A marvellous writer called Ronnie Harwood. Some of our year left to do their national service. We only had bombed theatres in those days. It was very scrappy! We used to borrow a West End theatre, and do pieces of plays.

I was a big film buff at the time, and I hated the way English women spoke in films. But at RADA, there was a teacher who wanted us all to speak in a particular way, in that English film way. That teacher gave me a big phobia. I was worst at that elocution class! I still got work afterwards, though.

I was a hard worker. I had no money for going to the lights and things. I found it a bit intimidating. You see, I was very beautiful but I didn't know it, I was embarrassed by the attention. I was very quiet and shy and insecure then. I didn't go out much. I remember I went to a party with an American who kissed me. He put his tongue down my throat and I've never been so scared in my life! I was out like a shot!

I got what they call the HM Tennent scholarship, which gave a year's work to someone as they left RADA. The year before, Rosemary Harris had gone straight into a West End play as the lead. Well, I didn't do that: I did go straight into the West End, though. I had a small part in a play with Noël Coward. Noël was marvellous.

I work all the time and I never think about it. That's all there is to it. I just plod along. I've done all the things, which are not supposed to be distinguished, that I've absolutely adored. That's me. I just work.

Bo Poraj, 1992-95

*When I asked Bohdan how he felt we should best capture an actor off stage,
he suggested that in front of the television, with a packet of crisps, would be the
most honest portrayal. So we faked the most honest portrayal.*

*Anton and I had such fun trying to look for new and creative ways of shooting in my
mother-in-law Sue's house. Partly because I had already shot Ian Holm, John Hurt and
Barbara Jefford there and partly because Anton was very generous with his time.
Ask him about the quantum theory of being photographed if you see him.*

Imelda Staunton, 1974-76

Imelda and I were discussing how much children change your life, and that things that seemed so important prior to their arrival can seem so trivial afterwards. Equally that things which appear trivial to us when growing up can be instilled with so much affection as parents. Hence the dolls' house.

I'd auditioned for three drama schools, and hadn't got in to Central or Guildhall. What was great about RADA was that you did it on a stage, rather than in a room, and the teachers were all in the dark. Anyway, it was my last chance. When I got accepted, my mother read out the letter and I thought she was joking!

I had an interview with Hugh Crutwell, who asked me what theatre I'd seen. Fortunately I'd just seen an Irish play with Virginia McKenna, so I said I'd been to see that. And he said 'Don't you mean Siobhan McKenna?', and I said 'No. Look, I saw it!'. And of course it wasn't her at all: Virginia McKenna was in *Born Free*…

I met my best friend at RADA. She's now a therapist and lives in the USA.

I was very accepting of any criticism. I didn't care what they said to me. They'd say 'You were rubbish in that!' and I'd say 'Yep, fine. OK. What can I do to make it better?' I was always fairly open and therefore had a really good time. The marvel about drama school is that you don't get stereotyped. You get to play all different parts. I played Polly Peacham in *The Beggars Opera* one minute, and the next, an old woman in something like *The Ghost Train*. I was in *The Cherry Orchard*, and also in Noël Coward's play *This Happy Breed*, which was a real family saga, set during the war. It was great, a real leading character part. I was just 20, and playing a woman between 20 and 50 years old.

My social life picked up only towards the end of RADA because I lived at home. I'd picked up a friend who also was living at home as well. But we never did all night drinking bouts or anything like that… Although I heard about quite a few others who did.

Young actors coming out of RADA now are so accomplished. It's very different. They seem to have more ability and more confidence, and that's very inspiring.

You know, I still catch myself remembering teachers from RADA now, thinking, 'Yes, I must do that.' All that information just seeped slowly down into me.

Theatre
The Corn Is Green (Old Vic) – Olivier Award for Best Supporting Actress; *A Chorus of Disapproval* (National) – Olivier Award for Best Supporting Actress; *Into The Woods* – Olivier Award for Best Actress in a Musical; *Habeas Corpus*, dir Sam Mendes (Donmar); *Piaf, Piaf* (Nottingham); Adelaide, *Guys and Dolls*, dir. Richard Eyres (National); *The Beggars Opera*, dir. Richard Eyres (National); Sonya, *Uncle Vanya*, dir. Michael Blakemore (West End)

Film
Peter's Friends; Sense and Sensibility; Chicken Run; Bright Young Things; Vera Drake in *Vera Drake; Nanny McPhee*

TV
The Singing Detective; Cambridge Spies; David Copperfield; Fingersmith

Leigh Lawson, 1967-69

Theatre
The Merchant of Venice, dir. Peter Hall; *A Touch of Spring*, dir. Allan Davies; For the National: *Dogg's Hamlet; From the Balcony; Yonadab; The Second Mrs Tanqueray*. For the RSC: *A Midsummer Night's Dream; The Relapse*

Film
Being Julia, dir. Istvan Zsabo; *Brother Sun, Sister Moon*, dir. Franco Zefferelli; *The Devil's Advocate*, dir. Guy Green; *Tess*, dir. Roman Polanski

TV
Heartbeat; Absolutely Fabulous; Black Beauty; Rachel's Wedding; Kinsey

Leigh and Twiggy have the most wonderful home and anywhere you shoot looks gloriously regal and sumptuous. Combine that with Leigh's longish hair (for a movie he was working on) and you don't have to work too hard as a photographer.

I'm on the audition panel now, just to repay my debt to RADA, because it changed my life. It's my way of saying thank you. It was much simpler in my day, because you did a three minute modern and a three minute Shakespeare, and they made up their mind. Whereas, now, they do workshops and all of that. I don't know how I would cope with it today.

At my audition, I remember it was just a black hole out the front, with voices. You know, 'When you're ready… What are you going to do first?' I did Dylan Thomas's opening to *Under Milk Wood* and a speech from *Hamlet*. All I can remember is the white light of fear.

What I do remember extremely well is getting the letter of acceptance. At the time I was working during the day, then going to drama school in north London in the evenings. For the first time, I realised what it meant when people said their feet didn't touch the ground. I couldn't walk – I had to run, because I had such an adrenalin rush. It was impossible to walk. I had that wonderful elated feeling for some time afterwards. I knew that this was going to change my life, and it did.

I was part of the second intake by Hugh Crutwell. I really did enjoy it, but I didn't think anyone in my group was supreme. The year above was very talented and yet, strangely enough, no-one's heard of them either. Some became writers. There were one or two other people around. Michael Kitchen, Stuart Wilson. Timothy Dalton had just left before. Jonathan Pryce came after.

I never enjoyed the dance or movement classes very much, ironically – my father had a variety act that was a dancing duo. I didn't seem to have inherited any of that at all!

I felt so privileged and happy to be there, and so in awe of the place. If Hugh Crutwell was waiting by the staircase in the entrance, I used to turn around and go out of the back of the building, so he didn't see me and realise I'd got in by mistake. He was a wonderful principal. It is the happiest memory I have, being at RADA. It was a wonderful time, and I really enjoyed it. I feel hugely indebted to the academy.

I was 21 when I went there, which isn't unusual today, but most of the intake then was 18 or 19 years old. I was always quite amazed that people took it quite so casually, would not attend all the lectures, or all the classes. Even the classes I didn't like, I went to. It was in the days when one had a grant. Your fees were paid and you could just about get by. You couldn't live very well, but you could live.

Peter Barkworth, 1946-48

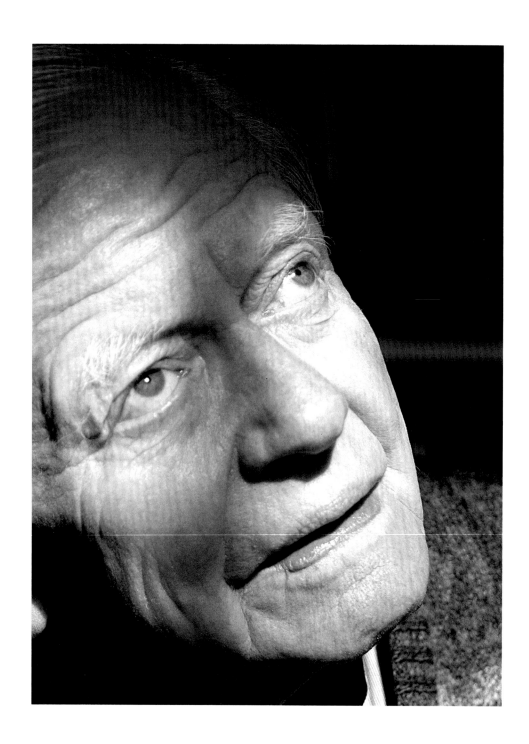

Peter is a gentleman of the first order. He is both interesting and welcoming in equal measure. His knowledge of the London theatre, and of RADA, is formidable. Most of all though, I like him because he went with every one of my suggestions.

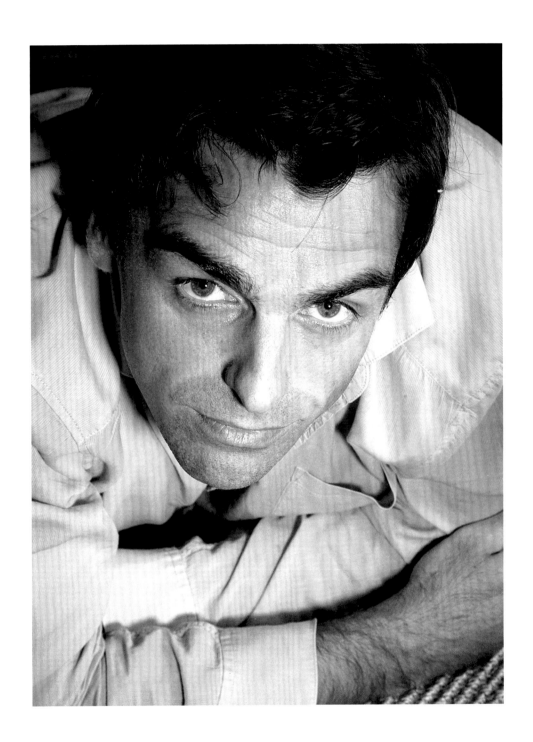

*I once ran a nightclub in London called Retro, and Jonathan was a regular attendee.
It was very nice to see him again after so much time. Of course, in the
interim he has become a very familiar face on TV.*

Timothy Spall, O.B.E., 1976-78

We had to clear the Christmas decorations for Timothy's portrait. Not that he minded – he was game for everything, but I thought it might make it too anchored in one season. He has a very sharp mind indeed, matched only by his wicked sense of humour. I can't repeat most of the things he said that made me laugh for fear of getting him into trouble.

I was licking envelopes at the National Youth Theatre, where I had a part time job, when my mum rang and said, 'I'm sorry, I couldn't resist it. I had to open the RADA letter. You've got in!' It was probably the best thing I've ever heard in my life. On my way back to Clapham Junction, I couldn't stop myself from tapping the shoulder of the woman in front of me and saying, 'Excuse me. I've just got into RADA!' And she said, 'Oh, marvellous'.

Michael Simpkins was in my year. Michelle Wade. I see Paul Kerry. He lives in Boston, but I got back in touch with him recently. I've been one of the most fortunate in terms of how my career's panned out for me. There are lots of people who've given up.

I hated movement with a vengeance and ended up having a preposterous scuffle with one of the teachers. I think I was so indolent she couldn't stand it any more, so we had a full-blown slanging match. I went away the last summer I was there and lost a lot of weight, and came back and got stuck into it. I changed from a lazy boy, not into full-blown goody-two-shoes, but somebody a bit more awake.

I really loved it. I loved being there. It was tremendous. I think going there made me realise I didn't have to limit myself. I mean, I played Othello and Macbeth when I was there! Being stretched in that way was great. I played all these classic roles in Chekhov, Beaumarchais, and so on. The great thing about RADA was that everything was very practical. You were in front of a paying audience by the second term. There was always a play going on.

One of the first things I did was a black comedy, where I played this very stuffy colonel. A teacher came up to me afterwards and asked me how I did it, because I was demonstrably working class. Then I did another play where I had to play a Geordie and a Tory minister in the same piece. He came up to me and said, 'Where do you learn about all these people?' And I said, 'I watch them on the television.'

I got a bit institutionalised at RADA. I used to spend a lot of time there because they had a bar and a restaurant and I'd spend the whole day and night there. We also had our green room where we could socialise. It became a kind of world, its own planet. We did go out and about, but mainly to the local boozers really.

I got a job straight away. I couldn't believe it! I went from being a south London working class kid, to performing on stage in the Royal Shakespeare Company for three years. It was amazing.

Theatre
For the RSC: *The Merry Wives of Windsor; Three Sisters; Cymbeline; Nicholas Nickleby.* For the National: *Saint Joan; Le Bourgeois Gentilhomme; A Midsummer Night's Dream,* dir. Robert Lepage

Film
Quadrophenia; Life Is Sweet; Gothic; White Hunter Black Heart; The Sheltering Sky; Secrets and Lies; Hamlet; Still Crazy; Topsy-Turvy; Chicken Run; Intimacy; Vacuuming Completely Nude In Paradise; Lucky Break; Vanilla Sky; Nicholas Nickleby; The Last Samurai; Harry Potter and the Prisoner of Azkaban; Lemony Snicket's A Series of Unfortunate Events; Harry Potter and the Goblet of Fire

TV
Home Sweet Home; Auf Wiedersehen Pet; Journey's End; Spender; Frank Stubbs Promotes; Outside Edge; Nice Day At The Office; Our Mutual Friend; The Thing About Vince; Perfect Strangers; Bodily Harm; My House In Umbria; Cherished; Mr Harvey Lights A Candle

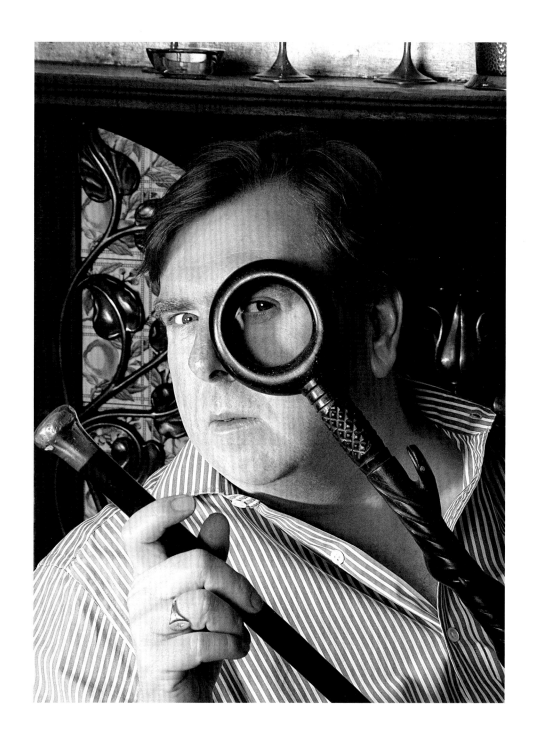

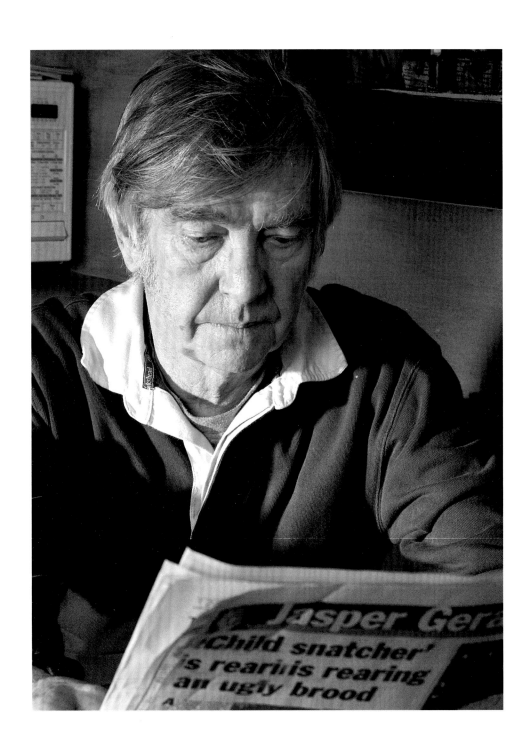

Sir Tom Courtenay, 1958-60

Theatre
Konstantin in *The Seagull* (Old Vic); *Otherwise Engaged* (West End, Broadway); *Cherry Orchard* (Chichester); *Macbeth* (Chichester); *Charley's Aunt* (69 Theatre Company, Manchester); *Hamlet* (Edinburgh Festival); *Time and Time Again* (Comedy Theatre) – Variety Club Stage Actor Award. For the Royal Exchange: *Uncle Vanya; Peer Gynt. Moscow Stations* (Traverse, West End, New York) – Evening Standard and London Critics Circle Awards for Best Actor; *Art* (Wyndham's); *Pretending To Be Me* (West Yorkshire Playhouse, Comedy Theatre); *The Home Place* (The Gate, Dublin, West End)

Film
The Loneliness of the Long Distance Runner; Billy Liar; King and Country; King Rat; Dr Zhivago; The Night of the Generals; One Day In The Life of Ivan Denisovich; The Dresser; Let Him Have It; A Rather English Marriage; Whatever Happened to Harold Smith?; Last Orders; Nicholas Nickleby; Ready When You Are Mr McGill

TV
She Stoops To Conquer; Me and the Girls; Absent Friends; Redemption; Young Indiana Jones and the Treasure of the Peacock's Eye; The Old Curiosity Shop

Tom Courtenay is a gentleman. He told me he hates being photographed but not only did he not put up any resistance, he offered creative ideas and made fine coffee, and then insisted on carrying my heavy equipment back to the car.

I can remember John Fernald leaning forward when I was auditioning. All day I'd been so nervous, and, from that point, I knew I'd be all right. I knew that the man in the middle was probably the principal, and when he leant forward, I guessed he was interested. That proved to be true.

They told me at the audition to come back next week for a scholarship. I said to the sergeant on the door, "If you want me to come back next week for another audition for the scholarship, does that mean I'm in?" And he replied, "Yes. It does." I was just elated. I'd wanted to go there for years. I went to UCL to study English, because it was in the same street as RADA. I wanted to spy on the RADA students. That was my scheme.

John Thaw was my best friend. We were exact contemporaries and we shared a flat together. I was very fond also of Geoffrey Whitehead. I bumped into him the other day and we both started laughing, because we both look exactly the same.

John Fernald was very kind and supportive to me at RADA. I'd failed my degree and I didn't want to go back to university. He got me some money from the higher education committee when they didn't want to give me very much. And in the second year, he wrote to them saying that I was very promising, and again they gave me some more money.

I was a bit chaotic because I'd had a rough time at university. I'd lost my confidence rather.

I got a break in the penultimate term. There was a director called Michael Ashton, and he got me to stand still for the first time. And I got a rather showy part in this musical. I was sort of discovered there really, even before I'd left RADA.

Peter Barkworth, who gave a great deal to RADA, also taught me. I learned a lot from him. And, I've never worked with him, but my inspiration is Paul Schofield. He's just beautiful.

It was a marvellous entry for me, mainly because of John Fernald. He was doing a production of *The Seagull* immediately after I finished, and he put me in it as the young man. I left RADA on the Saturday, and on the Monday started rehearsing at the Old Vic!

Trevor Eve, 1971-73

He claims he doesn't even play pool.

I'd never had anything to do with acting. In fact I was studying architecture, which I was a little disillusioned with. My interests were film and theatre, though, and someone suggested that I do something I was actually interested in. I found myself looking up drama schools in the yellow pages. I got auditions at RADA and Central, and went to the RADA one.

I went to an old lady for coaching, because I had no idea what to do. For the audition, I did *Richard II*. It didn't go terribly well. Then Mr Crutwell said that my audition was pretty awful, but that he could see there was something else there. He took me to room 4 in RADA and said, 'Ok, you've got five minutes to prove to me that you can act.' And I did.

The old lady took a very intellectual approach to the *Richard II* speech, so I spoke it very nicely. The second time I did it more viscerally and this time it worked. He smiled at the end, and I got a letter three weeks later saying I'd got in.

I know people who were in other years. I married someone in another year: Sharon Maughan. She'd already left when I arrived. The people who were there when I was there were Alan Rickman, Patrick Jury, Jonathan Pryce and Ben Cross, those kinds of people. We were a rotten lot. Yes, we really did party. There were a few times where we would go on an all-nighter and then crawl in the next morning.

I'd hated school. I'd been to university for two and half years, and didn't like that much either. I thought RADA was really great because you used all of yourself. You don't, when you're doing something academic. I loved the idea of all the movement classes, the improvisations; I loved singing, the lot! I wasn't very good at time-keeping, which Bosun, the guy on the door used to point out to me. I got the gold medal, but I didn't get an honorary diploma, because I was always late.

Socially, RADA helped me have more confidence in myself. Without question, in that life, it helped you to approach things. I'm a bit of a pro-RADA student. I think RADA was just tremendous. Hugh Crutwell was tremendous to me. He had huge faith in me. But I think if you spoke to other people in my year they'd probably slag me off, because I got a load of great parts. It all went very well for me there.

Hugh Crutwell was the man who got what the emotional core of acting was. That's what he was interested in: undergoing the experience. Being real, the audience knowing that you're doing what you're doing for real. That's something I've kept with me for a long time.

Theatre
John, Paul, George, Ringo and Bert (Liverpool Everyman, Lyric); *Filumena* (West End); *Children of a Lesser God* (Albert Theatre) – Olivier Award for Best Actor in a New Play; Astroff in *Uncle Vanya* (Chichester, tour) – Olivier Award for Best Supporting Actor

Film
Dracula; Scandal; In The Name of The Father; Don't Get Me Started; Next Birthday; Appetite; Possession; Troy

TV
Shoestring; A Brother's Tale; Lace; Jamaica Inn; Hindle Wakes; Shadow Chasers; A Sense of Guilt; Parnell and the Englishwoman; The President's Child; A Doll's House; Murder In Mind; The Politician's Wife; Heat of the Sun; The Tribe; An Evil Streak; David Copperfield; Waking the Dead; Lawless

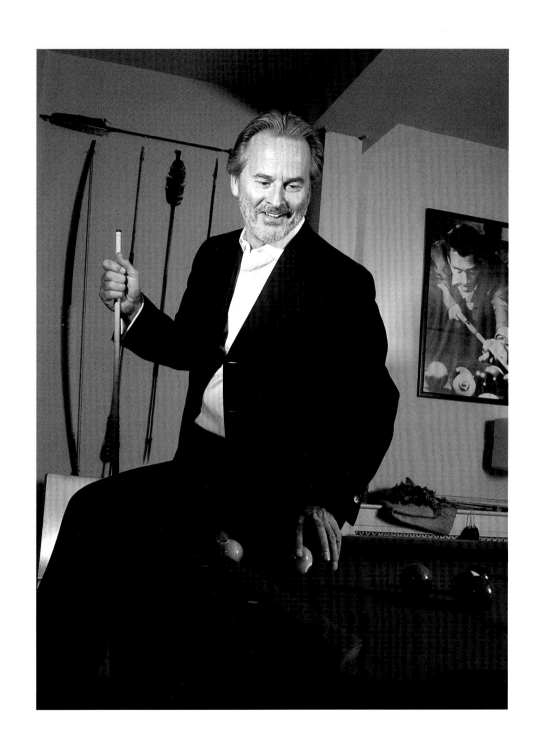

Amanda Drew, 1989-92

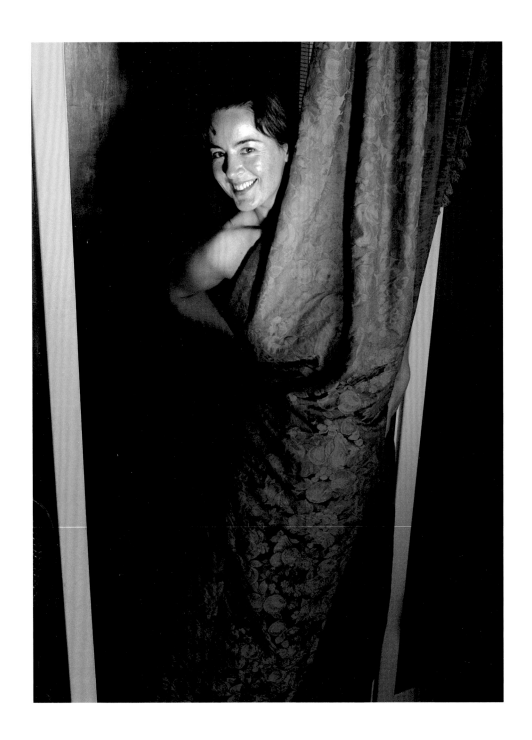

Apparently these curtains were purloined from a stylish London bar.
I think Amanda sets them off rather well.

Tanya was renovating her house when we took the portraits and we made use of every available nook and cranny. I like the idea of fitting someone so elegant and balletic into this confined space.

Tom Wilkinson, 1971-73

Tom was halfway through filming his latest movie in Canada but had returned home for Christmas and New Year. I caught him at home at midday on New Year's Day, which was fine for me having gone to bed at about 9.30pm, but I think he felt that he had probably made better appointments in his time.

RADA was the only drama school I auditioned for. I'd been at university for three years, and just thought that RADA was the only place to go. It was the only school I knew about.

My audition went very well and I was offered a place on the spot. You auditioned in front of a panel, and then if you were recalled came back and auditioned for Hugh Crutwell himself. He could be very impulsive.

This was the early '70s, and there were still those practices at school where you called the teachers Mr This and Mrs That. It was still rather formal. You turned up at ten o'clock and worked through. You didn't miss anything. I just felt like I was starting an apprenticeship really.

There were some very good teachers. I really enjoyed working with Keith Johnston. He was, and still is, a very gifted improvisation teacher. Improvisation was a lot to do with doing the obvious. A lot of improvisations were actually stymied by trying to be original. He taught us to do the first thing that came into our heads.

There was a very exotic teacher – Madame Fedro – who taught us movement. A rather grand elderly Polish woman – long dead – who taught us Restoration movement, how to walk with a cane. It was when she said to me, 'This is gut! This is gut, Wilkinson!', that I felt terribly gratified.

I'd lived away from home since I was 17, and didn't go to RADA until I was 21. I was a couple of years older than everyone else. I was new to it and didn't really have any sense of myself as an actor, but the thing about me was that I was terribly, terribly motivated.

I was then as I remain now, relatively private. I had a girlfriend at the time who I lived with, who wasn't anything to do with show-biz. We had a rather nice flat in West Hampstead. I'd do everything I had to do at RADA and then return to this grand flat. I don't really have any friends from that time.

RADA was wonderful. Tremendous. It was great training for what I was about to do. In those days, you didn't go into movies, you went into theatre and I started work the day I left. The thing is, of the twenty-one who were in my class, only three have made a success of it.

Theatre
For the RSC: *King Lear; The Crucible; Hamlet. Tom and Viv* (Royal Court); *Henry V; Peer Gynt; White Chameleon* (National); *Ghosts* (Young Vic) – London Critics Circle Award; *Uncle Vanya; Three Sisters*

Film
Sylvia; In The Name of the Father; Priest; Sense and Sensibility; Crossing the Floor; Smilla's Feeling For Snow; The Full Monty; Wilde; Oscar and Lucinda; The Governess; Rush Hour; Shakespeare in Love; The Patriot; Essex Boys; In The Bedroom; The Importance of Being Earnest; Before You Go; Girl With A Pearl Earring; Separate Lives; Piccadilly Jim; Eternal Sunshine of the Spotless Mind; Stage Beauty; A Good Woman; Ripley Underground; Batman Begins

TV
Crime and Punishment; Spyship; Squaring the Circle; Strangers and Brothers; First Among Equals; The Woman He Loved; Shake Hands Forever; First and Last; Prime Suspect; Resnick; Underbelly; A Very Open Prison; Measure for Measure; Martin Chuzzlewit; David Copperfield; The Gathering Storm

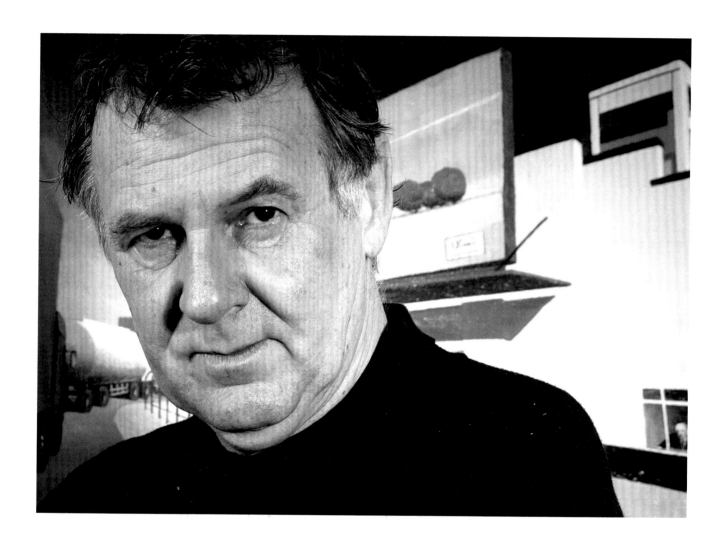

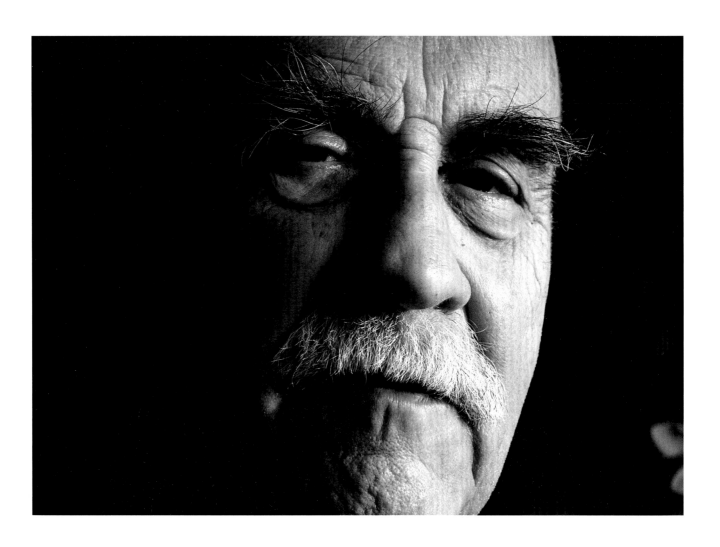

Warren Mitchell, 1948-49

Theatre

Death of a Salesman (National) – Olivier Award for Best Actor; *The Price* (Apollo) – Olivier Award for Best Supporting Actor

Film

Moss; Barnacle Bill; Three Crooked Men; Man with a Gun; The Pure Hell of St Trinian's; The Curse of the Werewolf; Postman's Knock; The Sicilians; Calculated Risk; Carry on Cleo; Help!; The Spy Who Came In From The Cold; The Jokers; The Assassination Bureau; The Alf Garnett Saga; Innocent Bystanders; What Changed Charley Farthing; Jabberwocky; Meetings With Remarkable Men; Norman Loves Rose; Knights and Emeralds; Kokoda Crescent

TV

Three Tough Guys; Underground; Colonel Trumper's Private War; The Channel Swimmer; Scoop; Tin Pan Alice; Frankie Howerd; Til Death Do Us Part; Calf Love; Tooth and Claw; Secrets; Men of Affairs; Moss; Merchant of Venice; The Last Bastion; Waterfront; Man of Letters; In Sickness and In Health; The Dunera Boys; So You Think You've Got Troubles; Wall of Silence; Death of a Salesman; Gobble; Ain't Misbehavin'; A Word With Alf; The Thoughts of Chairman Alf; Gormenghast; A Christmas Carol; The Shark Net

As I was admiring Warren's house, he quipped that this was the house that Alf built. Of all the actors I met on this project, I think Warren had most embraced, and come to terms with, the fact the world would always see him as one character in particular. I, on the other hand, will always remember the anecdotes, and the fun of meeting Warren Mitchell.

My wife was also at RADA. She won the prize for charm and grace of movement. What a load of cobblers!

Getting in was very exciting. It was a very late decision, to try and become an actor. I'd been at Oxford reading Physical Chemistry, and theatre was the last thing on my mind when I was there. It was when I was in the forces that the idea came to me about turning this ability to tell jokes into something more. I was in the RAF and they were wonderful. Towards the end of one's service, they had a fund for further education, and they'd paid for me to go to voice lessons and coaching before my audition.

In my year were Dorothy Tutin, and Lionel Jeffries. Dorothy is no longer with us. Lionel, I ring periodically.

It was a wonderful time really. I had just been in the RAF, and was coming up to this extraordinary place. The age-gap between these beautiful young girls just out of school, and these ex-servicemen was another thing. We found it quite difficult to commit to school discipline after being in the services: being told we couldn't talk in the corridors, that kind of thing. There was a doorman called Jim who was always saying, 'Don't stand there Warren. Sir Kenneth doesn't like it. I don't make the rules, son, I don't make the rules.'

It was quite fun really, because I was practically a trained bi-linguist. I remember Nancy Brown, the registrar, saying to me, 'Warren, you really must do something about that voice of yours'. It was sort of semi-cockney, and so I had to learn to talk posh when I was at RADA. I was also a communist at the time, though, and can remember standing on the corner at Camden Town selling *Daily Workers* saying, in my RADA accent, 'Get your *Daily Worker*. Get your *Daily Worker*.' The branch secretary said to me, 'You can't talk like that when you're selling *Daily Worker*!', so I had to also learn to talk Cockney.

I spent my evenings acting at the Unity Theatre, which is a very left-wing theatre, and so I was forever working really. I never had any time for socialising. The class that I was in at RADA were very supportive, although they opposed my political views. I remember having a tremendous argument with Dorothy Tutin about it, and she smacked me straight in the jaw one day. She nearly knocked me out! I remember seeing stars for a bit. She certainly punched more than her weight!

I've often said in interviews that RADA was a perfect training for the commercial theatre. It produced bad plays, and bad directors, and used influence to get parts. But I think it's very different now.

I remember one day Sir Kenneth Barnes saying, 'I don't want you doing Oscar Wilde. The man was a bugger!' We wanted to do a play by him, but it was very much opposed.

131

Susannah York, 1956-58

Rather like after the Kenneth Branagh meeting, I wondered if all had gone wrong when Susannah didn't return my email for three months. But then, on New Year's Eve, I got the most wonderful message a photographer can get. I won't repeat it all but she was kind enough to say that if she were drawing up a Hollywood contract today she would insist that I was written in as her stills photographer. The pleasure would be all mine!

I rehearsed all through the summer for my audition, first on my grandparents' garage roof on a mountain outside Tangier, and then on the hills round our farm on the west coast of Scotland. I was skivvying at Prestwick airport, in a maid's black uniform with white collar and cuffs, for hungry pilots and passengers fresh from early-morning flights: that paid for all the extras I might have to fork up for, such as tights, ballet-pumps for movement, sticks of Leichner. Some of that money would go towards my fees.

I was at home when the envelope came saying yes. I suppose I went white, shook, certainly went wild, rushing up to those hills again and yelling over and over that I'd passed, I was in!

For the audition I did a piece of *Alice in Wonderland*, and the monologue from Shaw's *St. Joan* when she revokes her 'confession'. I still remember both, word for word. Early in my first term, John Fernald told me, 'It was lucky we'd had about five St. Joans before you, Susannah, we wouldn't have understood a word otherwise. You gabbled so fast and whizzed all over the stage like a firecracker.'

Technique was the thing I found hardest to grapple with, and was worst at when I got to RADA. That and breathing, part and parcel of the same thing. As soon as I became conscious of myself, spontaneity seemed to fly out of the window.

I think what I enjoyed most was doing comedy, although I'd always believed acting was about 'tearing a passion to tatters'.

In my first term, I was friends with Julie Molins and still am. Later on I fell madly in love with Michael Wells, who suddenly turned up in my class in the second year, and no-one else figured very hugely after that. We married, had children, divorced, and are still very close. (Fernald gently advised it 'might not be such a good idea, marrying so young', but I'm glad we did, I don't think I'd have dared later.)

And I remember delicious Hugh Whitemore, with whom I'm still friendly, and Sian Phillips, who was the year ahead of us, and splendiferous. And there was Dyson Lovell, who became a well-known producer, and glamorous Cherry Butlin and sophisticated Tracy Reed, and brilliant Mitzi Webster in my class, of whom I was terribly jealous.

I don't think I worked nearly as hard as I should have on technique, but I did work on the roles, and that and being in love engrossed me through the last year. Playing Natalya in *A Month in the Country*, Rosalind in *As You Like It*, and Nora in *The Dolls House* were highlights for me. There was Olivelli's and often the pub after school, the odd party, but many after-school delights passed me by. I was having such a good time as it was.

Theatre
The Hollow Crown (No.1 Tour); *Amy's View,* dir. Robin Lefevre; *Picasso's Women*, dir. Andy Jordon; *Hamlet; Camino Real; Merry Wives of Windsor* (RSC); *The Cherry Orchard* (National Tour)

Film
Sharia; The Book of Eve; Superman; Superman II; Superman IV; A Christmas Carol; The Awakening; The Riddle of the Sands, dir. Tony Maylam; *Images,* dir. Robert Altman; *Jane Eyre; Oh! What a Lovely War,* dir. Richard Attenborough; *Battle of Britain; They Shoot Horses Don't They?,* dir. Sydney Pollack; *A Man for all Seasons; Tom Jones; Freud*

TV
Casualty; Holby City; Boon; Tender is the Night; The Love Boat; Second Chance

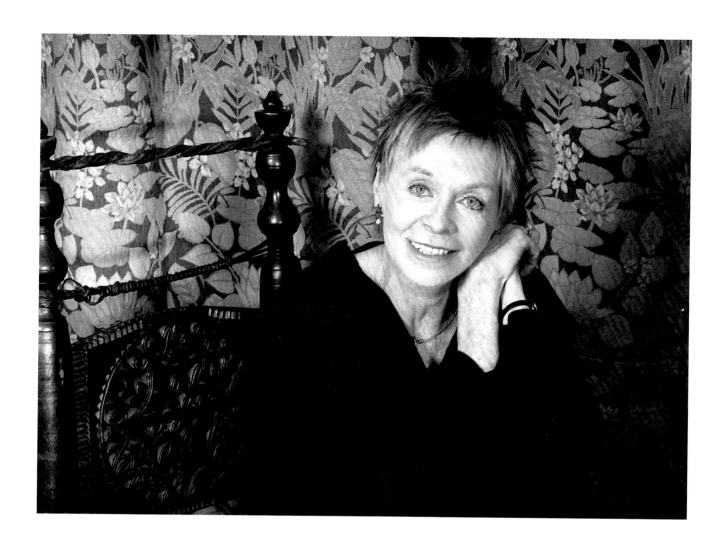

Ben Whishaw, 2000-03

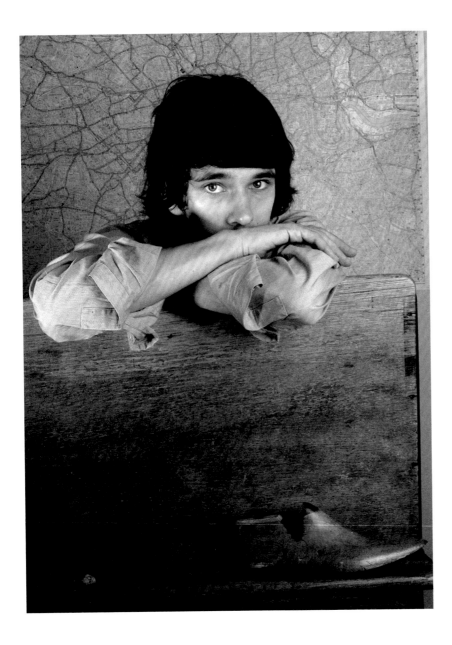

Between the time when I started shooting this project and the moment I got to photograph Ben, he appeared to have come from nowhere to be omnipresent. When I phoned my wife to say who I was photographing next, she was sitting in a square in The Peloponnese reading all about him in Vanity Fair!

In my audition, I performed a monologue from a play called *I like a Slag's Deodorant* and a really hard speech from *Troilus and Cressida*. Bad choice. I remember leaving the final audition convinced I'd messed up and wouldn't get in. But Nicholas Barter called just before Christmas 1999 to tell me I'd got in. He said he'd send a letter confirming the offer of a place, but it didn't arrive for weeks and I remember thinking I must have imagined that phone call.

In my year were Jack Laskey, Laura-Kate Frances, Chris Logan, Sinead Matthews, Nick Barber, Trystan Gravelle, Jed Staton: I still live with Nick, Trystan, Chris and Jed.

I was hopeless at stage fighting, and continue to be. But in the animal project, I enjoyed being a horse. Acting teacher John Beschizza is a god. I loved his classes.

I was a stupidly hard worker and wasted my student years. I was far too serious to go out and enjoy London's after-school delights.

Theatre
Hamlet (The Old Vic); Elliot in Philip Ridley's *Mercury Fur* (Paines Plough)

Film
Layercake; Perfume

TV
Pingu in *Nathan Barley*

Thelma Holt, 1951-52

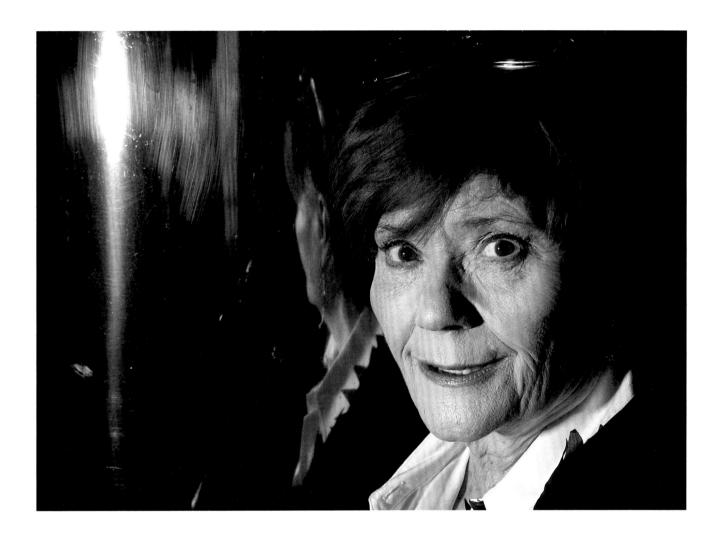

I gave up trying to pretend I knew all the cultural references emanating from Thelma's conversation and found myself just nodding. Thelma knew Greece better than me – and I live there.

My audition pieces were Hermia from *A Midsummer Night's Dream*, and the girl from *Bill of Divorcement*. I wore a black skirt with a huge petticoat underneath it, topped off with a black sweater.

Of course I remember receiving my letter of acceptance. How did I react? I slid down the banisters.

In my year were Peter O'Toole, Joe Orton, Peter Dutton, and Liz Wallace. I am still friendly with Liz, with whom I shared a home until we both got married. I was best at verse speaking, and worst at playing middle-aged women. Old ladies were not too difficult. I burned the candle at both ends, and worked and played very hard indeed.

Theatre

Katherine in *Taming of the Shrew*; Lady Macbeth in *Macbeth*; Getrude in *Hamlet*.
Founded Open Space Theatre; Artistic and Executive Director of Round House, 1977-83; Executive Producer for Peter Hall Company; Head of Touring and Commercial Exploitation, National Theatre

Film
The Double

Producer
International 87 (National) – Olivier Award for Outstanding Achievement, London Critics Circle Special Award; *Fairy Queen*, dir. Adrian Noble (Aix-en-Provence Festival); *International 89* (National)

Formed Thelma Holt Ltd in 1990
Productions include: *Three Sisters; Tango At The End of Winter; Electra*, dir. Deborah Warner; *Hamlet; Six Characters In Search of an Author*, dir. Franco Zeffirelli; *The Tempest; Much Ado About Nothing; The Clandestine Marriage*, dir. Nigel Hawthorne; *Antony and Cleopatra*, dir. Vanessa Redgrave; *A Doll's House; The Maids; Cleo; Camping; Emanuelle and Dick; Miss Julie; Semi Monde; Pericles*, dir. Yukio Ninagawa; *Ghosts*, dir. Ingmar Bergman; *Hamlet*, dir. Jonathon Kent; *We Happy Few*, dir. Trevor Nunn; *Man and Boy*

Sir Anthony Hopkins, 1961–63

I auditioned with the Saint Crispin speech from *Henry V*. I was nervous and hadn't a clue how to perform it – I think I gave it a lot of Welsh vibrato and Celtic twilight stuff. The only reaction I remember was, Thank you. Next.

Acting was not something I always wanted to do. I wanted to be a pianist and a composer more than anything. I stumbled into the acting business by pure chance, and never felt a part of it. Never have. I'm still waiting for the knock on the door and someone to inform me that my ladder has been leaning against the wrong wall for forty years.

When I got in, my father said: 'Thank God you've found something to do, because you're bloody hopeless at everything else.'

I lacked discipline and confidence. I hated ballet and mime, and always found a way out of attending those classes. There were two teachers, however – Christopher Fettes and Yat Malmgren – who taught a fascinating course on the Laban/Carpenter theory of movement, and the Chekov theory of the 'psychological gesture'. It was Stanislavski-oriented, and, though it was an unpopular class among the staff and many students, I found it intriguing and learnt a great deal from it all.

The social scene was good – a lot of drinking at the Marlborough, and egg and chip cafes on the Tottenham Court Road. The new and spicy Indian restaurants had arrived in Britain, so there was drinking and smoking and general rioting, late nights in cold and gloomy bedsits.

I never had any money. I drank and smoked most of it away. It was fun.

I was starting out on a way of life that was a total mystery to me. I didn't make friends easily and enjoyed my own company. I spent many Sunday afternoons at London Zoo watching the big cats and the monkeys. Fascinating. Then, to the cinemas in Leicester Square. I always found something to do. I loved walking miles and miles around the city.

I never felt comfortable in Shakespeare and was more drawn to film acting than theatre, because I'd spent the post-war years in an escapist world, watching American films, with great actors. That's what I wanted more than anything.

Theatre

Equus; Pravda (National) – British Theatre Association Award: Best Actor, Observer Award: Outstanding Achievement; *Antony and Cleopatra* (National); King Lear (National)

Film

The Lion in the Winter; 84 Charing Cross Road; The Elephant Man; Magic; The Bounty; Desperate Hours; A Bridge Too Far; The Silence of the Lambs (Academy Award: Best Actor); *Nixon; The Remains of the Day* (BAFTA Award: Best Actor); *Shadowlands; Amistad; Hannibal; Meet Joe Black; Titus; Howard's End; Bram Stoker's Dracula; August; Surviving Picasso; The Edge; The Mask of Zorro; The Human Stain; Alexander; Proof; All the King's Men; The World's Fastest Indian*

Director

August

TV

QB VII, The Lindbergh Kidnapping Case (Emmy Award); *The Bunker* (Emmy Award)

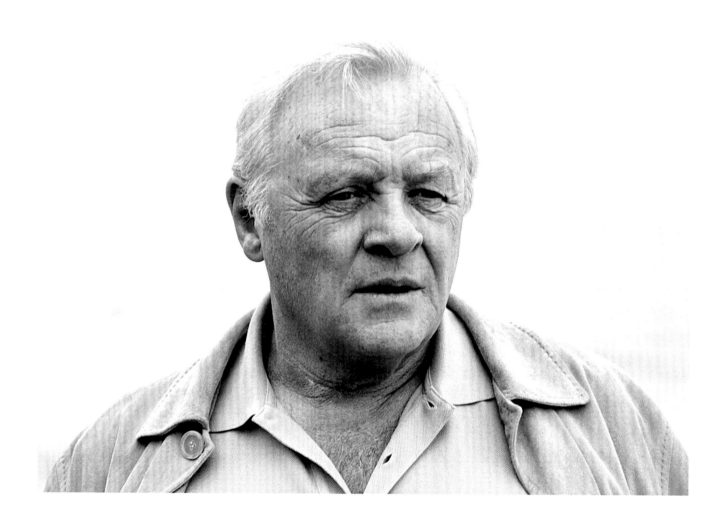

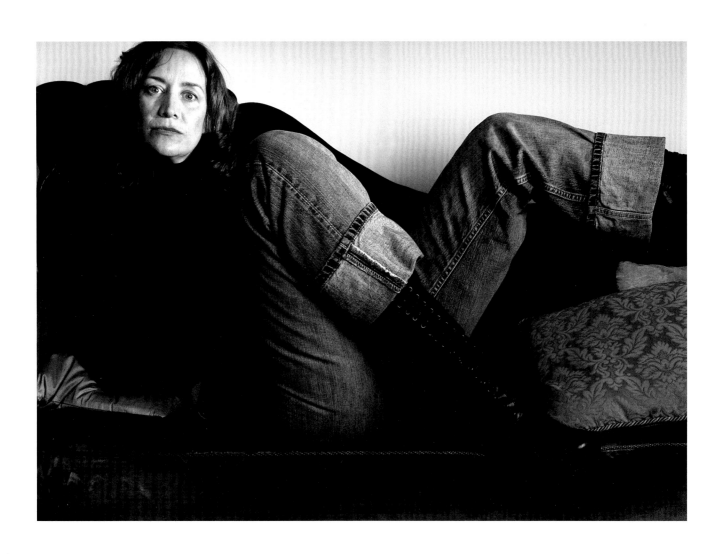

Janet McTeer, 1981-83

Theatre
Mary Stuart (Donmar); *A Doll's House* (Playhouse) – Olivier Award and London Critics' Circle Awards for Best Actress; *A Doll's House* (Broadway) – Tony Award for Best Actress; *Much Ado About Nothing* (Queen's); For the Royal Court: *Simpatico; Greenland; The Grace of Mary Traverse.* For the RSC: *A Midsummer Night's Dream; Worlds Apart; The Storm.* For the National: *Uncle Vanya; The Duchess of Malfi*

Film
Half Moon Street; Hawks; Sweet Nothing; Prince; Dead Romantic; Wuthering Heights; Carrington; Saint-Ex; Tumbleweeds; Waking The Dead; The King Is Alive; The Intended; Romeo and Me

TV
Les Girls; Precious Bane; Portrait of a Marriage; Yellowback; 102 Boulevard Haussmann; The Black Velvet Gown; My Life; Masterpiece Theatre; A Masculine Ending; Don't Leave Me This Way; The Governor; Miss Marple: The Murder At The Vicarage

Janet had been away filming with Terry Gilliam in Szechwan where they had no mobile contact. We very nearly missed each other, but I just caught her on my last day in London.

My English teacher thought all my audition speeches were rubbish, so she picked out this piece for me. It wasn't until much much later that I realised it was from a play that had been written for the principal's wife. Still, it was absolutely the most fantastic choice for me, brilliant. It was a piece about this girl who'd never really had a voice and, all of a sudden, she started speaking – a bit how I felt at the time. I was very untrained, had never done any acting, and had done one play when I was 12. When I finished, they said, 'Who helped you with that piece?', because I'd already done a Shakespeare that was absolutely dreadful. They said, 'Where did you rehearse it?'. I said, 'In my bedroom'. And they said, 'Well, who to?' and I said, 'To a mirror!'

I was so nervous I actually phoned up RADA to ask if I'd got a recall and they said that I'd got in. I jumped up and down, went berserk. I knew I wanted to do something with English, and I thought I'd go to university and do English literature. But then I got a job selling coffee in the theatre in York. That's when I realised – This is where I belong, this is what I want to do. So I was thrilled to get in.

I wasn't quite 18 when I went, and it was a real coming-of-age experience. I lived in a bedsit in the first term, and I was really lonely, but then I got this flat with Melanie Hill and a couple of other bods, and it became fun. A lot of us still keep in touch, it's really nice. We have get-togethers every now and again, and whoever's around comes along.

I shared the flat with Sean Bean and Melanie. Kenneth Branagh had just left RADA. Fiona Shaw was two terms above me, I thought she was just brilliant. Imogen Stubbs was the term below. Iain Glen was below too. We had some fantastic people.

Melanie and I had jobs on Sunday nights at a little café near where we used to live. We met quite a few friends there.

I enjoyed most of the course, but wasn't very good at movement. I was very tall, and singing and dancing just made me feel huge, in the wrong kind of way. But I was very lucky, I got the big character parts. Which was great, because I've also managed to continue that.

I remember doing *Medea*, and I was playing the lead. There was a bunch of girls in the dressing room, and I remember thinking, 'God, this is fantastic': we were all doing something terrifying, but we were doing it together. I still remember Melanie dressed in ridiculous hair and make-up, playing an 85 year old. That sort of camaraderie never really goes. In our job you really have to work with people, you work off each other and with each other, and become emotionally involved with each other too. It's something you don't get in a lot of other jobs.

139

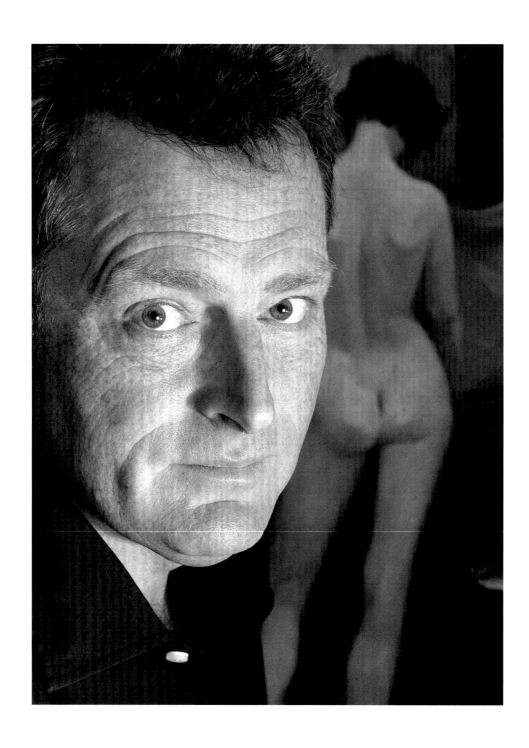

Michael and Judith had arrived back in from LA the night before my shoot with Michael.
How honourable he was to go ahead anyway, after periodic false starts to the day by
both of them, and with Judith still not entirely sure whether it was night or day.

Jonathan Hyde, 1970-72

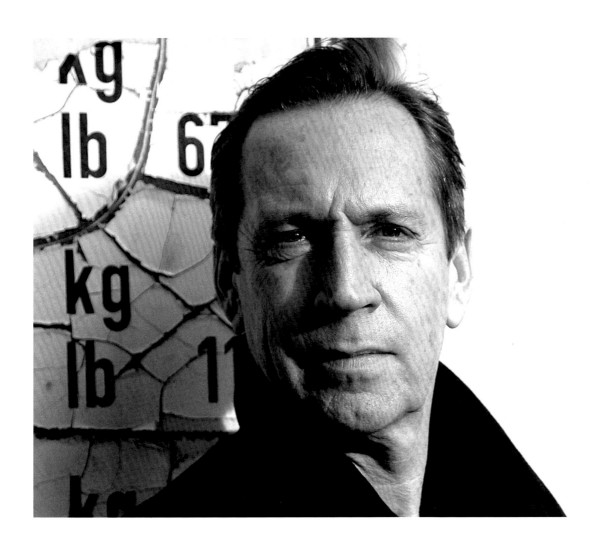

I swung by Shepperton Studios on my way to Wiltshire to photograph Michael Kitchen.
Ralph Fiennes and Jonathan Hyde were filming 'Land of The Blind' and my plan was to see if
an impromptu shoot could be fitted in, with one or both. Jonathan even delayed his
driver taking him home by a good hour to accommodate me.

Liza Tarbuck, 1984-86

We managed to take over everything from Liza's bedroom to her garden – including uprooting a sculpture at one point. All in the name of art. Or maybe just a good gossip. Very enjoyable either way!

At my audition, I was overdressed, with too much make-up on. I wore a grey pleated pinafore, with a shirt underneath: like some hilarious twist on a school day. I also wore Carmen curlers. I looked a fright!

I didn't want to go to RADA. My dad was very impressed because it was in the dictionary. I wasn't convinced that I wanted to go there, because I thought I didn't want to be stuck with a bunch of hoorays that would drive me potty. It turned out that couldn't have been further from the truth.

My worst thing was sword fighting. I was the only girl in my year to fail the test. I couldn't have given a monkeys though! I used to say 'But why do I need this? Why do I need this skill? Why can't I go and sit in the common room?' It was that horrible lazy trait that's always been there, but I just couldn't see the point in it.

We had a very good group for laughter, fun, and stupidity, which was our downfall. We became known for being quite naughty. I got a warning letter, for my schoolgirl misbehaviour. It stemmed from being bored. If somebody has 15 of you in a room and then says, 'This afternoon you're all going to be dogs', it was like a red rag. I would do the dog, but I'd take it just that little bit too far.

We didn't have any money. One of the boys would always be in the shower rooms when we got in, and it turned out he was sleeping rough. He couldn't afford his fees and so got a scholarship, but he had no money for living and was too proud to tell. Someone went to Oliver Neville and said, 'If there's some kind of bursary, we've got to give it to him.' He ended up living next door to my boyfriend in my boyfriend's mother's house. I sorted him out. I was quite a fixer! Clive Owen lived downstairs, so we had a right old mix of people.

It was interesting to see people changing over the years. A couple of boys had breakdowns, because they couldn't take having that level of honesty.

We never learned about television there. When I first did telly I was shouting, until the sound-man said 'I've got a mike just above you, you can speak how you want.' We were hugely ignorant, when people assumed you'd had an extremely well-rounded education. The thought was that you were going to walk into this wonderful theatrical career.

I remember being a scene carrier. Iain Glen was playing the king and wore the most glorious cloak. As he swept round the corner, there was all this dry ice and he was lit from the back. It was supposed to look like a fire. But he wasn't making the most of it, so I'd fold his cloak and hold it down, so that when he came out from the back, it billowed. Three shows later, he still hadn't said thank you, so I thought, 'Sod you, pal'. The next time he said, 'Do my cloak', I was like 'No! Shove it'.

But he was fantastic to watch! He was the only actor at RADA that could make me cry. God, he was good. The assumption with him was that, when he left, he'd be massive straight away, and he wasn't, which was odd.

Theatre
Absolutely! Perhaps (Wyndham Theatre); *Absurd Person Singular,* and *Bazaar and Rummage* (National Tour), dir. Peter Wilson; *Three Way Split* (Edinburgh Fringe)

TV
Linda Green; The Hound of the Baskervilles; The League of Gentleman; Watching; Tumbledown; Thingummy Doodah; Chimera, Zenith

Television Presenting
Without Predjudice; Have I Got News for You; The Big Breakfast; She's Gotta Have it; This Morning; The Weekend Show

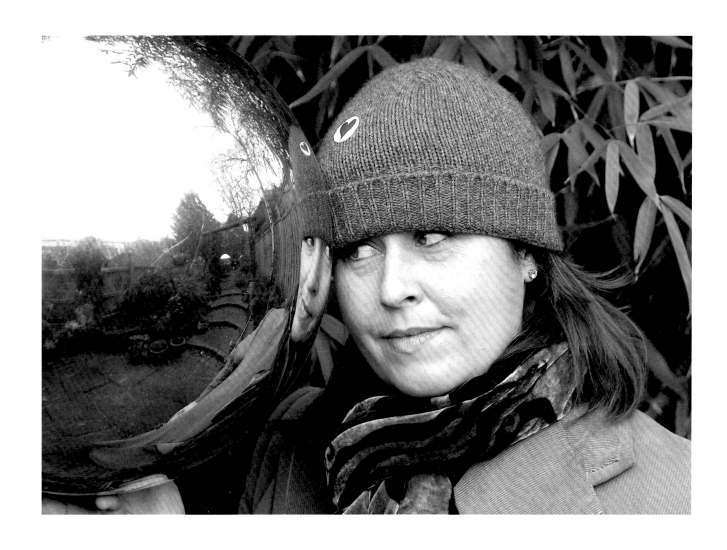

Trevor Baxter, 1949-51

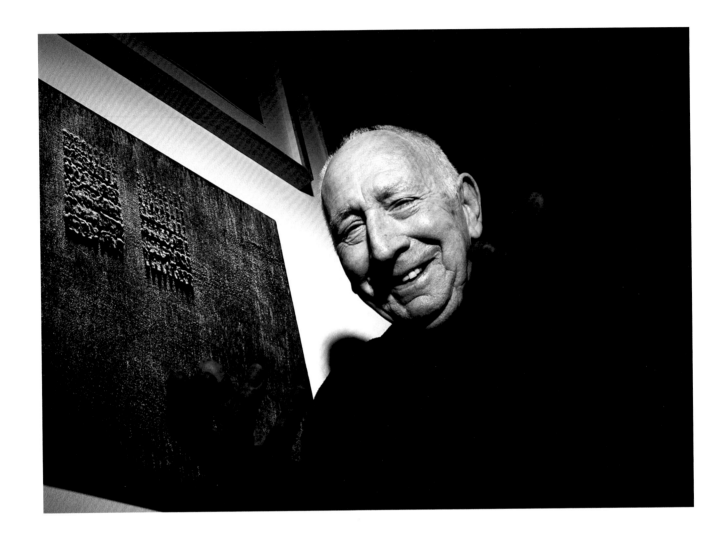

This portrait was taken just after we had finished the session. It was exactly what I had been looking for, but I hadn't spotted the picture previously. It happens quite often with me that the very first or the very last shot is the one I choose. I don't have an explanation for this, it just happens.

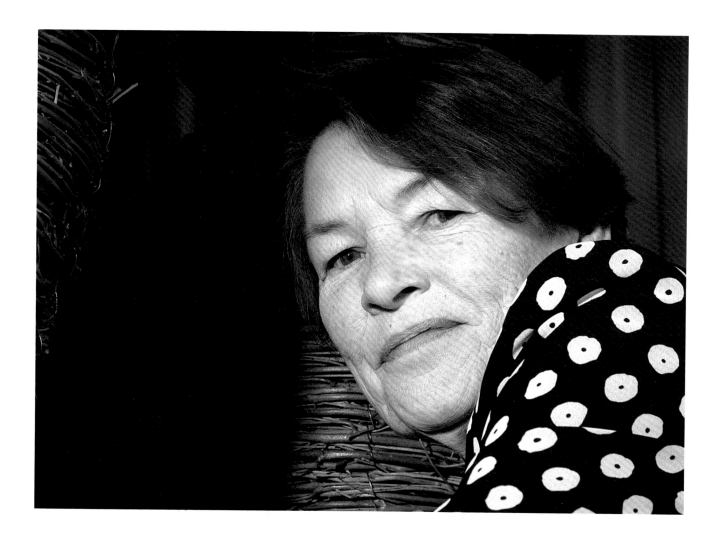

I'd photographed Glenda for a previous exhibition and wanted to take something a little different this time around. So we went to a basement 'style bar' in Westminster. We had had to cancel once because the day before we were due to shoot, Glenda had been bitten about two hundred times by nasty little insects.

Oh, it was an awfully long time ago! I can remember doing the audition in the little theatre and not being able to see anyone in the auditorium and no-one saying anything. I had to do two auditions as I was after a scholarship, so made the journey from the Wirral to London twice. My mother worried. She thought I'd be kidnapped by white slave traffickers.

I was in very good digs, in a home with another family and another girl who was at RADA too. But I always had a very blinkered view: I was there to learn, and that's what I did. It was only years later that I discovered a whole maelstrom of emotions running through me, that I never knew about when I was there.

I can't remember ever being told I was best or worst at anything, but my accent, with its flat As, caused much distress.

My ignorance of life was a great protector. It took me quite a long time to work out where everything in London was.

Theatre
Marat/Sade, dir. Peter Brook; Ophelia in *Hamlet*, dir. Peter Hall; Cleopatra in *Antony and Cleopatra*

Film
Women In Love; The Boyfriend; A Touch of Class

TV
Elizabeth R; several *Morecambe and Wise* appearances

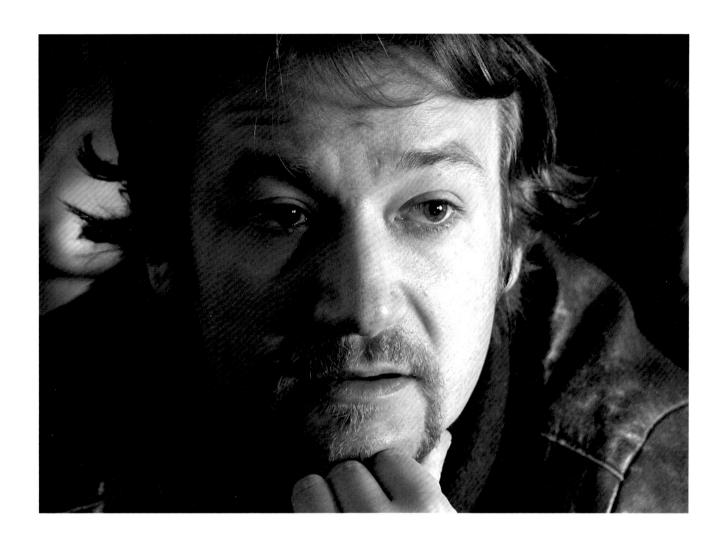

James Dreyfus, 1987-90

Theatre
Lady In The Dark (National) – Olivier Award for Best Supporting Performance in a Musical; *The Producers* (Drury Lane)

Film
Richard III; Notting Hill; Being Considered; Agent Cody Banks II: Destination London; Fat Slags; Churchill: The Hollywood Years; Colour Me Kubrick

TV
Paris; The Thin Blue Line; Frontiers; Gimme Gimme Gimme; Gormenghast; Bette; Willo the Wisp

I was there at 1.10pm at his Soho flat, as arranged. Only James wasn't up yet. So after a quick regrouping we dived into The Alphabet Bar (which I co-owned in a former life). A very relaxed session later (including much yawning) my last shoot was complete.

I was quietly confident because I'd failed to get into Central so miserably. RADA was always the place in my head that I wanted to go. I just thought, 'If I don't get in now, I'll try next year', because I was only 19 at the time. I remember the first person I auditioned for was Hugh Fraser, and it's thanks to him that I went through to the next round. Whenever I see him, I always embarrass him by saying he was my creative, and he always goes, 'Stop it, James, stop it'. I've still got my letter of acceptance. Oh yes. Oh, God, yes. It took three weeks to come, and the wait was agonising. But I knew I'd done quite well on the day, I knew in my heart I'd end up going.

In my year were Marianne Jean-Baptiste, Sophie Okenedo, Stephen Beckett, Mark Benton. We drank huge amounts. A very social year, but also known as the 'naughty' year – the year that didn't behave as we were supposed to. We actually all got on very well.

I loved most of it, but I was never very into movement-orientated things. Once we started working on productions it really kicked in for me. They cast me all over the place – very intensive. I said to Oliver Neville that there should be a room with a punch bag, so you could go there at the end of the day and vent your nervous energy.

My fondest memory is when John Gielgud came and listened to our poems.

Guy Henry, 1979-81

Guy will forgive me, I know, for reminding him that at 11am on the day of our rendezvous he was awoken with a start by a photographer trying to find him. He opened the door somewhat startled, in his dressing gown, and I saw the ghastly recollection of our date wash over him. To his credit he got up, shaved and went straight to work.

At audition, I performed the school teacher, in James Saunders' monologue *The Pedagogue*. I got through three minutes before being told it wasn't really acting, more revue. I also did 'We are amazed...' from *Richard II*. Hugh Crutwell told me I was 'illustrating, not being' the character. I said didn't he think it rather difficult to 'be' *Richard II* in a university classroom, a pool table in one corner and a picture of Snoopy on the wall. He said 'No'. Which was essentially the only important acting lesson one could ever have!

My oldest school friend had been accepted for the stage management course a week or two earlier, so I was delighted that I could join him in the Big Smoke.

My most prominent fellow-students were Kathryn Hunter, Paul McGann, Nigel Pivaro, Adam Blackwood, and I still see them sometimes. I've lost touch with those who weren't fortunate enough to get established as actors and have gone a different way.

I was best at voice stuff and sleeping a lot, as I chose to be a three-toed sloth in animal class. I was terrible at most things to do with movement in leotards.

Theatre
Delahay in *Another Country* (Queens Theatre); Feste in *Twelfth Night* (Cheek By Jowl); Turgenev in *Coast of Utopia* (National). For the RSC: Lelio in *Venetian Twins*, Mosca in *Volpone*, Malvolio in *Twelfth Night*, King John in *King John*, Parolles in *All's Well That Ends Well*

Film
Bright Young Things

TV
Young Sherlock Holmes; Sword of Honour; Colditz

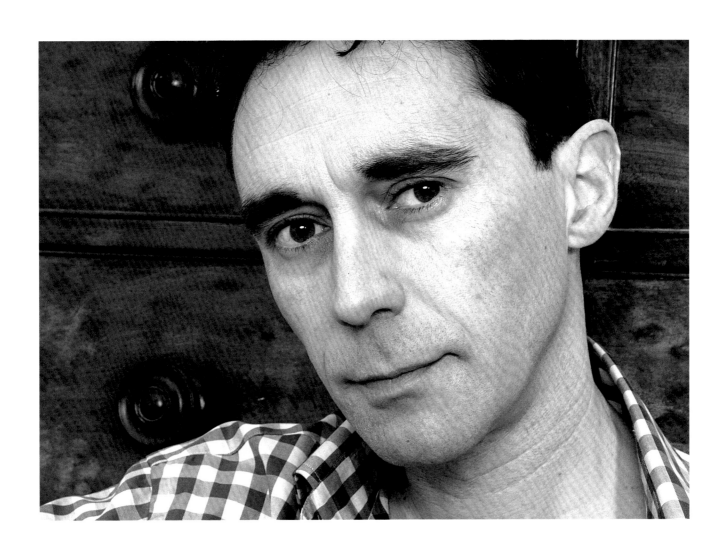

Stephen Beresford, 1991-94

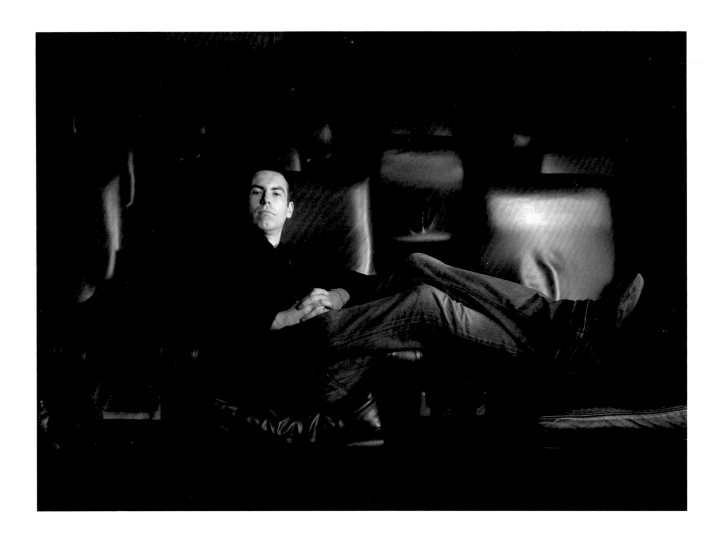

This portrait was taken at the Electric Cinema in London, where we met on a very rainy day. I can't remember how Stephen had travelled, but it certainly involved getting wet at some point. Stephen is a writer and director as well as an actor, he's also the funniest man I've ever met.

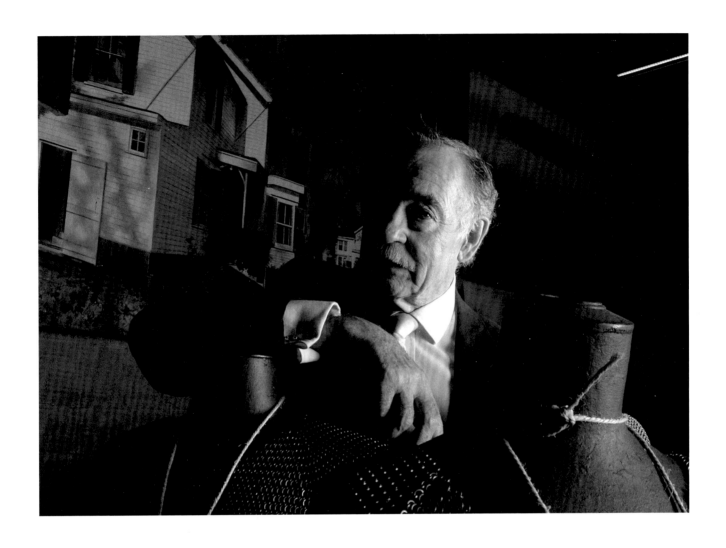

I took Richard's portrait in the GBS theatre at RADA, where the stage management team had just set out all of their extraordinary creations for an exhibition. It was amazing to see giant Edward Hopper paintings, original suits of armour, ancient Greek sites and more, all side by side in the theatre.

Ralph Fiennes, 1983-85

Ralph was in the middle of rehearsals for Julius Caesar, which I thought explained the skinhead look, but it turned out that it was our old friend Harry Potter that took the number 1 to him.

People used to knock RADA, people who didn't really know anything. The word of mouth between wannabe actors was that RADA was very stuffy and old-fashioned. But there was still the feeling that if you got in there, that was it. Very few people turned down a place.

I'd been offered a place at Central, and I remember telling my mother. She said to me, 'That's great. But have you heard from RADA yet?' So I held out and got in.

I did three auditions. I did the first one, was told to wait, then did a second one, about an hour later. Then I heard nothing for four or five weeks, until I was asked for a recall, in which I had to audition in the space of an afternoon for three different directors, ending up with Hugh Crutwell. I felt he was particularly engaged with me, in the sense that he was very positive… to the point where I was very hopeful of being offered a place. Sure enough, three days later, I got a letter, which I still have.

Hugh Crutwell was a unique man of the theatre, with a very forceful, idiosyncratic take on the integrity of the actor. It was very important to him. He hated phoneyness, he hated anything over-technical. He looked for the right spirit: the spirit of commitment and individuality.

My year held a wide range of people from different parts of the country. The idea was that Hugh created an ensemble each term, which would be nurtured into doing plays together as a company. Our year was very strong as a company. We liked each other, and the differences in each other. Wanting to work together is something you can never really describe. Even though we've lost touch, there's an incredibly strong bond each time we see each other.

I always thought I was terrible at movement. There were people who were the most incredibly graceful dancers, but I was physically very tense.

Henry Marshall used to teach prize fighting. He was eccentric and adored, sported a moustache and a goatee like something from a Robin Hood film. Weirdly, although I was terrible at dancing, I was particularly good at stage fighting. Iain Glen and I competed in the RADA prize fight, and took on an incredibly complicated fight of rapier and daggers. It went on forever! We won, though. I think.

I lived at home because my father had a flat in Clapham. I used to bicycle in every day. I'm not a native Londoner, I'd just been living there since 1982, but I'd done a foundation course at Chelsea, so was reasonably well-versed in London. I'd thought I wanted to be a painter, but I didn't have anything to paint. I'd acted at school and liked it – but I'd never liked the people at school who'd wanted to be actors. I thought they were a bit too self-conscious.

I wasn't particularly debauched. I think people had a much more debauched time than I was able to discover!

One of the features of the course was its high intensity. You were doing all kinds of things, learning songs for one teacher, poems for another class, and lines for a play you'd be doing as a company. You were given a lot of tasks to do and it was up to you to find the time to do them.

I'm sure loads of people have talked about Hugh Crutwell. He's come to see me in things I've done. He's very honest. Things I've been thought to be good in, he's said, 'Oh no. You shouldn't do this', or, 'You're singing the note. Don't sing it.' He was always very direct. I never knew him well enough to call him a friend but I think of him as a mentor. He was someone who saw right into the actor that you were.

Theatre
For the National: *Six Characters in Search of an Author; Fathers and Sons; Ting Tang Mine; The Talking Cure; The Play What I Wrote.* For the RSC: *The Plantagenets (Henry VI parts 1 and 2; Richard III)*, dir. Adrian Noble; *Much Ado About Nothing*, dir. Deborah Warner; *King John; The Man Who Came To Dinner; Troilus and Cressida*, dir. Sam Mendes; *King Lear*, dir. Nicholas Hytner; *Love's Labours Lost*, dir. Terry Hands; *Brand*, dir. Adrian Noble. For the Almeida: *Hamlet* – Tony Award for Best Actor; *Ivanov; Richard II; Coriolanus*, all dir. Jonathan Kent. Marc Anthony in *Julius Caesar*, dir. Deborah Warner (Barbican)

Film
Wuthering Heights; The Baby of Macon; Schindler's List (BAFTA Award Best Supporting Actor, London Film Critics Award for Best Actor); *Quiz Show; Strange Days; The English Patient; Oscar and Lucinda; The Prince of Egypt; The Avengers; Onegin; Sunshine* (European Film Academy Award for Best Actor); *The End of the Affair; Red Dragon; Spider; The Good Thief; Maid in Manhattan; Wallace and Gromit: The Curse of the Were-rabbit; The Chumscrubber; The Constant Gardener; The White Contest; Chromophobia; Land of the Blind; Harry Potter and the Goblet of Fire*

TV
A Dangerous Man: Lawrence After Arabia; Prime Suspect; The Cormorant; How Proust Can Change Your Life

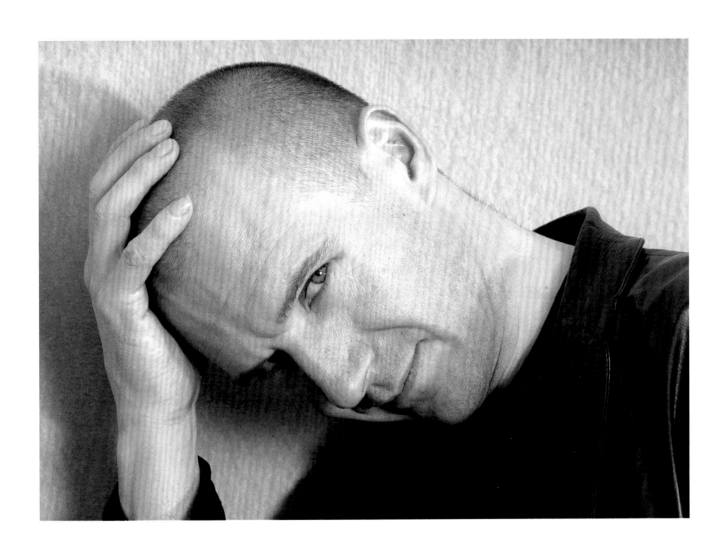

Ioan Gruffud, 1992-95

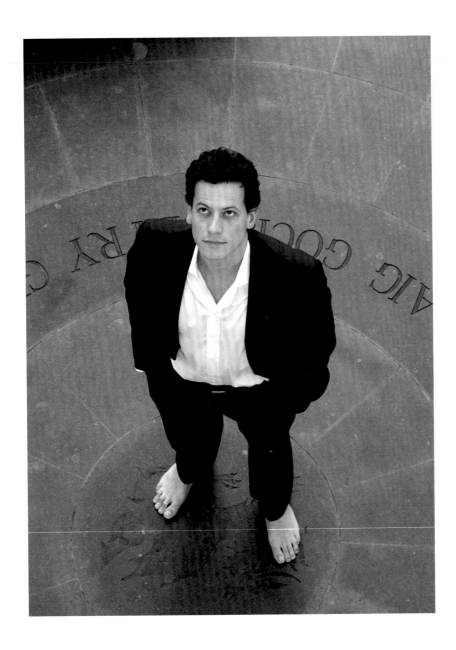

Theatre
The Decameron (Gate); *The Play What I Wrote* (Wyndhams)

Film
Wilde; Titanic; 102 Dalmations; King Arthur; Fantastic Four

TV
Pobol Y Cwm; Horatio Hornblower in the *Hornblower* series; *Man and Boy; Warriors; The Forsyte Saga*

Ioan has starred in so many films in the last few years that I doubt even he could list them. A less starry person you will not meet. This was taken as he was promoting King Arthur in Cardiff. Something he was doing for his home town, not because he had to.

We were asked to wear something comfortable for the audition, so I wore my Welsh International shell suit. I got the call when I was meant to be revising for my A Levels, and I was in the garden sunbathing. Later, my mum walked into the garden, carrying huge bags of shopping and was about to give me this massive bollocking for not revising, when I said, "Well, the reason I'm out here, Mum, is I've just been accepted into RADA". She dropped all her shopping bags and started crying.

At RADA, my social life was sort of non-existent because the course was so intense that by the time you'd got home and got something to eat, it was time to go to bed. But Mike Pickering and I used to save up our money and one weekend a month, meet at a café for a cappuccino. Then we'd go for a fabulous boozy lunch at Mezzo's, sit there with a bottle of white and one of red, and many armagnacs. By the time we'd finished, we were ready to go to dinner again in the evening, and then go clubbing until dawn.

Every time I'd walk out of my singing class, I'd end up singing all the way home. I was really inspired by the teaching.

I hated the acting classes. I was probably a bit too young to be there: I didn't feel I had any life experience to draw on in the acting exercise. They'd say stuff like, 'Right. Your girlfriend is pregnant and you've broken up with your gay lover' and I'd never had a girlfriend. I really lost confidence. It felt like my natural instincts had been taken away.

I remember being thrown out of a dance class for mucking around and having the giggles. And I loved the dance classes. I was so devastated that I burst into tears. Very embarrassing!

I didn't grow up at all. I couldn't wait to get out into the outside world. It was an institution, where you studied. You grew up after leaving where you'd obtained all these skills.

Douglas Hodge, 1979-81

I arrived at Douglas' place in Oxfordshire to find that his friend and neighbour had died in the night of a heart attack. All very sad – especially since he had been a professional footballer and was still an active sportsman. On a lighter note, Douglas showed me a letter he had received after reading at the Christmas service in the local church... welcoming him as the new vicar to the parish... we laughed so much.

I didn't get in first time round. The second time I tried, I don't think I was that nervous, because I'd already got a place at three other drama schools, so I was very happy.

Kenneth Branagh was in my year, so were Kathy Hunter and John Sessions. I'm not in contact with any of them. I was in the National Youth Theatre and so I had great friends from that anyway. The person I most admired watching was Mark Rylance. I thought he was a very special actor.

I really didn't like it at RADA at all. I didn't enjoy it, and, in fact, I left early. I haven't got many positive memories. I was pretty serious, over-earnest, and that was the problem: I took the whole thing too seriously. I should've lightened up a bit, but it's very difficult to see that at that age. I've also never responded very well to institutions. If I'd been a bit more mature I probably would have got a lot more out of it.

I sort of decided when I was there to give up acting. I decided it wasn't for me.

I was very good at being late. I was late every single morning. I was very bad at almost everything else. Oh, I joined the RADA football team.

My accent became much more Gillingham than it was when I was in Gillingham, to prove to everyone how working class I was.

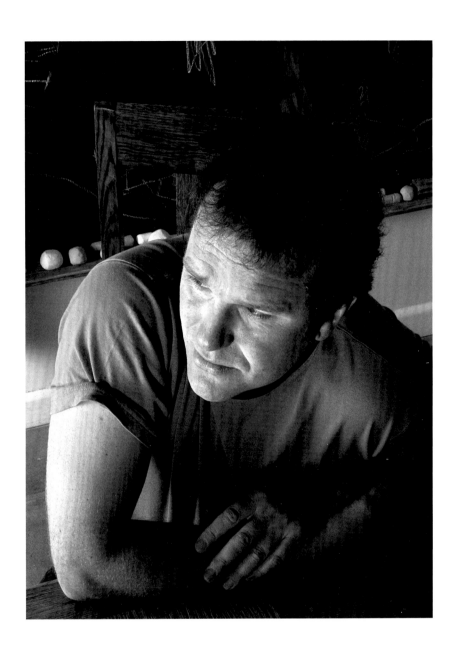

Theatre
Coriolanus, dir. Deborah Warner (Almeida); *Hamlet* (Bolton Octagon); *Romeo and Juliet* (Birmingham Rep); *Three Sisters* (ATG); *King Lear,* dir. David Hare (National); *Dumb Show* (Royal Court); *Guys and Dolls.* Douglas collaborated closely with Harold Pinter over 10 years, and performed in many of his plays: *The Caretaker* (for which he won an Olivier Award); *Betrayal; The Lover*

Film
Vanity Fair; Out of Time; Saigon Baby

TV
Red Cap; The Russian Bride; Middlemarch

Marianne Jean-Baptiste, 1987-90

Marianne now lives in LA with her young family, and they were just moving to a beautiful, Spanish finca-type house in Hollywood. We decided to pick a day when the builders were not present, and just had fun shooting around what was there.

Acting was not a life-long dream. I always wanted to be a barrister. I remember being very excited to be auditioned by Pat Hayward because I thought she was such a great actress. I had a lot of difficulty finding a modern speech, so in the end I wrote my own! For my classical piece, I did Queen Margaret's speech from *Henry IV part 1*. I remember feeling quite nervous but also that I had nothing to lose so I had a just-get-on-with-it feeling too, and Pat was so lovely and supportive that it was a very pleasant experience.

I remember getting the letter of acceptance: I was in bed at the time and my father came in and said to me, 'Before you accept the place at the other school you'd better open this'. And he handed me the sealed envelope with the name of the school across the top. It was just a single sheet, so I thought, short and sweet – has to be a no. But then I was pleasantly surprised.

In my year were Barry Aird, Julian Hill, Sophie Okenedo, Ruth Lass, James Dreyfus, Trilby Harrison, Anastasia Mulroony. I am still in contact with a couple.

Singing was definitely one of my strengths, but I also had a good time doing acting exercises and improvisational exercises.

I didn't get a full grant for my studies so I had to work after school. When everyone was hanging out at the pub, I was hanging out with a torch at the Empire Leicester Square, showing people to their seats. The upside was, I got to watch lots of movies for free.

Theatre
It's a Great Big Shame, dir. Mike Leigh (Stratford East); *The Way of the World* (National); *Measure for Measure* (Cheek by Jowl, National); *Le Costume*, dir. Peter Brook (Paris)

Film
London Kills Me; Secrets and Lies; Nowhere to Go; The 24 Hour Woman; A Murder of Crows; 28 Days; New Year's Day; Spy Game; Don't Explain

TV
The Wedding; Silent Hearts; The Murder of Stephen Lawrence; Men Only; Without a Trace; Loving You

Music
As a composer – *Career Girls;* as a singer – *Keeping Time* (album)

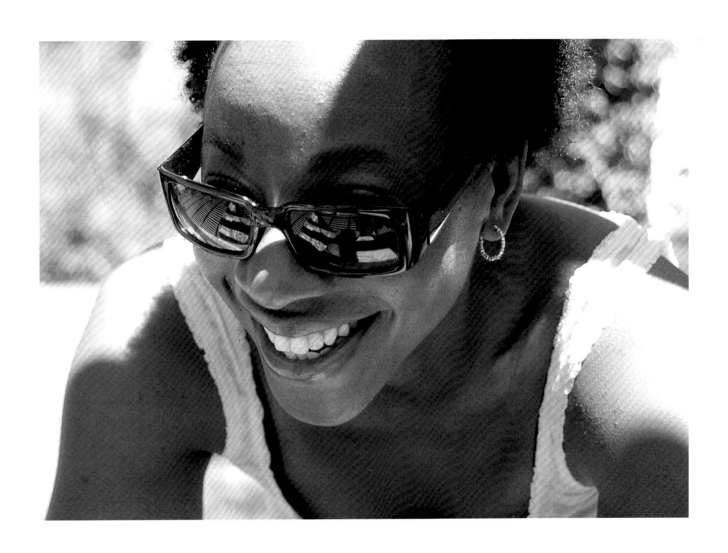

David Morrissey, 1983-85

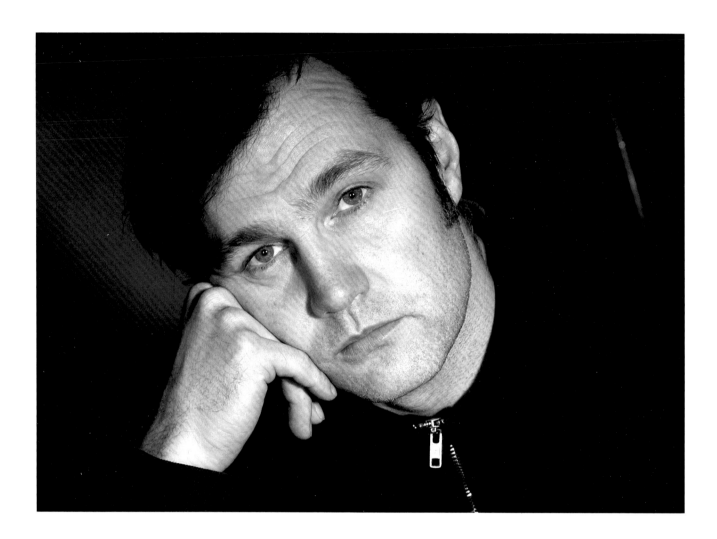

David Morrissey came straight from a day's shoot for a style magazine where they had subjected him to all the usual; art director, make-up, wardrobe etc. So when he got to me, I think he was happy to just treat it as 'time out'. I hope this is reflected in the portrait.

For my audition, I did 'Oh that this too, too sullied flesh' speech from *Hamlet*, and I remember Malcolm McKay saying to me, 'You're from Liverpool – tell me a joke'. I was back in Liverpool when I got the letter and I tried to defer the place for a year in order to travel: when I came back from Africa, I went to RADA.

I was very good at socialising and drinking. I wasn't very good at fencing. I worked hard, and played hard too.

Theatre
The Alchemist

Film
One Summer; Drowning By Numbers; Captain Corelli's Mandolin; Fanny and Elvis; Stoned; Derailed; Basic Instinct 2: Risk Addiction

TV
Blackpool; The Deal; State of Play; Out of Control; Holding On; Clocking Off; Linda Green

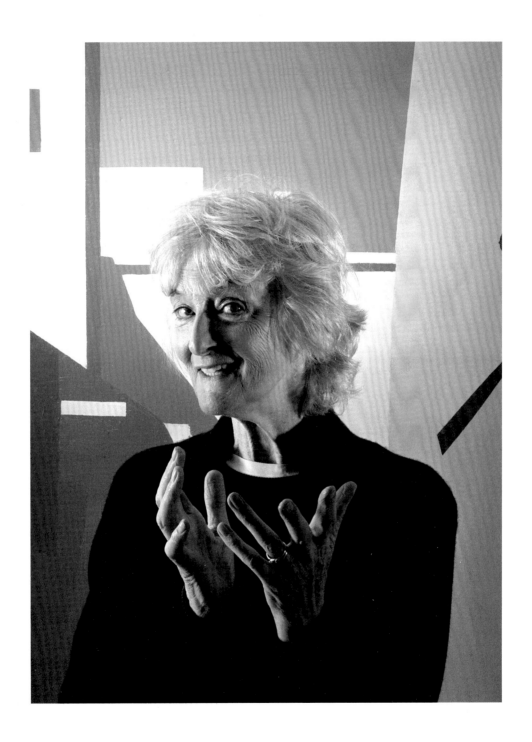

*Caroline has a flat directly opposite one of the galleries that shows my work and,
just prior to phoning her, she had seen an exhibition of mine. Lucky for me
this didn't seem to put her off being subject to my lens.*

First published in the United Kingdom in 2005 by
Dewi Lewis Media Ltd.
8, Broomfield Road
Heaton Moor
Stockport SK4 4ND
England

wwww.dewilewismedia.com

Photographs: © 2005 Cambridge Jones
Texts: © 2005 Miranda Sawyer and Lord Attenborough
For this edition: © 2005 Dewi Lewis Media Ltd.

The right of Cambridge Jones and Miranda Sawyer to be identified as
Authors of this work has been asserted by them in accordance with the
Copyright, Designs and Patents Act 1988

ISBN: 0-9546843-2-X

Interviews & Research: Miranda Sawyer and Lucie Greene
Design & artwork production: Dewi Lewis Media
Print: EBS, Verona

with thanks to

gettyimages